ART IN ODD PLACES
BODY
NEW YORK CITY, 2018

Published by Art in Odd Places
New York, NY
www.artinoddplaces.org

©2019 Art in Odd Places
All rights reserved. This book may not be reproduced in whole, or in part, in any form, without written permission from the author and/or publisher.

Edited by Katya Grokhovsky
Catalog Design by Kit Fretz & Alex Sullivan

ISBN 978-0-578-21533-4

Front cover: Jessica Elaine Blinkhorn, *Gaze*
Photograph by Walter Wlodarczyk

Back cover: Questions Collective, *Foundation*
Photograph by Walter Wlodarczyk

October 11th-14th, 2018
14th Street, Manhattan

October 4th-27th, 2018
Westbeth Gallery
55 Bethune St, New York City
NY, 10014

Founder and Director: Ed Woodham
Curator: Katya Grokhovsky

Artists:

Elaine Angelopoulos | Jessica Elaine Blinkhorn | Kasie Campbell | Stacey Cann | Deborah Castillo | Donna Cleary & Kathy Halfin | Don't Move: Kat Cope, Kate Frazer Rego, Kelly Savage | Dominique Duroseau | Catherine Feliz | Dakota Gearhart | Maryam Monalisa Gharavi | Nicole Goodwin | Claus Hedman | Martha Hipley | Pei-Ling Ho | Kinsfolk: Holly and Jackie Timpener | Daniela Kostova | Joanne Leah | Legacy Fatale | Luiza Kurzyna | Lulu Lolo | Jodie Lyn-Kee-Chow | Nadja Verena Marcin | Daniela Mekler | Esther Neff | Rose Nestler | Laura Nova | No Wave Performance Task Force: Christen Clifford and Amy Finkbeiner | Jody Oberfelder | Sierra Ortega | Verónica Peña | Maya Pindyck | Questions Collective | Yali Romagoza | Clarivel Ruiz | Jody Servon | Meg Stein | Jaime Sunwoo | Tanga: Rachel Chick, Andrew Prieto, Alfredo Travieso | The Do-Mystics: Arantxa Araujo and Monique Blom | The Museum on Site | Denise Treizman | Grace Whiteside

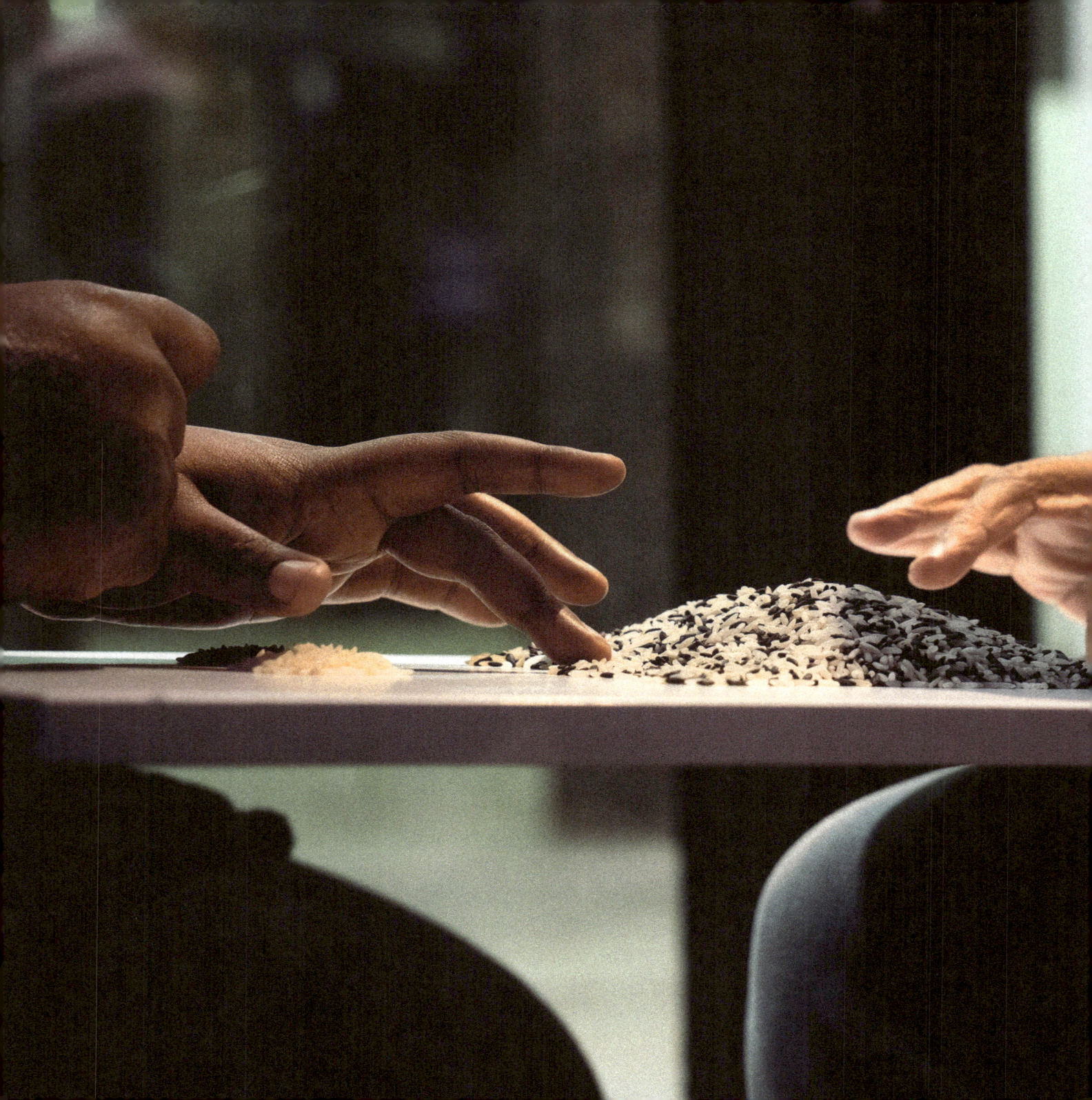

Rap on Race with Rice, Dominique Duroseau, 2018

Table of Contents

1	**Opening Statement** *Ed Woodham*
3	**On *BODY*: Curatorial Statement** *Katya Grokhovsky*
4	**Let's Talk About *Art in Odd Places*: Interview with Founder, Ed Woodham, and *AiOP* 2018 Curator, Katya Grokhovsky** *Quinn Dukes*
11	***AiOP* Reflections** *Katie Hector*
13	**"Is my presence a stain that can never be removed…"** *Nicole Goodwin*
16	**Westbeth Gallery**
26	**Artists & Street Performances**
115	**Artists Biographies**
123	**Contributor Biographies**
127	**Gallery Key**
129	**Photo Credits**
131	**About**
133	**Acknowledgments**

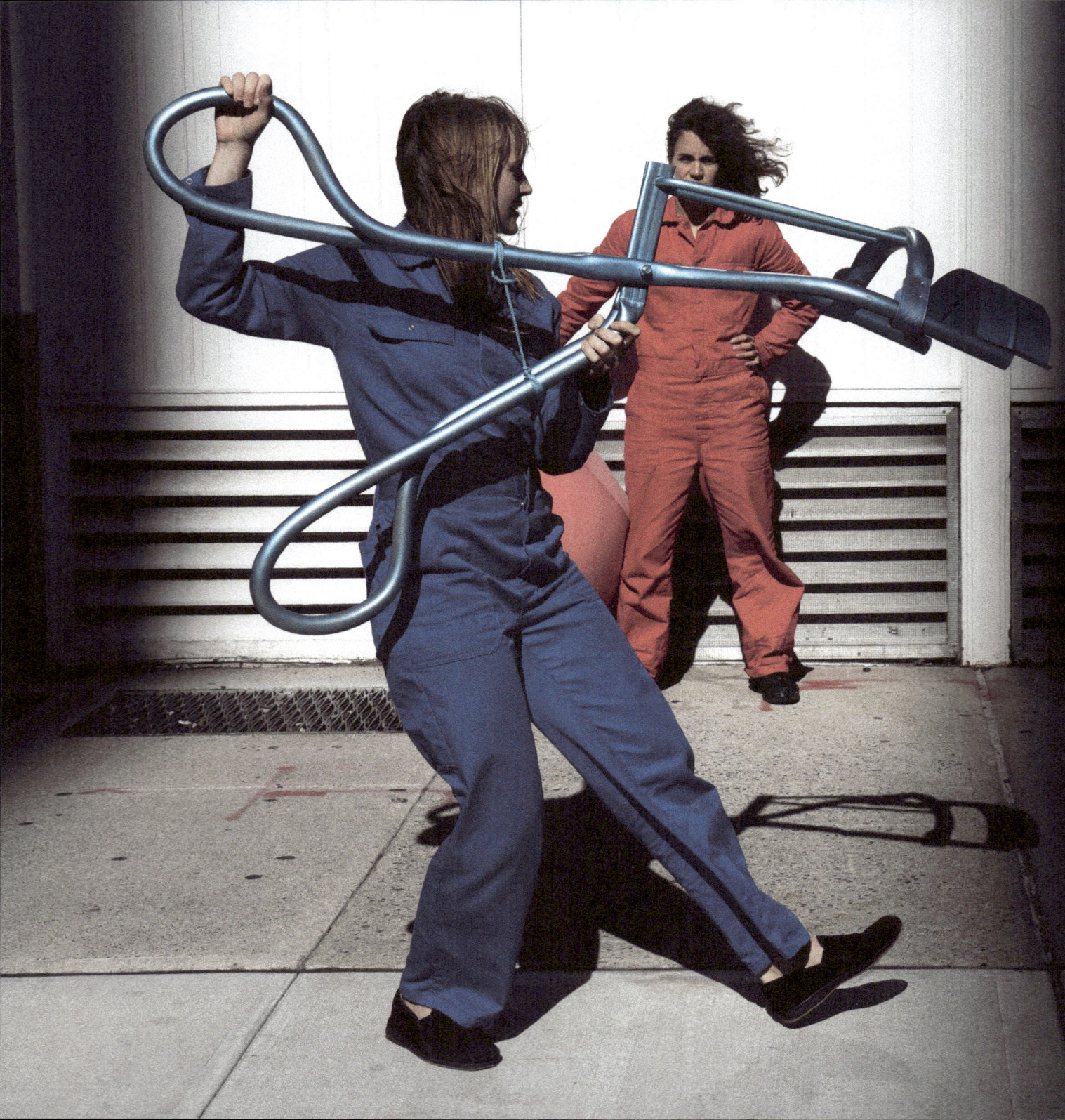

Opening Statement

The mission of *Art in Odd Places (AiOP)* is to engage and activate the everyday places in our lives. In creative, unexpected, and sometimes unusual ways we claim our shared rights to public spaces, while also making sure to question, subvert, and occasionally shake-up the socio-political status quo that regulates it.

The sites may look empty, vacant or just plain ordinary, yet they hold the extraordinary possibility for us to collectively imagine change or perhaps even change the ways in which we imagine.

Art in Odd Places has been and remains an independent free agency challenging institutional political normative conformation; challenging sexism, racism, ageism, genderism, homophobia, transphobia, xenophobia – isms and phobias that marginalize and colonize peoples, cultures, and ideas.

Art in Odd Places 2018: BODY was a timely and powerful experience under the visionary direction of Katya Grokhovsky. I've watched and participated in the production of *AiOP* for 14 years in NYC and other cities. And this year, even though I was more outside the process than ever before because of health issues– provided me with a genuine (unanticipated) opportunity to witness the integrity of what is possible via unfettered intervention – despite numerous obstacles and limited resources. The collective investment of the *AiOP BODY* team combined with their connectedness with the dedicated artists read clear –from the articulated joy of everyone involved – to the palpable electricity on the street during the public performances. I was honored and proud of this year's *Art in Odd Places* that Katya and her team created.

It was a year of firsts. It was the first time a veteran *AiOP* artist, Katya, had taken the helm as the *AiOP* curator. It was the first time *Art in Odd Places* was open only to artists who identified as female and non binary. It was the first time a corresponding gallery show accompanied the *AiOP* public arts festival. It was the first time I had handed over the reigns of control to a curator/producer and their team – a long time wish – due to the combination of circumstances and trust in the team's ability. It was the first time I observed the sustainability of *Art in Odd Places* as it was expertly crafted into this year's iteration from the timelines, templates, and archives – and a vision of updating the old version.

I immensely appreciated the understanding and support of Katya Grokhovsky, Katie Hector, Alex Sullivan, Audra Lambert, Bridget Leslie, Allison Pirie, Emily Market, Kit Fretz, and Juana Urrea during an overwhelming time. They upheld the standards and vision set by past *AiOP* curators, staff, and artists who have their imprint of ownership on this cooperative mission of acknowledging the importance of free speech, public space, human rights, social justice, and change making through art. In these foreboding times – together [then, here and now] – we collectively gathered with our individual and collective stories to reframe our surroundings, our patterns and our lives. Mighty formidable female and non-binary artists and thinkers led/lead the way. Change and power are with us – moving onward.

Ed Woodham
Director & Founder of *Art in Odd Places*

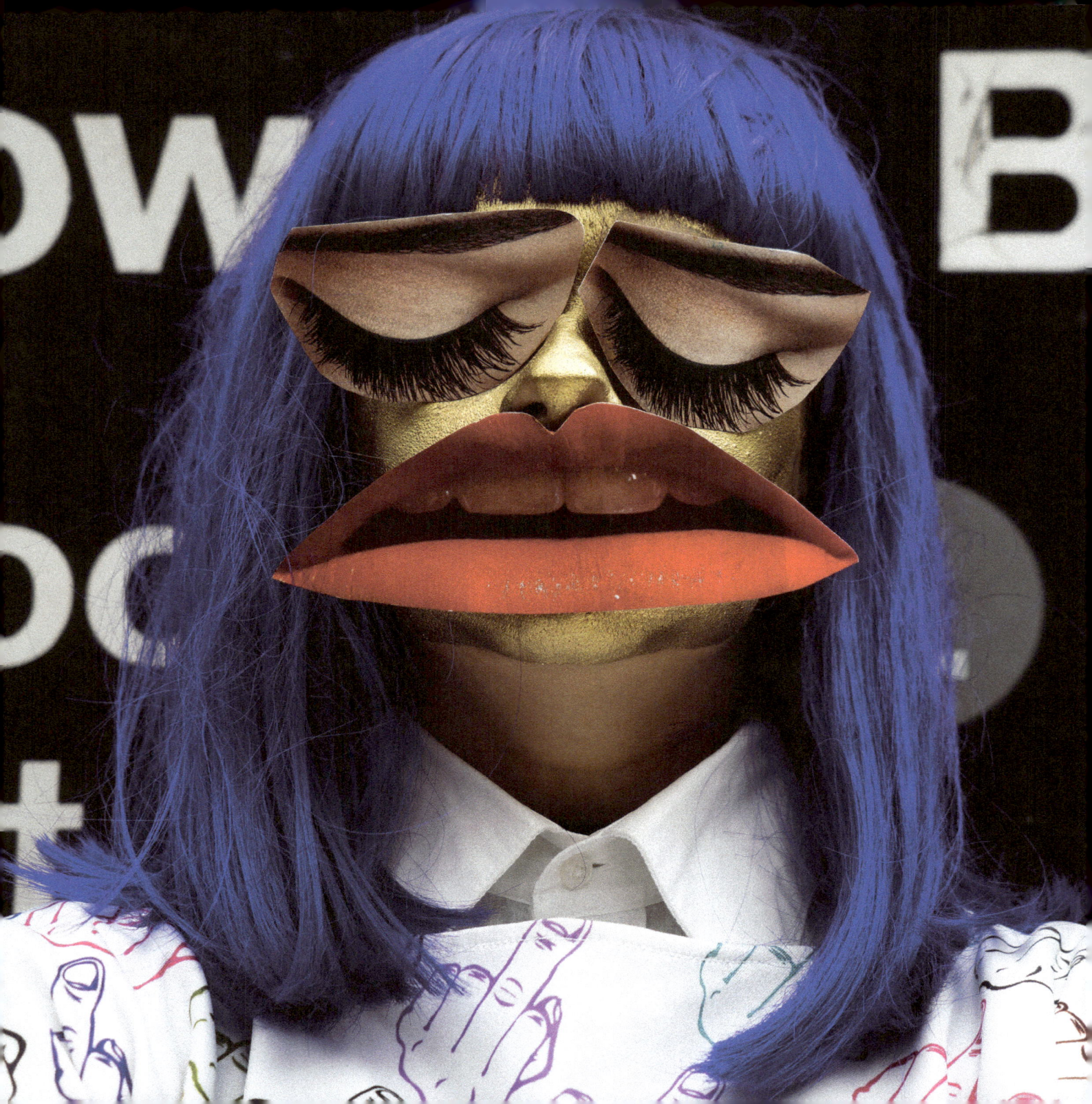

On BODY: Curatorial Statement

Why the theme *BODY*? *AiOP* has always been thematically driven in a broad sense of one word, and I immediately gravitated towards the notion of the body as a potential loaded site for investigation and creative, politically charged urgent inquiry. *BODY* explored agency, politics and status of the "other" in an urban environment, through various media including performance, social practice, installation, sculpture, photography, sound, video, text, etc. extending the visibility and the dialogue around interdisciplinary, ephemeral and difficult to categorize works situated independently of the commercial market.

Forty-three female and non binary artists from around the world challenged notions and societal constructs of gender, age and beauty, analyzed contemporary ideas of self, death, sex, viscera and health, investigated issues of otherness, body image, language, memory and belonging through staging of multimedia interdisciplinary projects, movement and participatory works, artifacts and ephemera, exploring issues of exclusion, displacement and absence in the current discourse.

The gallery site of Westbeth, an artist run and lived-in organization acted as an extension of the body of the festival, positioning works by the artists back into the brick and mortar space, facilitating a festival hub throughout most of the month of October. During the public festival, the entire length of the 14th Street, historically the main site of *AiOP*, was activated by the simultaneously occurring projects over the length of four days, intervening into the fabric and daily grind of the great body-city of New York. Otherness reigned and the vein of Manhattan seemed to glow with electrified energy of art, despite rain, first wintery winds and hurried crowds. For a brief moment, the city seemed to celebrate, partake and unite its' visitors and residents, confronted by a challenging dialogue, providing abundant audiences, lifting the heavy burden of its' habits. Social media was a constant companion, delivering both worldwide visibility and censorship. Artistic encounters were often provocative and I experienced great jolts of vitality, curiosity, unanticipated spectacles, intermixed with bouts of discussion, arguments, conversation and excitement.

In the age of "me too", my decision to exclude male and male identified artists should have not surprised anyone or solicited much critique, however, that was or is still not the case. My response is simple and unwavering: as art history proves, women, female identified and non binary artists have been excluded for centuries from participating, full equality is yet to be achieved and time has come to correct the balance, unapologetically. *AiOP BODY* made history and I am especially proud of and grateful to the dedicated 2018 team and the participating artists for working tirelessly together to move the needle of cultural production towards the right direction. We have only just begun.

Katya Grokhovsky,
Curator, *AiOP 2018 BODY*

Let's Talk About *Art in Odd Places*: Interview with Founder, Ed Woodham, and *AiOP 2018* Curator, Katya Grokhovsky by Quinn Dukes, of Performance is Alive

Each fall, the streets of New York City (more specifically 14th Street) are injected with a higher and more concentrated dose of public installation and performance art via Ed Woodham's grass-root initiative, *Art In Odd Places*. Curated by performance artist and curator, Katya Grokhovsky, this year's festival and corresponding exhibition exclusively features female identifying artists. After reviewing the largest number of applications ever received in the organization's 14-year history, Ed and Katya spoke with us about *AiOP*'s exciting history, the necessity for reclaiming public space and the decision to focus on the (female) *BODY*. It is a great honor to share our discussion with you here and stay tuned for the incredible list of participating artists for *AiOP 2018 BODY*. - Quinn Dukes

QUINN DUKES: *Art in Odd Places* was one of the first live performance events that I experienced in New York City. Can you talk about the first edition of *AiOP* NYC?

ED WOODHAM: The first edition of the NYC iteration was my personal artistic response to the disappearance of civil liberties, the hyper-surveillance and privatization of public spaces after the events of 9/11. It was a reimagining of the original version that had been created in Atlanta for the Cultural Olympiad in 1996 – to bring attention to the importance of free speech in public space through multidisciplinary art mediums. So. The first 2005 *AiOP* was a ragtag patch-work festival relying heavily on a close group of my dear friends without whom I couldn't have made it happen. But if you look back, the archive of *AiOP* is a testament of what can be achieved working independently of institutions and permissions, and with the dedication of many collaborators.

QD: So do you feel that the festival still has the same collaborative energy as 2005?

EW: Absolutely. More so than ever – as the festival has grown larger the effort to create it requires a huge collaborative engagement from the *AiOP* team: curator, curatorial manager and assistants, designers, administrators, interns, artists, and volunteers.

QD: What led you to 14th Street?

EW: 14th Street is the longest stretch across Manhattan (east to west) East River to the Hudson River 2.0 mi (3.2 km) and it marks the southern border of Manhattan's grid system. 14th Street has a rich storied history of social justice activism (Union Square to The Living Theater), night life (from The Palladium to The Hell Fire Club), artists' residences (Ginsberg to Duchamp), food (Luchow's to Disco Doughnut), commerce (the original Macy's to The Meatpacking Fashion District), gentrification (again the Meatpacking/Highline to Stuyvesant Town). It's a perfect NYC street laboratory to explore communication, trend shifts, urban construction, diverse socioeconomic neighborhoods, and the pedestrian organism – in public space.

EW: *Art in Odd Places* has evolved as the times and 14th Street public spaces have progressed. When *AiOP* began in 2005, urban dwellers/pedestrians were more cognizant of personal and public space. With the introduction and advancement of the mobile phone/personal computer, there has been a shift in the navigation through civic space. Gentrification and displacement of residents and businesses has changed the landscape of the environment for possible engagements. For example the sale of Stuyvesant Town and Peter Cooper Village in 2015 foreshadowed the leveling of many long time far east side establishments to make way for high rise upper income residencies – drastically reshaping the neighborhood's inhabitants. 14th Street is ever evolving. Also, in 2012, *AiOP* began to travel to cities around the world and U.S to model the concept for civic and educational producers.

QD: *AiOP* is not exclusive to performance art, what led you to the decision to present such a complex array of mediums?

EW: A major impetus of *AiOP* is to present a collection of creative works in a variety of mediums outside of the privilege, elitism, and constrictions of the institutions of museums, galleries, theaters, and brick and mortar spaces.

QD: Each festival seems to have a thematic container, how do you select these themes?

EW: In the beginning I created the one word focus that has ambiguous meanings like *SIGN* for *AiOP* 2009. Now the curator or curatorial team select the focus or theme.

QD: Does this shift in theme impact the selected work and the experience of the works presented?

EW: Hopefully – as it's the idea – that the theme is topical and timely.

QD: When did you meet Katya?

EW: I met Katya as a participating artist in *Art in Odd Places 2014: FREE* curated by Juliana Driever and Dylan Gautier.

QD: Do you recall your impressions of performance that she conducted?

EW: Oh yes! The project, Slow Dance, immediately sparked my attention as I wondered if passersby would actually take the time to participate. It seemed an awkward (and brave) exchange for strangers to dance with strangers – threatening their personal space in a public setting. It was an experiment in comfort zone and interesting to observe the responses to invitations to the intimacy of a slow dance.

QD: Why is *AiOP BODY* an essential project to present in 2018?

EW: It's vital at this point in time for *Art in Odd Places* to provide Katya – a veteran *AiOP* artist who moves fluidly between visual and performance art (and her curatorial and administrative team) with the *AiOP* systems to present artists' (who identify as female) projects that question patterns about gender, sexuality, politics, status, agency and the other interpretations of body.

QD: When did you first experience *AiOP*?

KG: I think it was possibly around 2011, soon after I moved to NYC post grad school from Chicago. I initially volunteered as a performer for artist Rob Andrews, in his project Union Square Cleaning, as part of the festival's edition *RITUAL*. Afterwards in 2014, I participated in the festival with one of my own projects, Slow Dance in NYC in *AiOP FREE*, then again the following year in Orlando's *TONE* edition with Status Update, and recently with a collaborative project in *2016 RACE* in NYC. So, I know it intimately as an artist first, as well as an audience member. I've always liked the core of *Art in Odd Places*, how it aims to broaden the dialogue around interdisciplinary practices, positioning artworks outside of mainstream spaces, in public domain, outside of institutional regulations and any interior constraints. Specifically, such as scarcity of physical spaces for artists to exhibit experimental and alternative work in New York.

QD: What brought you to the festival and exhibition parameters concept for *AiOP BODY*?

KG: As an artist - curator, I'm always searching for expansion of the definition of contemporary art practice, and *Art in Odd Places*, founded and directed by a practicing artist, appeals to my concerns and interdisciplinary way of working. I often utilize the body in my own work and am interested in exploring what this subject matter means to other practicing artists. What does the body, as a battlefield, situated in public realm signify. Specifically a non-male identifying body, in the city like New York, in USA at this time? What is the body's relationship to site, agency, status, visibility, erasure, absence, exclusion, etc. The theme felt innately natural and relevant to me to explore as a curator at this moment.

QD: You mention, non-male identifying body, this is the first year that the festival has presented works from an all female identifying selection of artists. What led you to this decision?

KG: My decision to present works by female identifying and non-binary artists this year stems from my interest in seeing so called "other" bodies stage a take over of public space, exposing and questioning certain truths and absurdities of non-male existence in our current climate.

QD: Have you experienced any resistance to this?

KG: We have experienced some negative feedback so far, and I'm sure we can expect more as we move forward, but I do believe this is a necessary and timely subject matter and way of dealing with it. As a curator, I am simply attempting to correct the balance through support, exposure and visibility of these voices, which is still pretty uneven in the arts.

QD: What are your overall thoughts on the open call submissions this year?

EW: It was one of the largest response to an *Art in Odd Places* open call in 14 years. The application pool was extremely strong and very exciting.

KG: I am very excited by the overwhelming response we received. Especially, by the great number of critically engaged, exciting submissions from local, national and international artists. It's definitely quite an involved and challenging process putting the festival together, and I'm enjoying evolving my vision as we move along through it.

QD: Do you think performance art grown over the past 10 years? If so, what do you think has contributed to this growth?

EW: Yes, but perhaps even more recently – due to our current unstable political and social climate. Performance art has a history of shifting to the cultural vanguard when there is a collective artistic need to express discontent with the status quo.

KG: I definitely think the medium has been much more visible and exposed, entering mainstream spaces, ever since museums have internalized and embraced it through several seminal exhibitions during the last decade, such as Marina Abramovic, Tino Sehgal, Carolee Schneemann, etc, as well as presenting platforms such as PERFORMA, numerous performance festivals globally, etc. Performance art has been with us for quite a long time, and deserves to have a much bigger audience, support and recognition.

QD: This year's festival is accompanied by an exhibition, what led you to this addition?

KG: Adding an exhibition component at a brick and mortar space this year might seem to exist in contradiction to the ethos of *Art in Odd Places*, but I felt I wanted to expand the dialogue into a gallery space as well as give the festival a longer duration and higher visibility. I am looking at the site of Westbeth gallery, also an artist-run and artist-inhabited organization, as an extension of the body of the city, a somewhat art-historically oddly significant place for exhibiting non-commercial and challenging works of art.

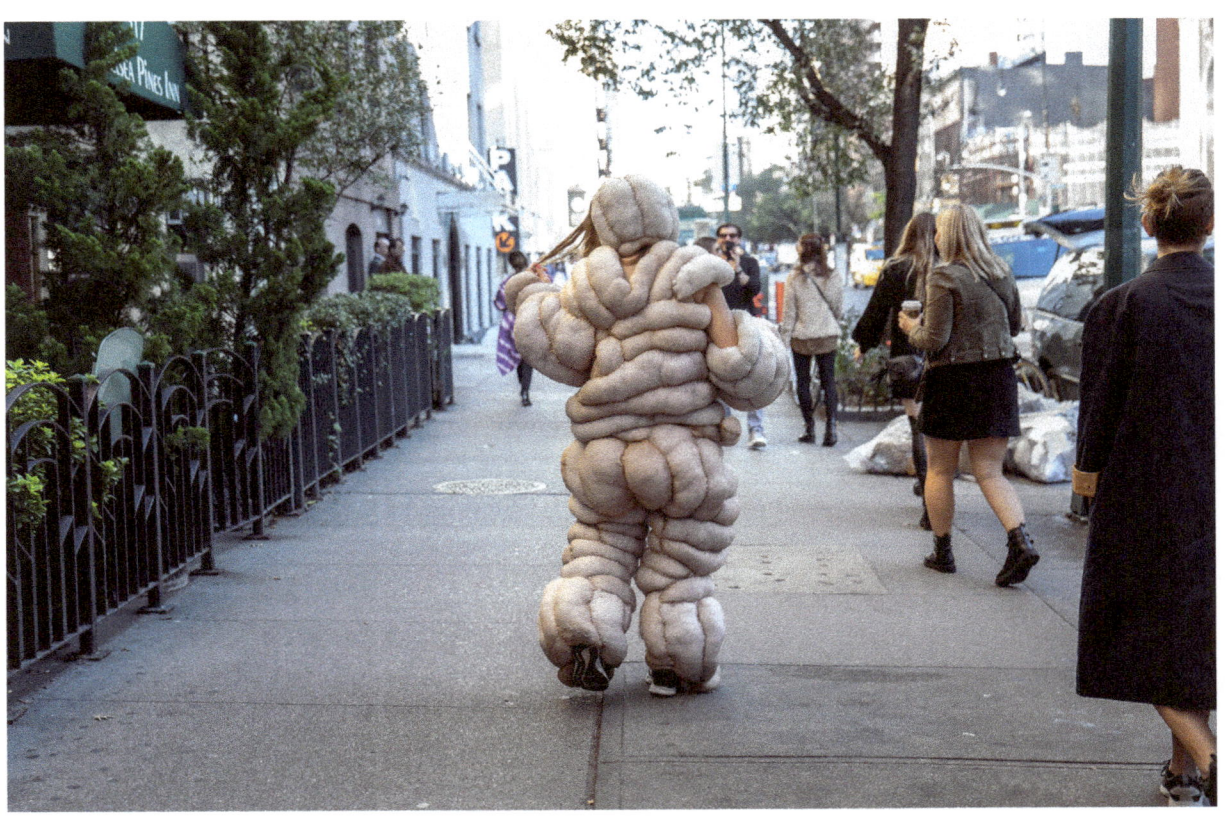

We are Revealed, Kasie Campbell, 2018

QD: So all artists that are presenting during the 4-day festival will also present work within Westbeth gallery?

KG: Yes, all artists will be activating both sites, simultaneously, in different ways. The gallery will mostly be dedicated to the presentation of post and pre-performance ephemera, objects, video, installations, photographs, text etc, in conjunction with the participatory, interactive live performances, interventions, posters paste-ups, etc which will happen along 14th street. The gallery will act as the festival's hub for information, public events, such as panel discussions, opening and closing. I am interested in expanding the dialogue around the public, interdisciplinary and performative practices through both the street and the gallery site.

QD: How has the curatorial process gone so far?

KG: For me, it has been an eye opening and invigorating experience, it feels like I'm inside an eye of the storm somehow, taking the world's current temperature. There is so much we need to talk about and explore as a society today, the festival feels ever more urgent and needed. I also rarely work with a team, so this experience is definitely teaching me to adapt, listen and step up. In my opinion, all artists should curate at least once, it's an invaluable process.

QD: Have you selected all of your artists?

KG: Yes, artist selections have been finalized, soon to be revealed! It's going to be quite an experience, I hope, both for us and the audiences.

QD: What are the challenges of conducting a grass-roots event like this?

EW: It's an ongoing test to remain independent and outside the structures of institutions. Making and sustaining this choice is challenging: financial, maintainable staffing, logistics. Providing a platform for free artistic expression outside of these regularities is a major benefit.

KG: There are many challenges we face and have to overcome, financial, time management, space, administrative, etc. As an artist and independent curator though, I am quite familiar with all and any DIY and grassroots methods of organizing events, so these types of problems don't scare me. I think the benefits, such as freedom of expression and vision, innovative, uninhibited approach to building the festival, finding and working with a dedicated team of people and of course, working with artists I want to work with, do outweigh all of the obstacles in the end.

QD: What can we expect for *AiOP BODY* in October? Care to reveal any hints?

KG: You can expect an explosive, challenging and timely extravaganza of diverse mediums, materials, genres and themes. From conceptually driven art to visceral performances and mixed media installations, local, national and international artists will come together to explore the *BODY* in New York.

QD: Well, I can't wait to experience it and cover the events on Performance Is Alive! We are so excited to be the Media Sponsor for this year's *Art in Odd Places*!

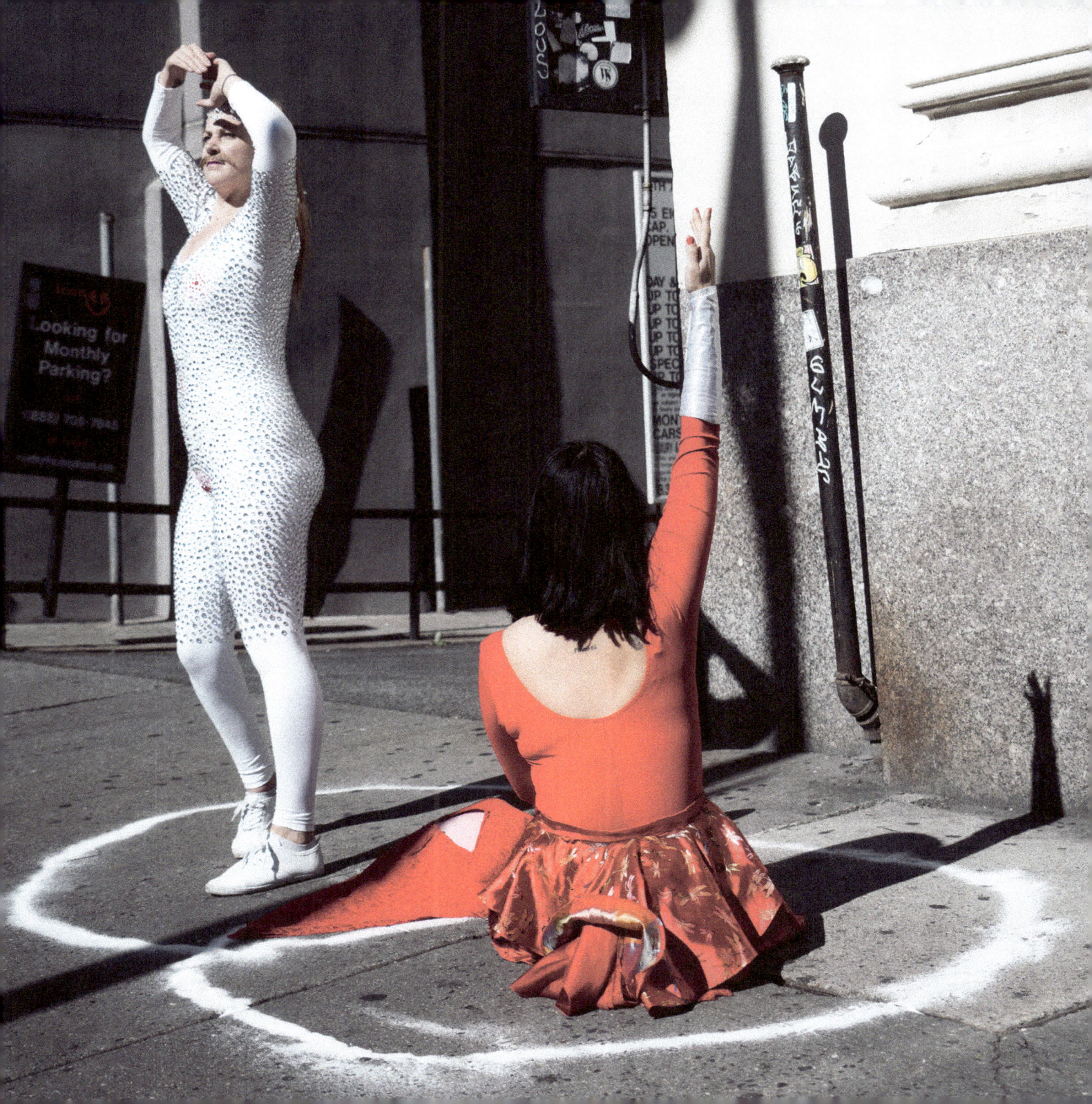

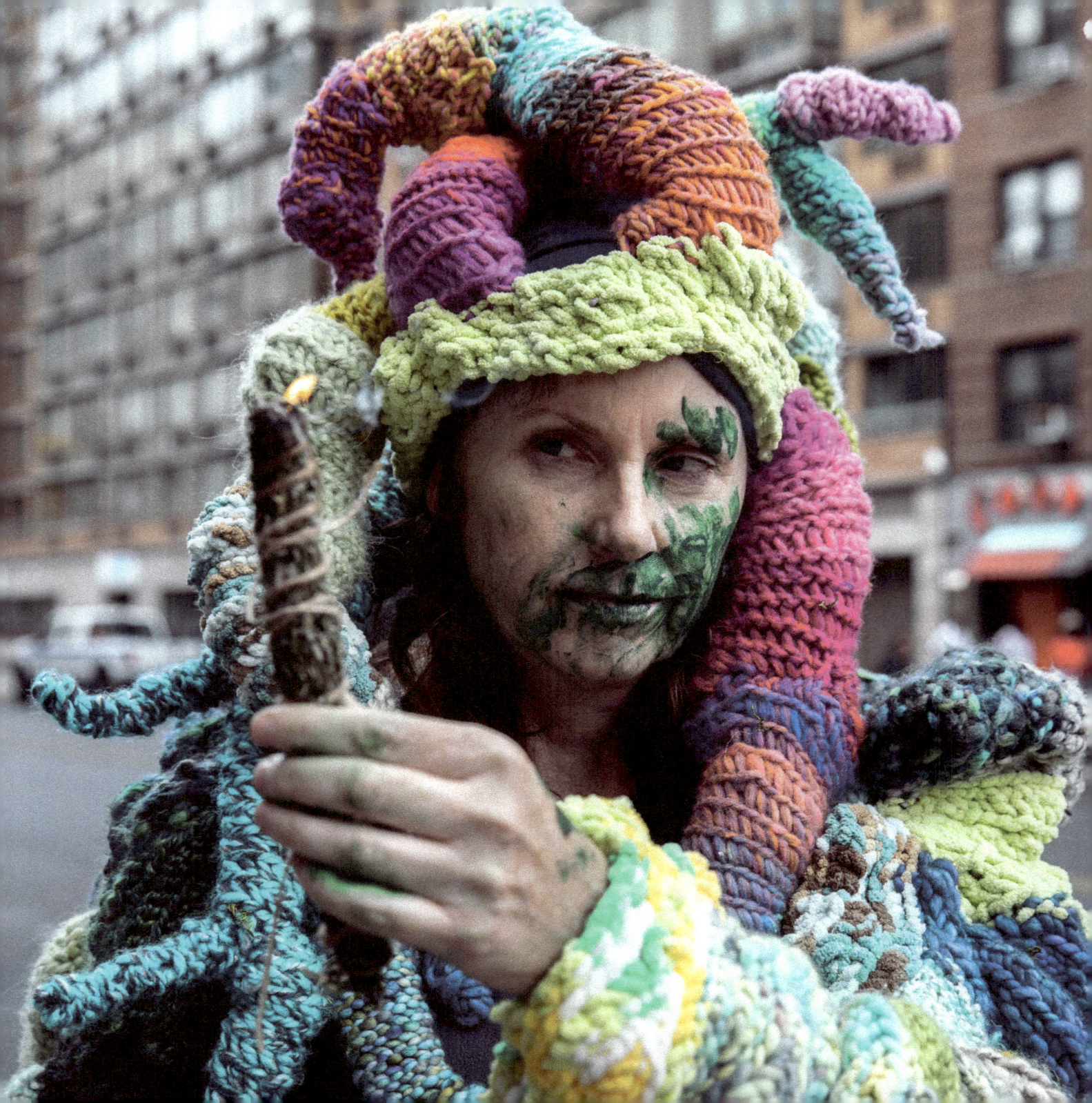

AiOP Reflections:

As I reflect upon 2018, I recognize it was a year punctuated with weekly meetings hosted in Brooklyn apartments, characterized by flurries of texts, emails, instagram DMs, WhatsApp messages, and epitomized by driving a minivan packed so full of artwork that the rearview mirror was often rendered completely useless. These memories and the time and effort that went into creating them were directed towards constructing a platform. During the month of October that platform actualized both on the streets of New York City and at Westbeth Gallery in the presentation of work by forty-three artists and collectives from all over the world for *Art in Odd Places 2018: BODY*.

Since its genesis *AiOP*'s annual performance festival has tactfully utilized the visibility of public space as a forum for artistic agency and the unhindered exchange of ideas. For many artists the hustle and bustle of a New York City sidewalk represents a stark contrast to the institutional white-walled architecture of a gallery space. Yet, there is an intangible raw magic present when performing in public space, an energetic mixture of vulnerability and unpredictability galvanized by the palpable stares of a transient audience. I am intimately aware of how electrifying this interaction can be having performed in 2017's festival, I subsequently felt inspired to share this formative opportunity with more artists. I jumped at the chance to help organize the *AiOP*'s 2018 festival and carry on its grassroots, artist-run spirit.

Guided by Katya Grokhovsky's curatorial vision the *AiOP 2018* team created a sizable platform by expanding upon the customary four-day performance festival to include a month-long exhibition at Westbeth Gallery as well as a discussion panel and public receptions. Through my role as an organizer I helped facilitate a broad range of creative practices and collaboratively worked with individual artists to ensure their projects were realized. After the gallery closing reception, after the exhibition was de-installed, and the holes patched, work shipped back to the artists, I took stock of my role as an organizer and began to acquire a deep appreciation for the collective energy shared during the month of October.

I believe *AiOP* and artist-run organizations serve as examples for how to build and fortify creative communities. No movement in the history of art was conceived and executed by a single artist. Movements originate from creative communities which support, discuss, and encourage each other. My hope is that as the artists from *AiOP 2018* move forward they carry with them the connections they made and recognize the influential force artists possess when collectively working together.

Katie Hector
Curatorial Assistant

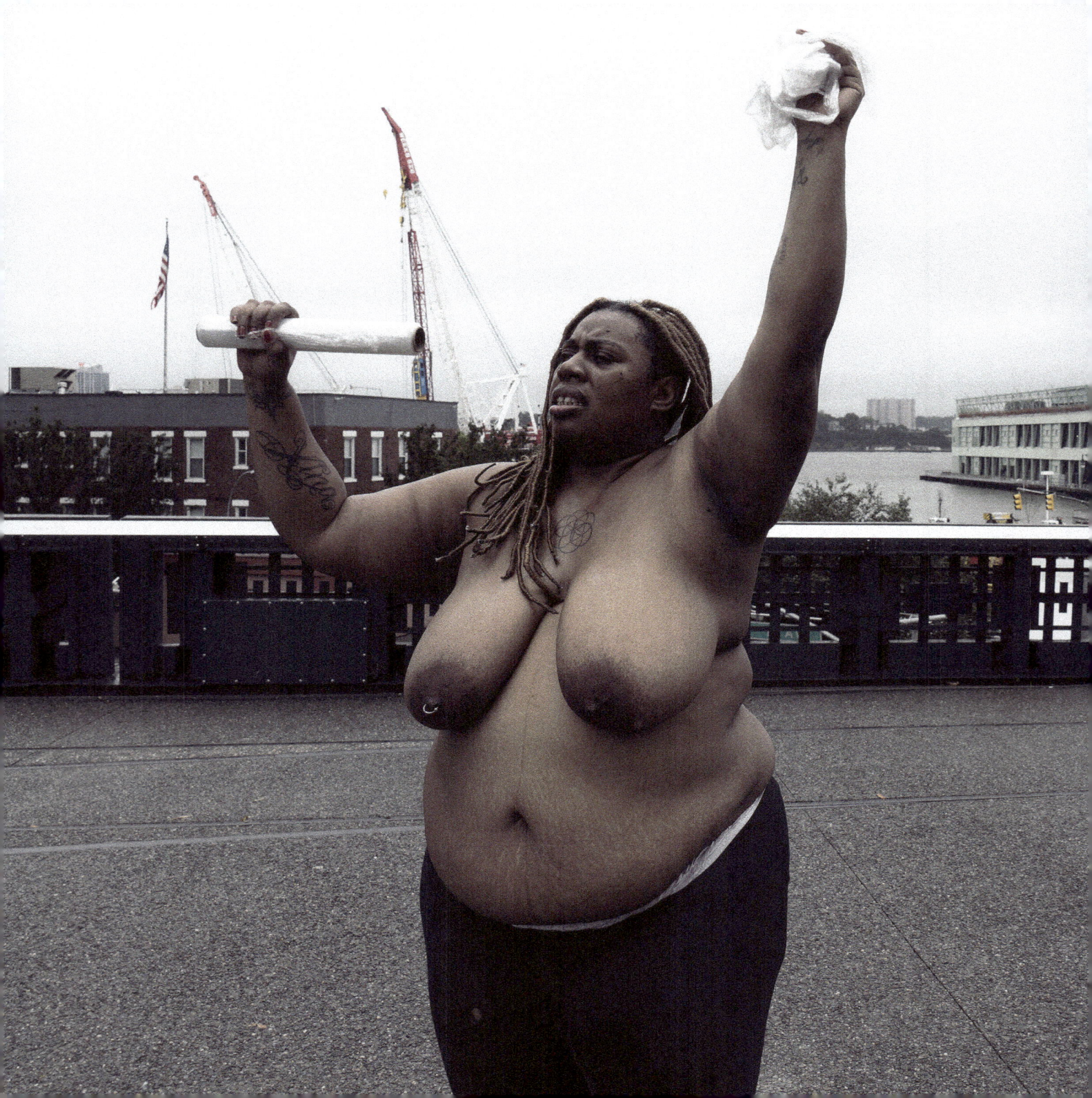

"Is my presence a stain that can never be removed…"

Bodies. In this age we are privy to works of art that deal with the body in provocative ways. Ways outside the dictated norms and standards set by the classical viewing of the body and the acceptance of Western standards. This can be seen as a threat to those who enforce those standards and censorship is a dangerous way of prohibiting ideas that can change the course of an audience reactions to how our society operates.

When chosen to perform "*Ain't I a Woman (?/!)*" at the 2018 iteration of *Art in Odd Places* (*AiOP*) I was excited but also hesitant. The idea of performing such and intimate work always sends me in a spiral of exuberance and self-doubt; these two forces pull at my insides up until when I literally am performing, each emotion gripping into my mind, body and spirit-holding on up until the very last second. "*Ain't I a Woman (?/!)*" is my way of tackling issues concerning the Black body presence and existence in the Western society, but I pushed it further for *AiOP* including political responses to the Kavanagh verdict that had just come out a week before. Responding to rape is a personal recourse due to my past in the Army and my suffering from Military Sexual Trauma. This coincides with the previous appearances of "*Ain't I a Woman (?/!)*," but also evolves the work to include other issues revolving around large Black bodies.

What I found disappointing is that my piece had become dependent upon social media and the betrayal that came with Facebook's and Instagram's community standards and policies. When it comes to large bodies there seems to be a standard of censorship that doesn't apply to bodies that are more mainstream and accepted. The procedures conjoin with the public beratement I felt every time the cops and ambulance were called to collect me, for being "irate" and for conduct that was "inappropriate", while in full knowledge that I was not breaking any laws. Toplessness is permissible in New York City, and yet the social decorum only allows for "certain bodies" to display this. Bodies that are deemed worthy to be on display as a way of further policing "undesirable" bodies through shame.

It seems that my body is caught in a vicious cycle to receive such treatment, while social media pages on Facebook allow for the most violent of scenes to go unchecked and unregulated. Or better said by Ayana Evans, "Facebook - where's your violence algorithm?". Which leaves me to wonder who or what these programs and practices are designed to protect and why. This censorship in real life and in the virtual world is a slap in the face considering how Black bodies are not allowed their own space and respect in public. The larger the Black body, the bigger the perceived threat, and swifter and harsher the retaliation against it. Case in point, I was banned from using Facebook for three days, unable to promote my show due to one post that showed my breasts. Yet fetish porn goes shared and uncensored throughout its' pages and those that do share such things go unpunished—this is not to say that fetish doesn't belong in the realms of social media, but moreover to say that the fetishism of Black bodies under the white gaze is a dangerous form of erasure. This leaves me to believe that those behind the algorithm are judging more than social conduct, they oversee judging social practices that interrogates and questions authority, by way of art and quite possibly - protest.

People often ask why I don't just cover up my breasts before I display the pieces, or why don't I notify the police before I begin my practice in public. And to them I say this: I want my piece to be as authentic as possible. With performance art there is some risk, but in this running of that risk you find the greatest of truths. I do not feel that my partial nudity in my work should be regulated as problematic and conducting myself in a way that censors or augments the reality within the work gives way into thinking as such.

In the durational video I ask, "Is my presence a stain that cannot be removed?" who I am addressing isn't just those who bore witness to the durational piece, I am asking that of society at large. A society that is dependent on standards set by those that govern the law—as well as the community standards that the internet dictates and enforces others to follow. When those forces combine to create and atmosphere in our daily rituals that exclude the rights of those challenging and questioning the logic behind censorship, our very existence becomes binary, and banal.

I often ask myself, is this practice worth undergoing the ridicule that society enforces both in and outside of cyberspace? The concept of policing large Black bodies under the guise of "safety" through police and ambulance workers mirrors the application of enforcing dubious community standards through social media, in that although no laws were being broken, my presence and existence in "white spaces" is an unspoken liability. Yet this concept in itself is indeed why "*Ain't I a Woman (?/!)*" is a necessity. Exposing such practices challenges people, and places to move forward in the conceptualism of the Black form. I pose topless to push these boundaries to the limits. By obeying the law and yet exposing my body in the extreme, I ride the fence that pushes our society's prejudice against anything other than the mainstream physique.

Nicole Goodwin
AiOP BODY 2018 Artist

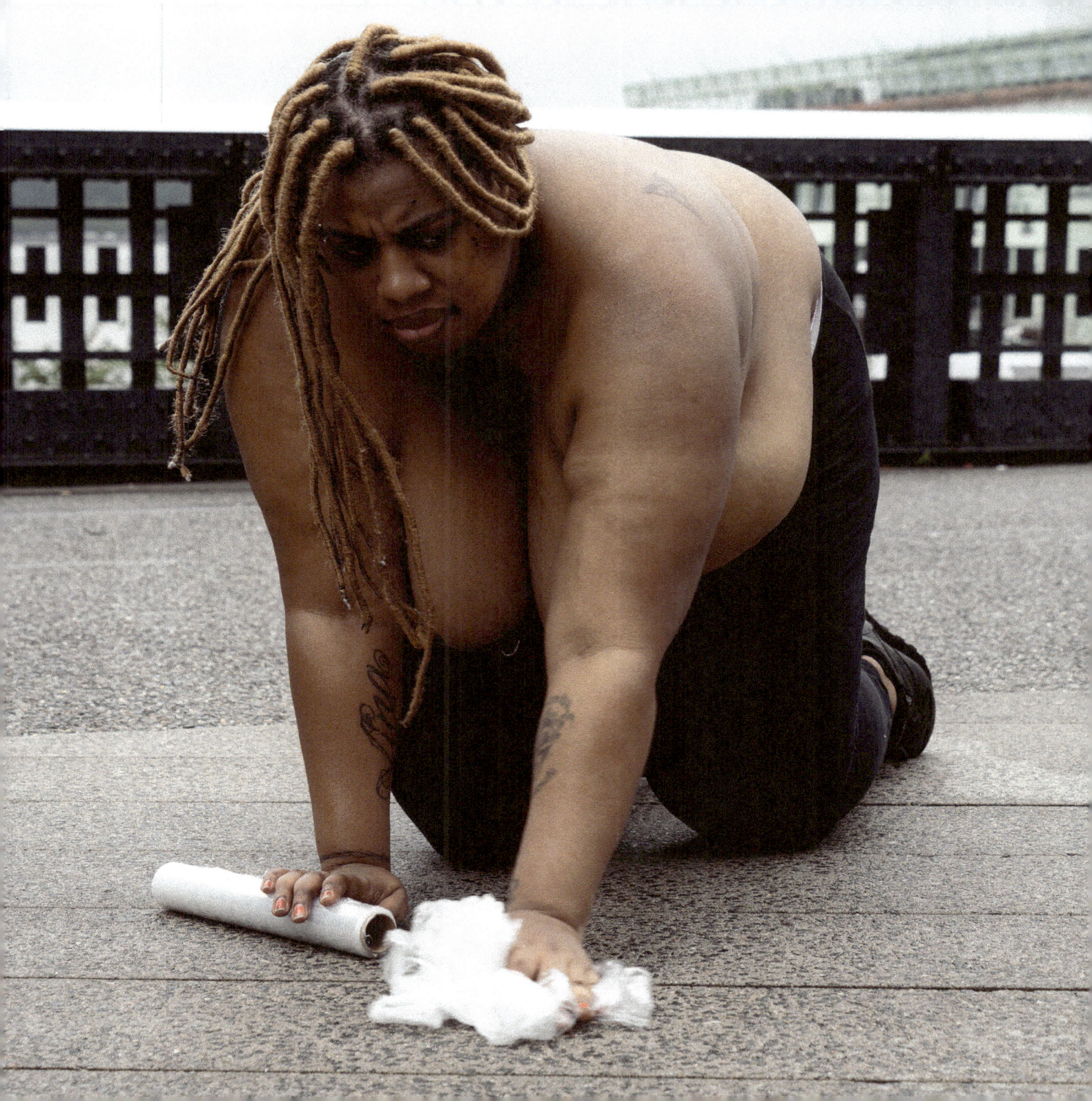

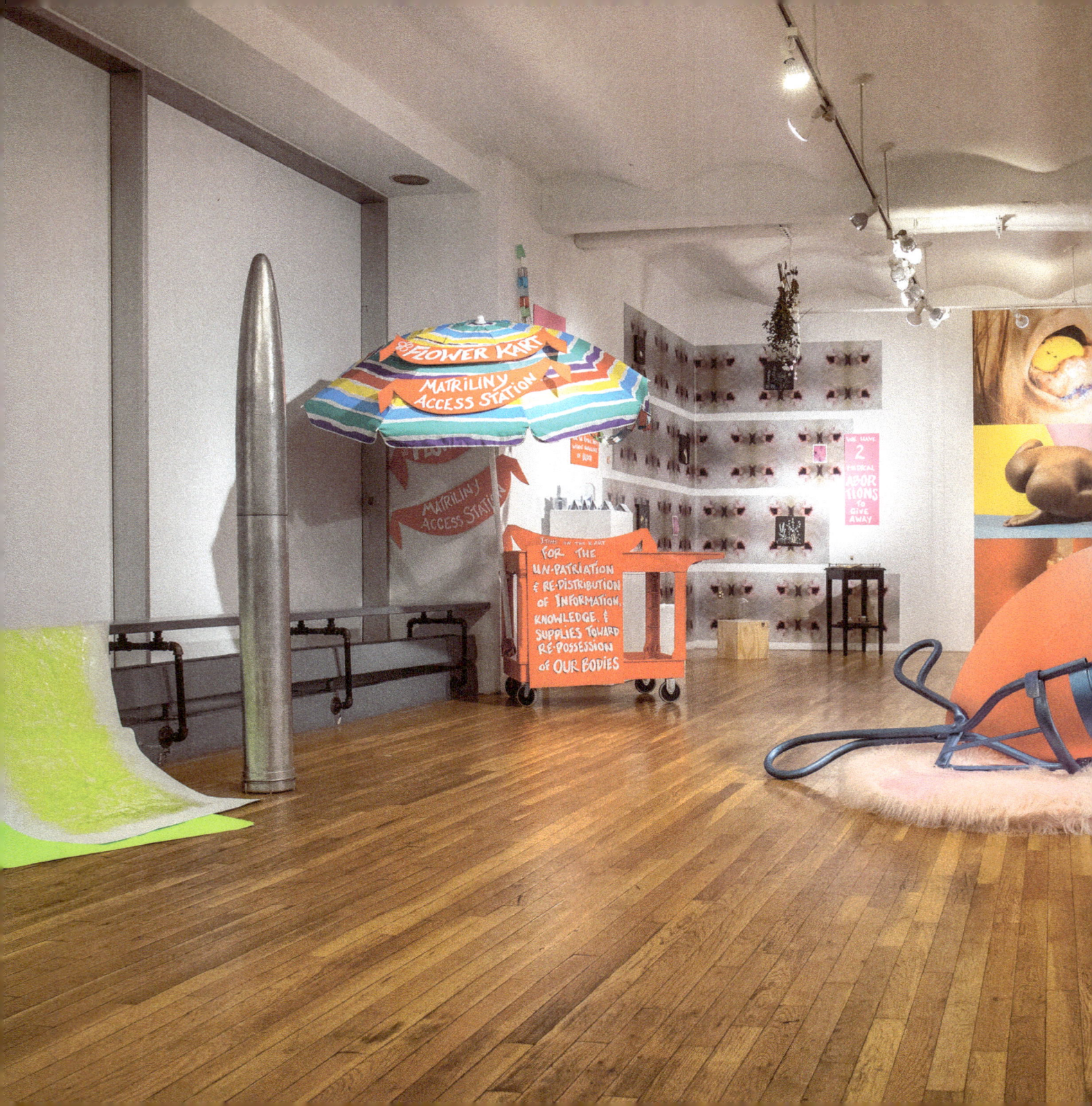

Unseen/Reclaimed Exhibition
Westbeth Gallery

Curated by Katya Grokhovsky

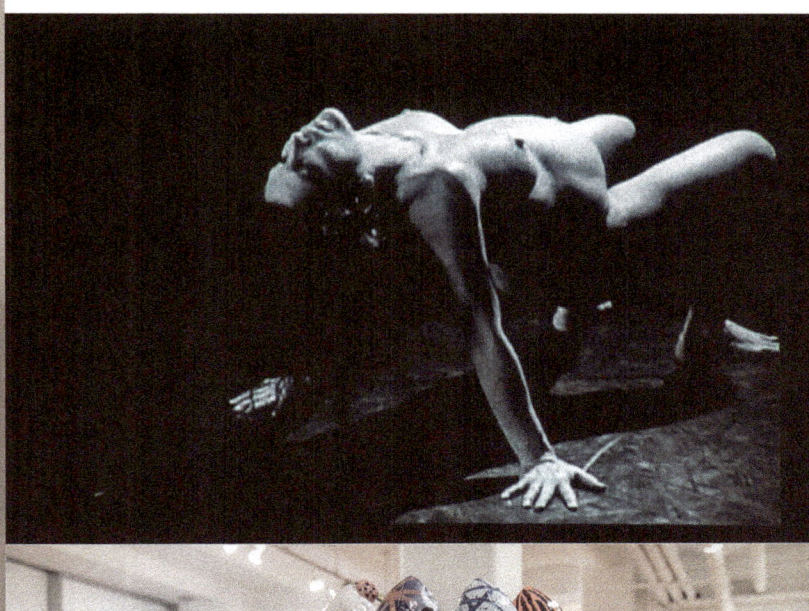

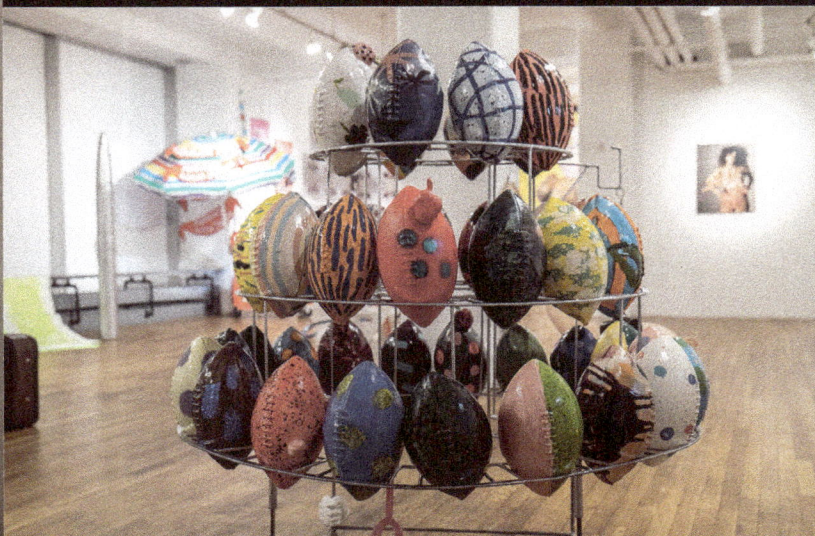

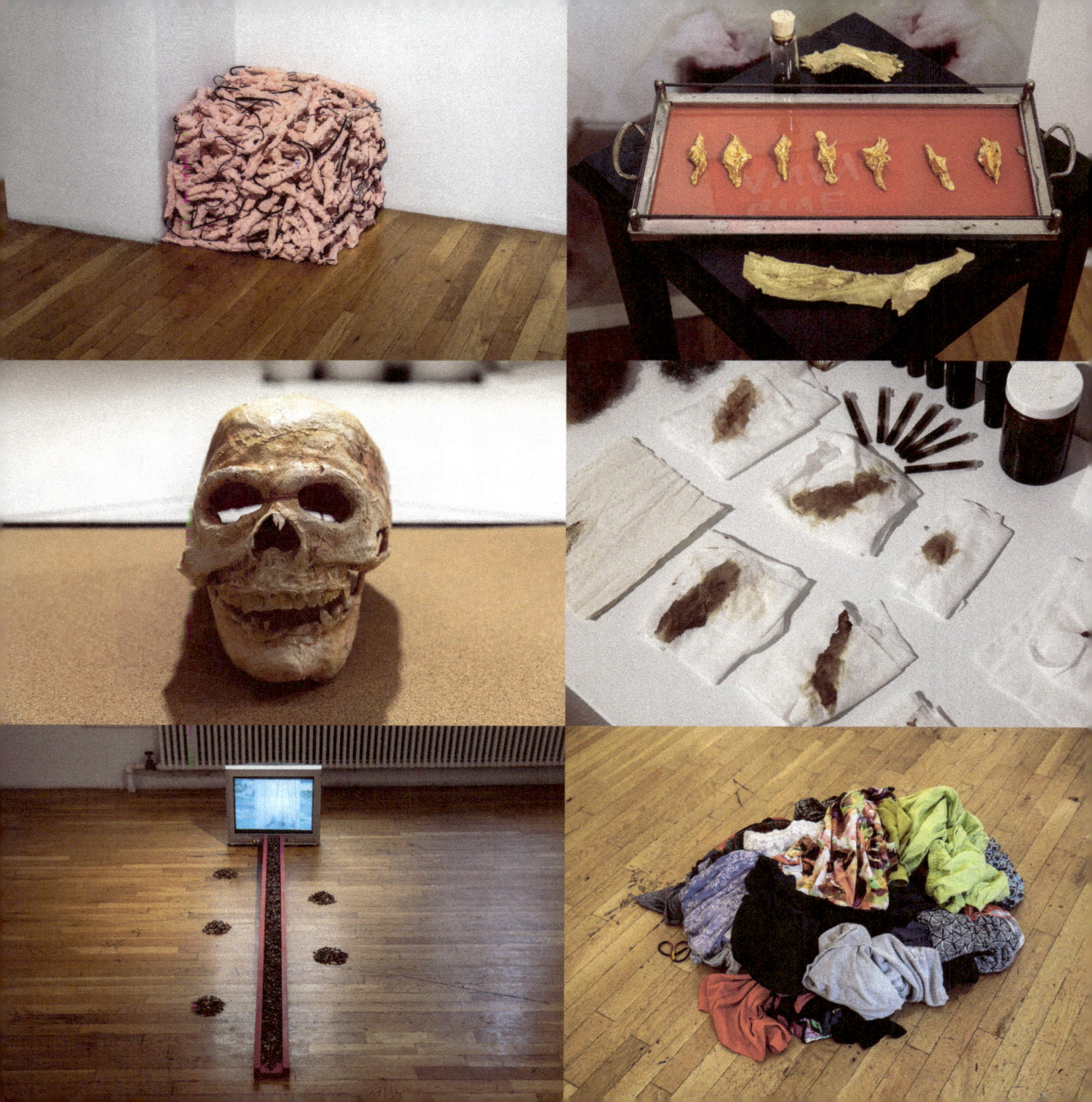

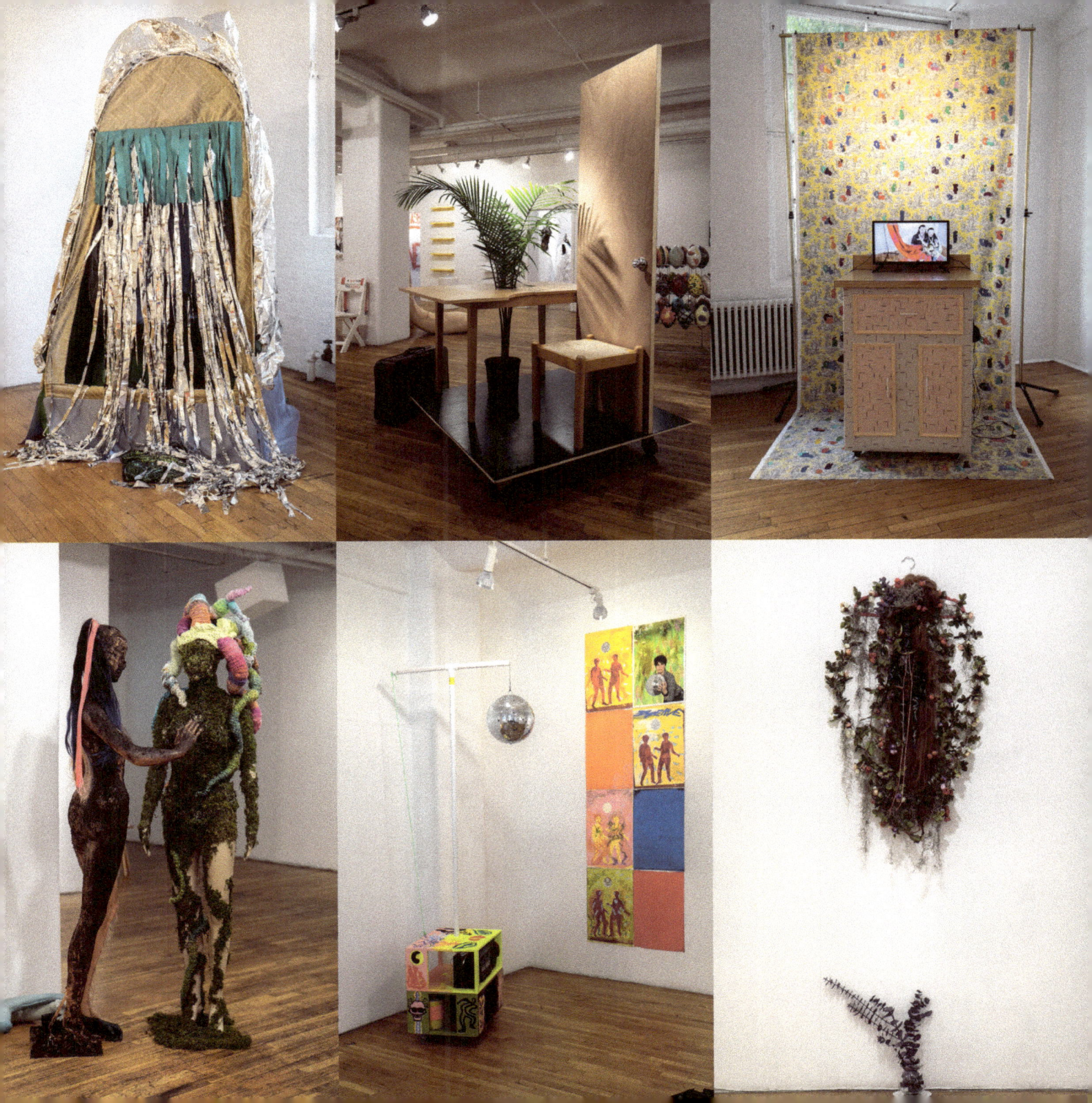

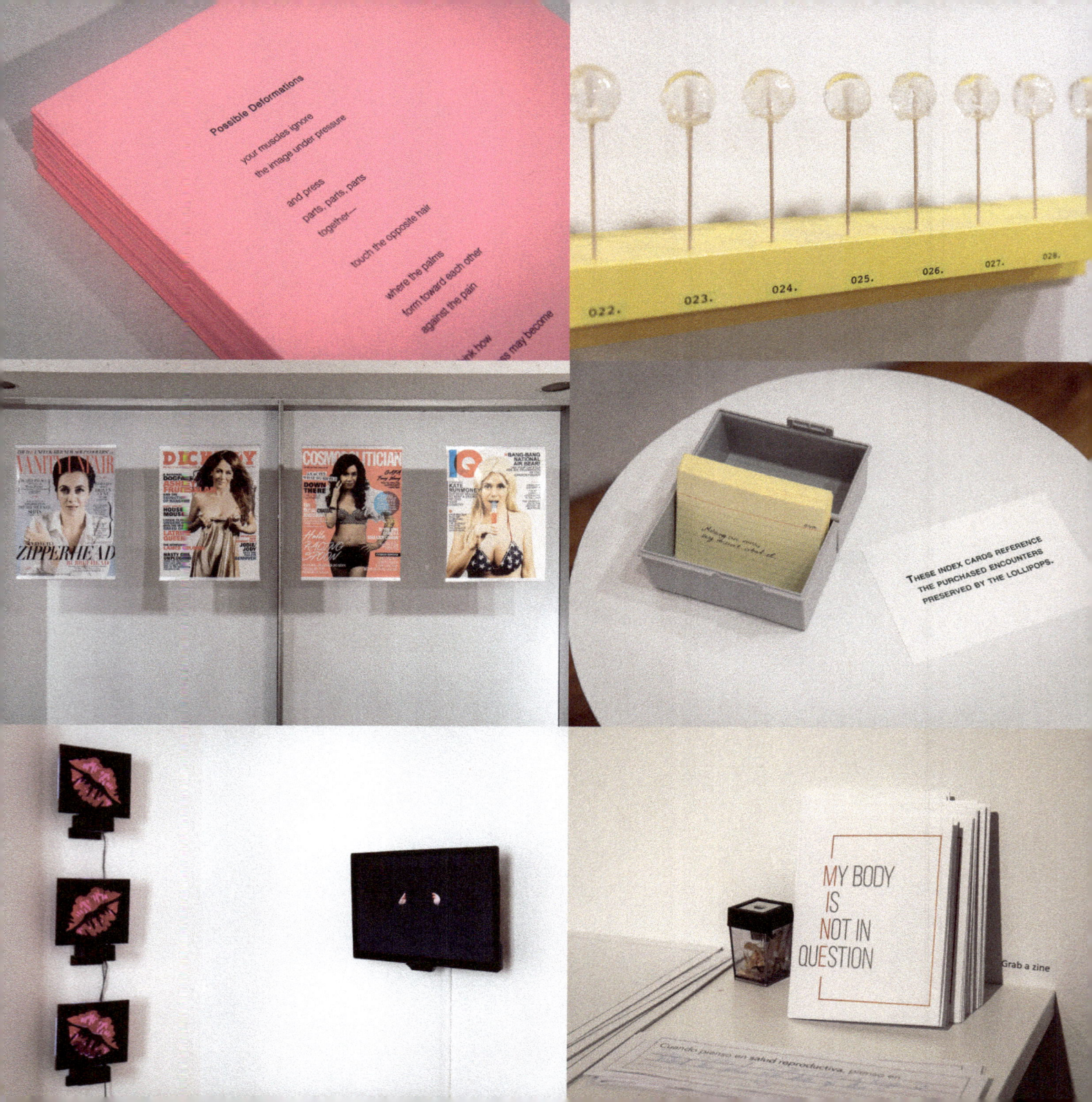

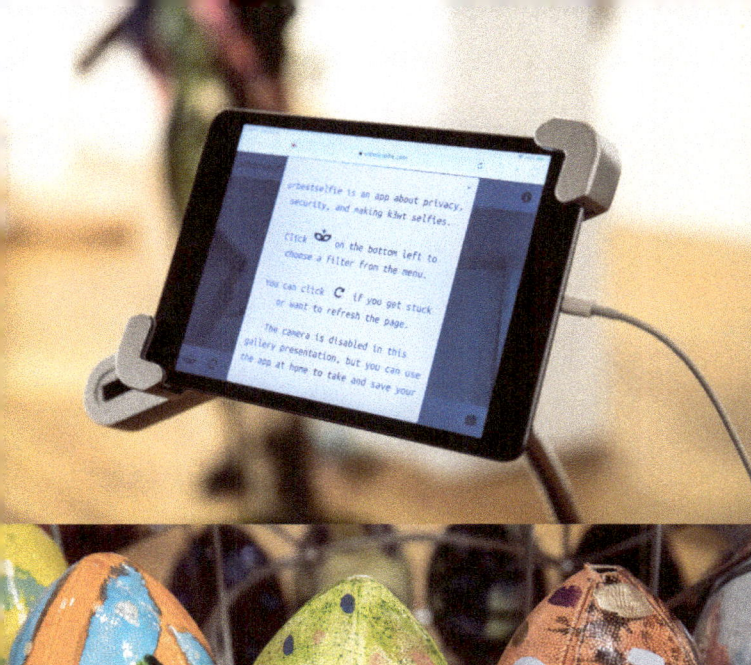
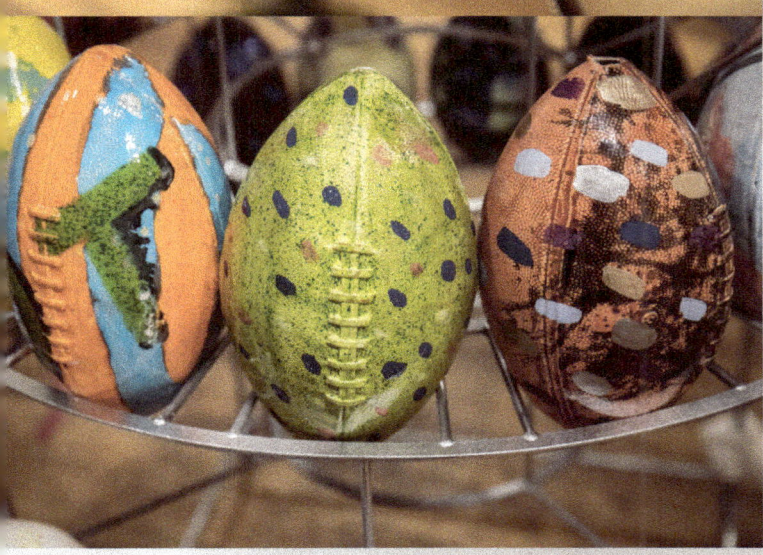
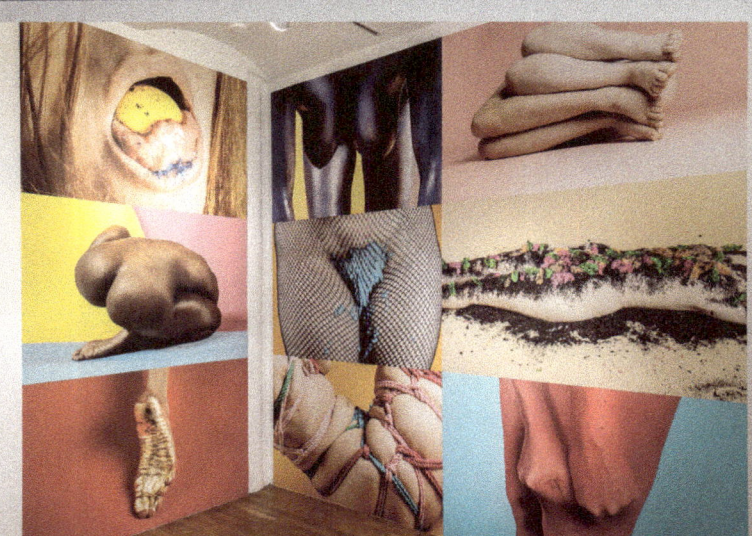
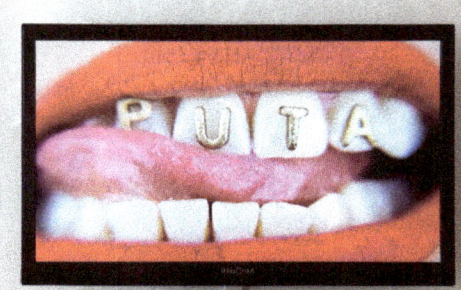
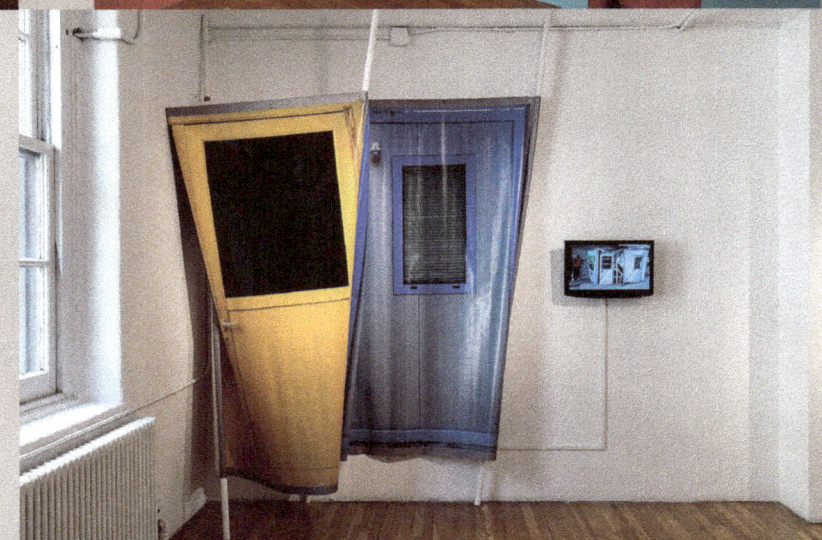

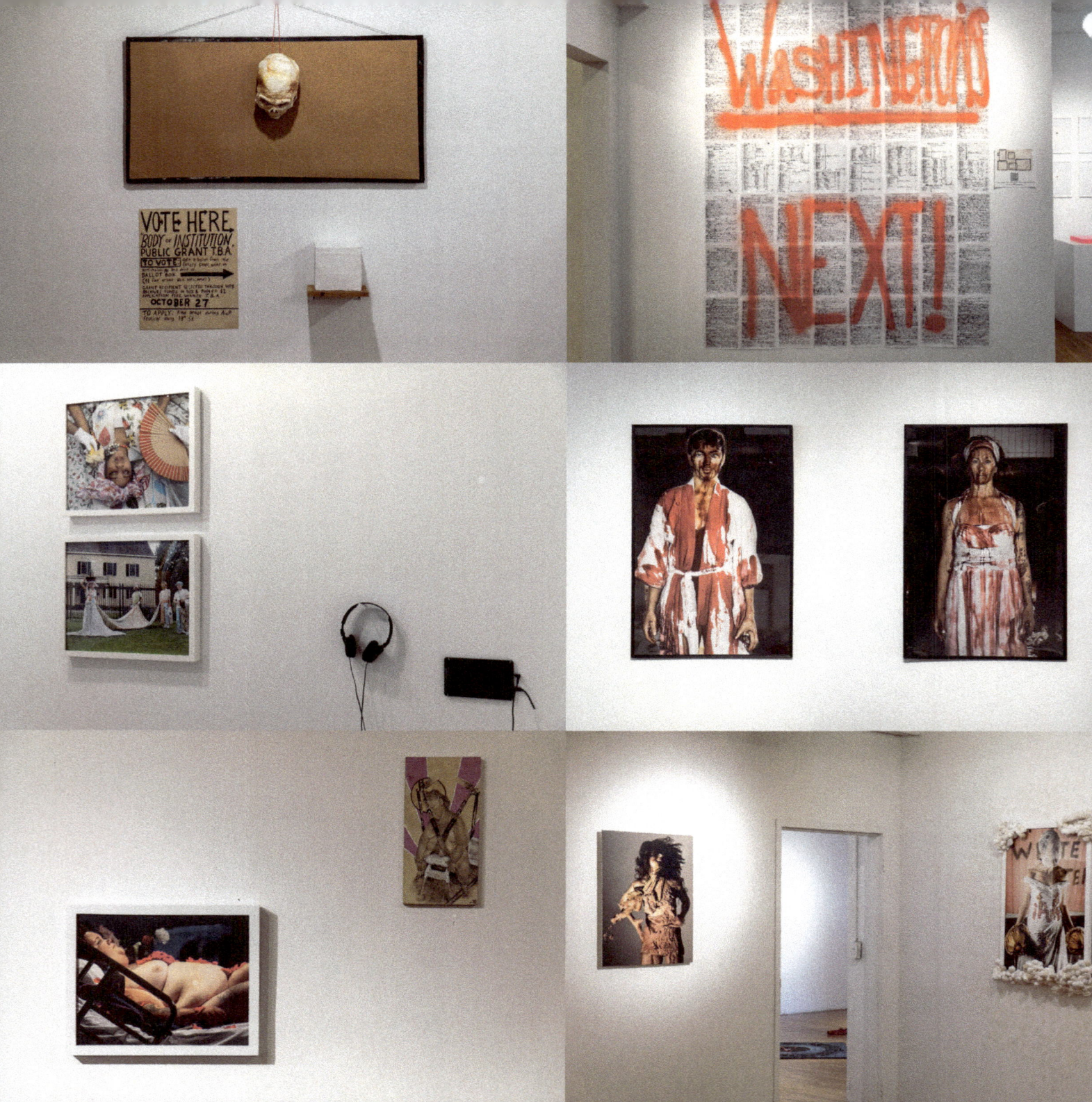

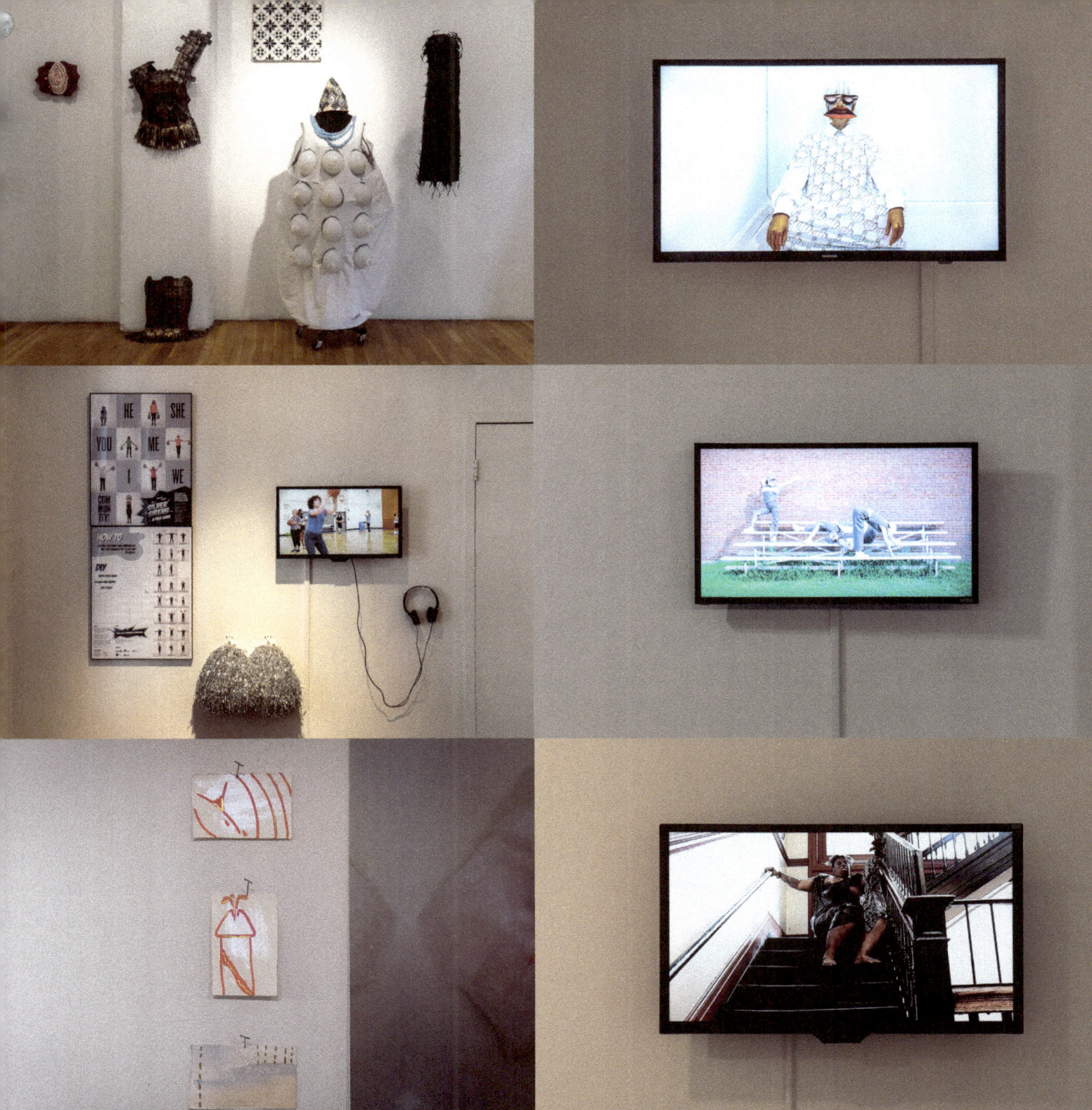

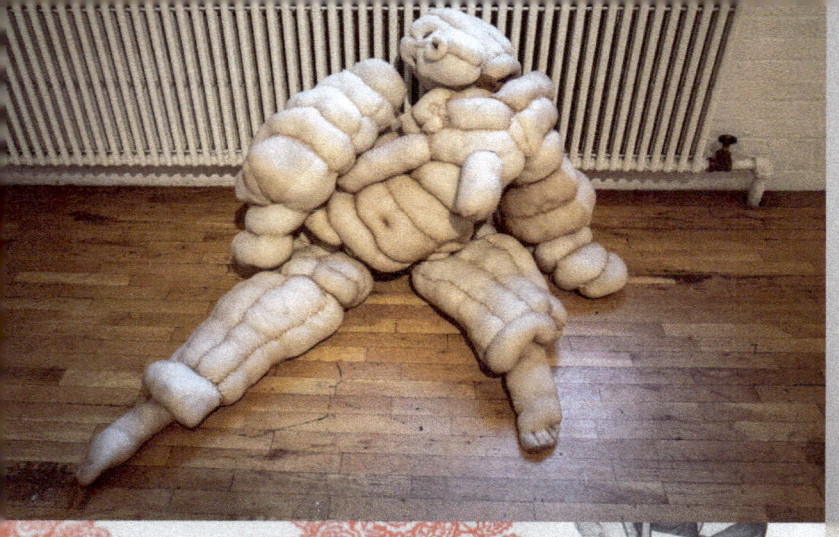
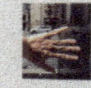
the image under pressure

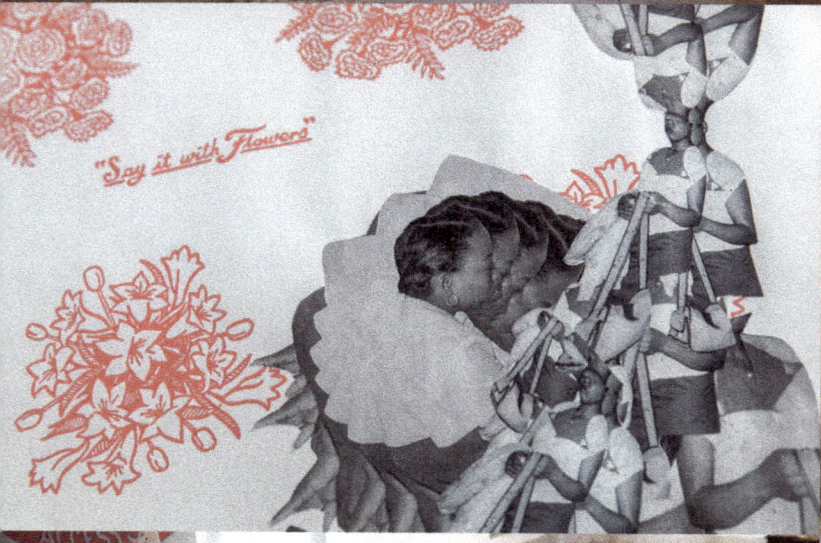

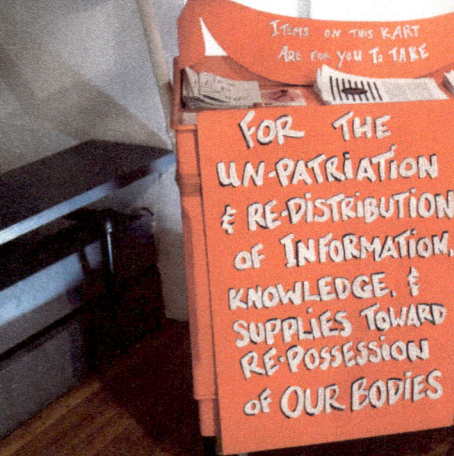
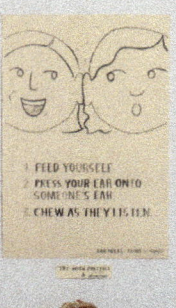

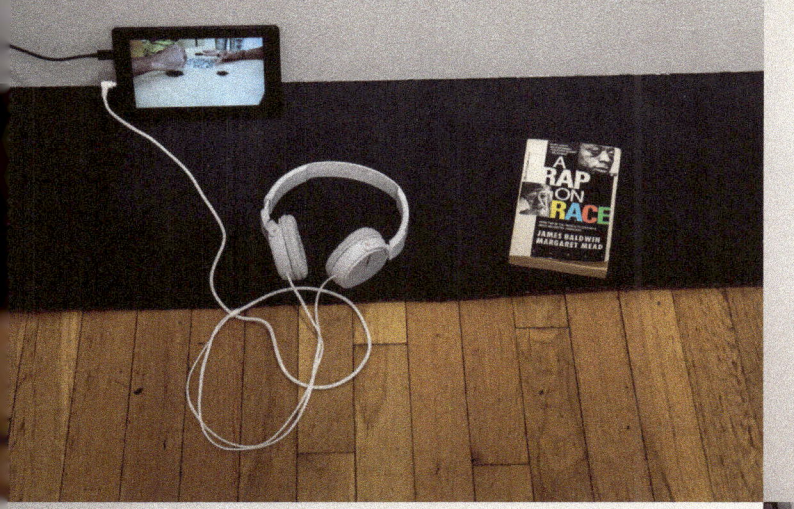
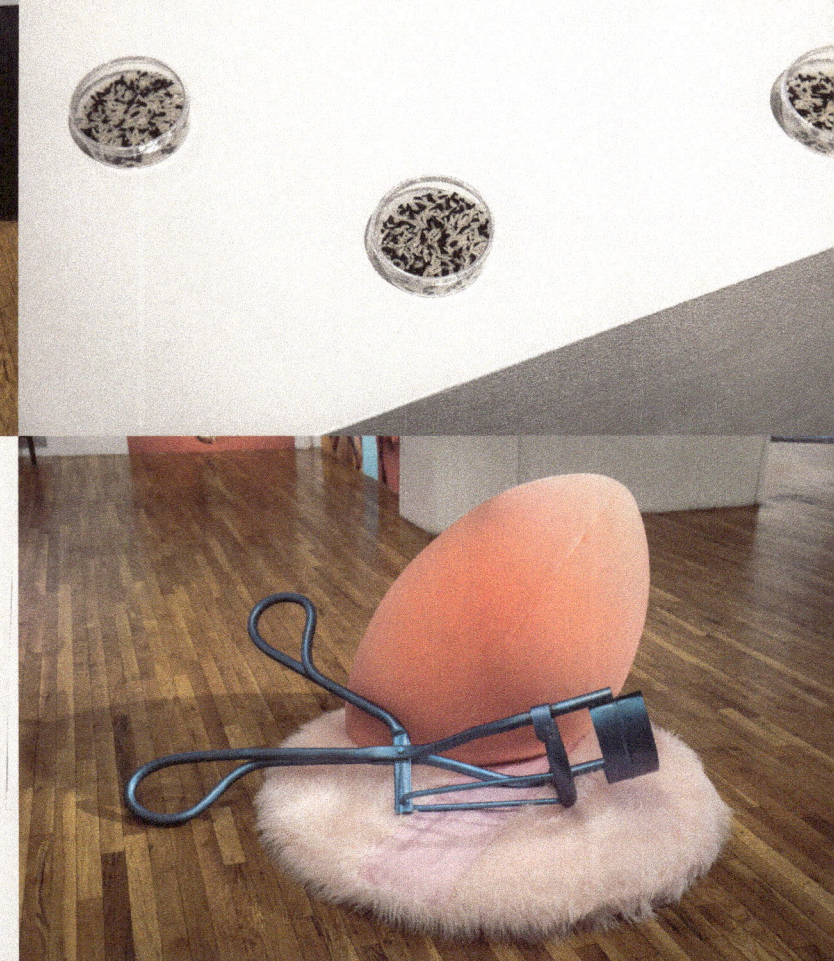
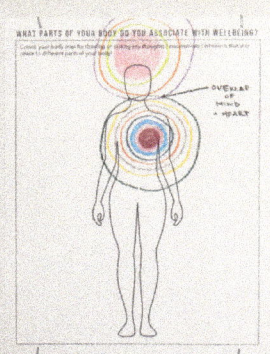

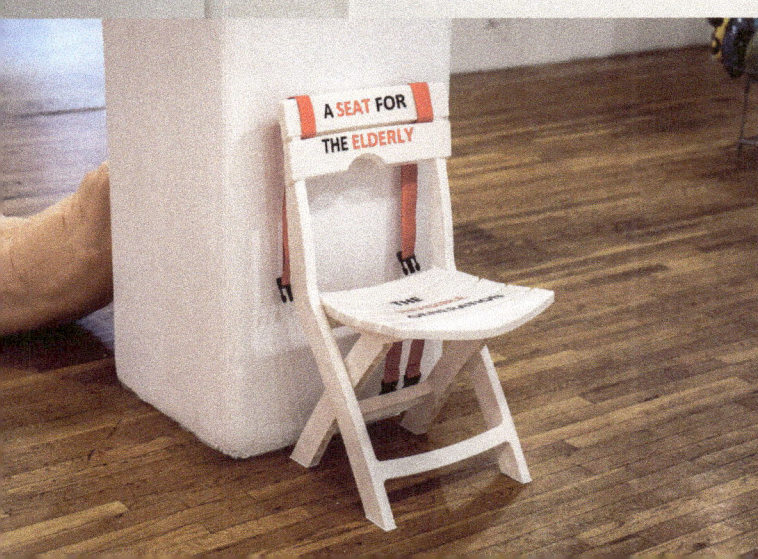
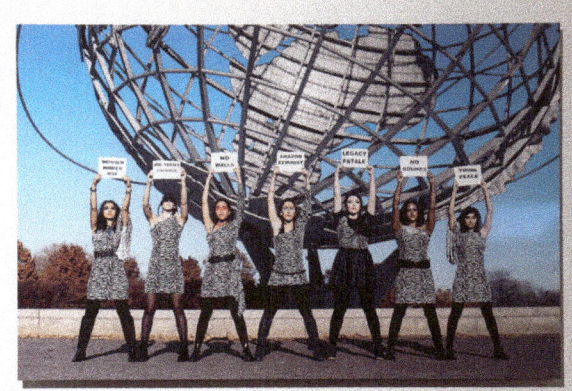

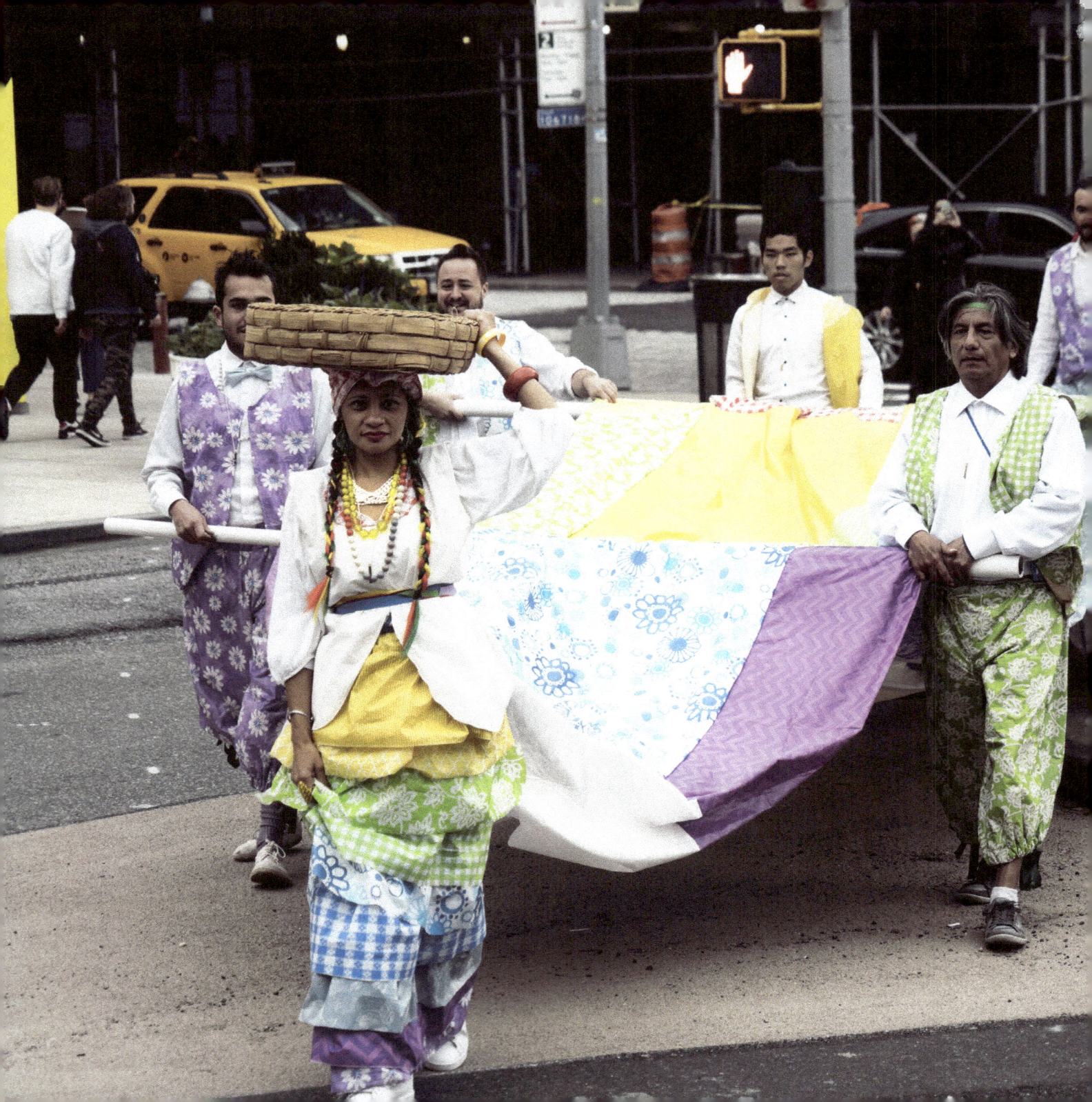

Artists & Street Performances

The Picnic: Harvest of the Zephyr, Jodie Lyn-Kee-Chow, 2018

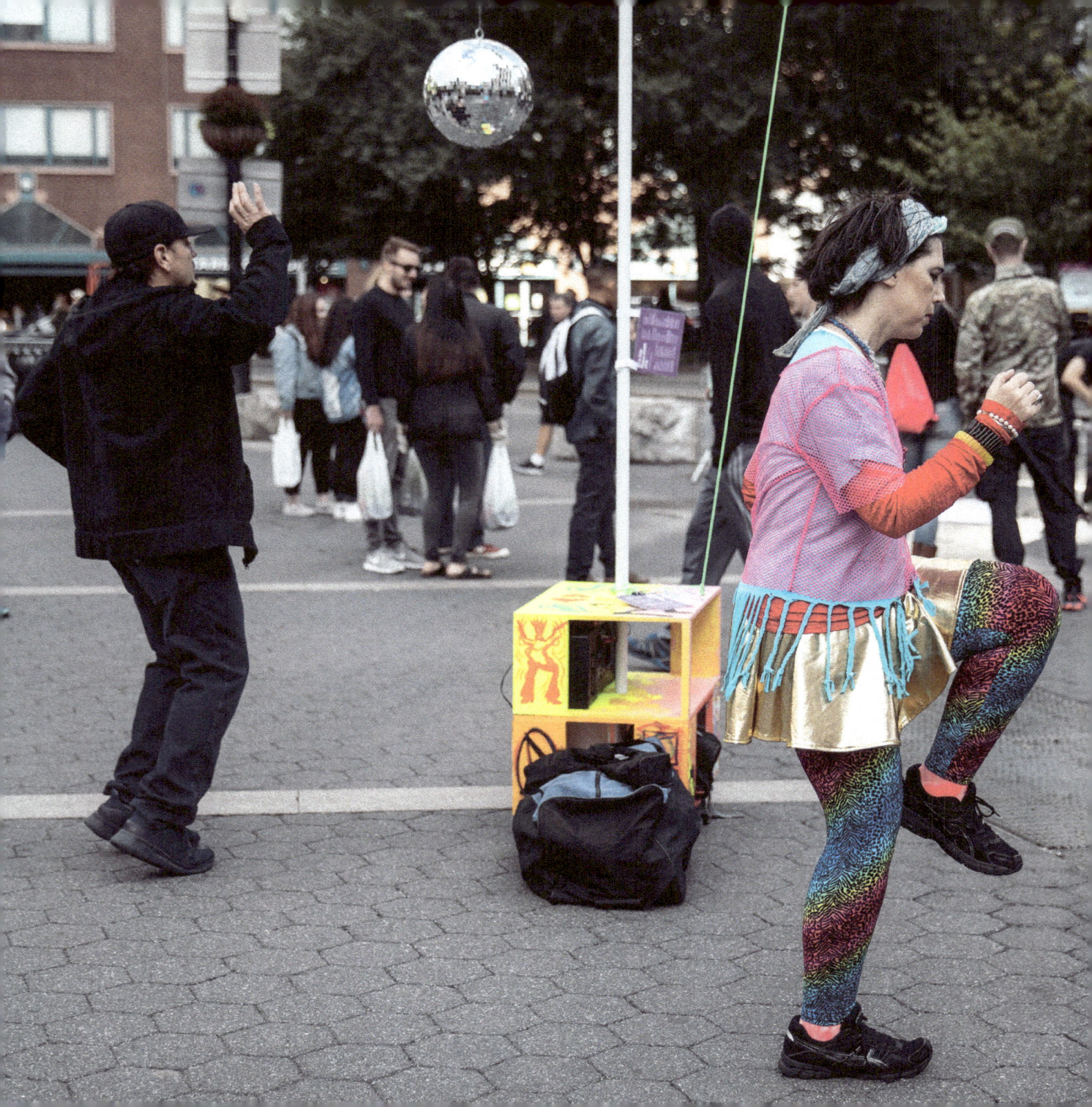

Elaine Angelopoulos:
Dance Memoir

This project invited people to dance with music from the 1980s-90s and share how dancing had changed their life and body image.

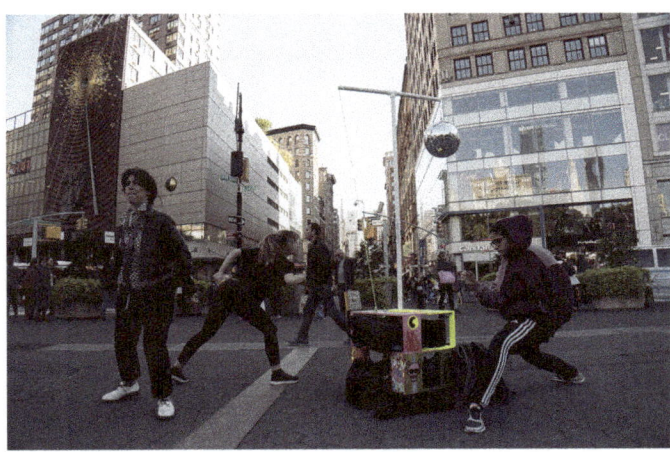

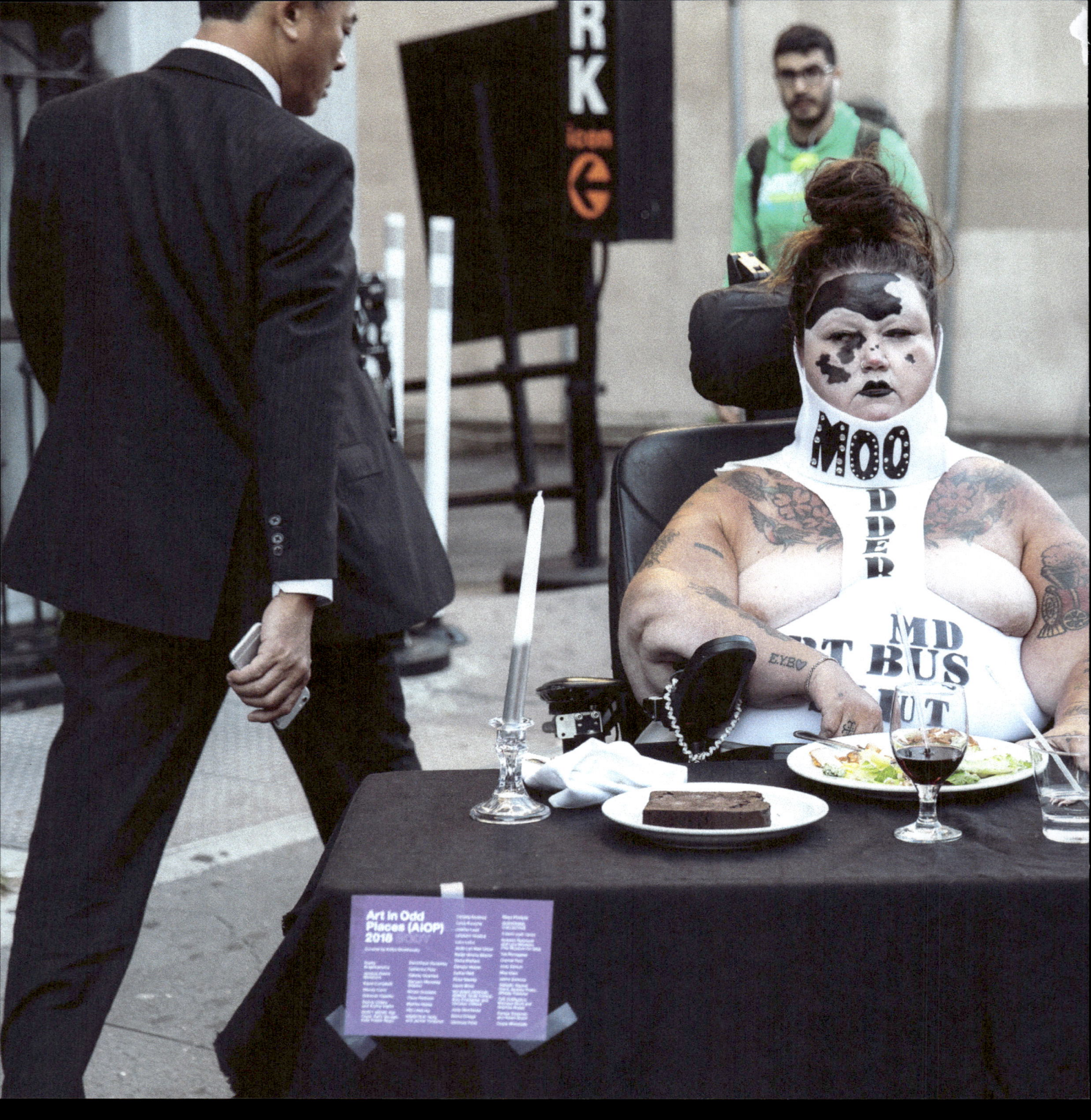

Jessica Elaine Blinkhorn:
Gaze and Graze

This two-part performance played with the idea of being a 'spectacle' as it pertained to social settings.

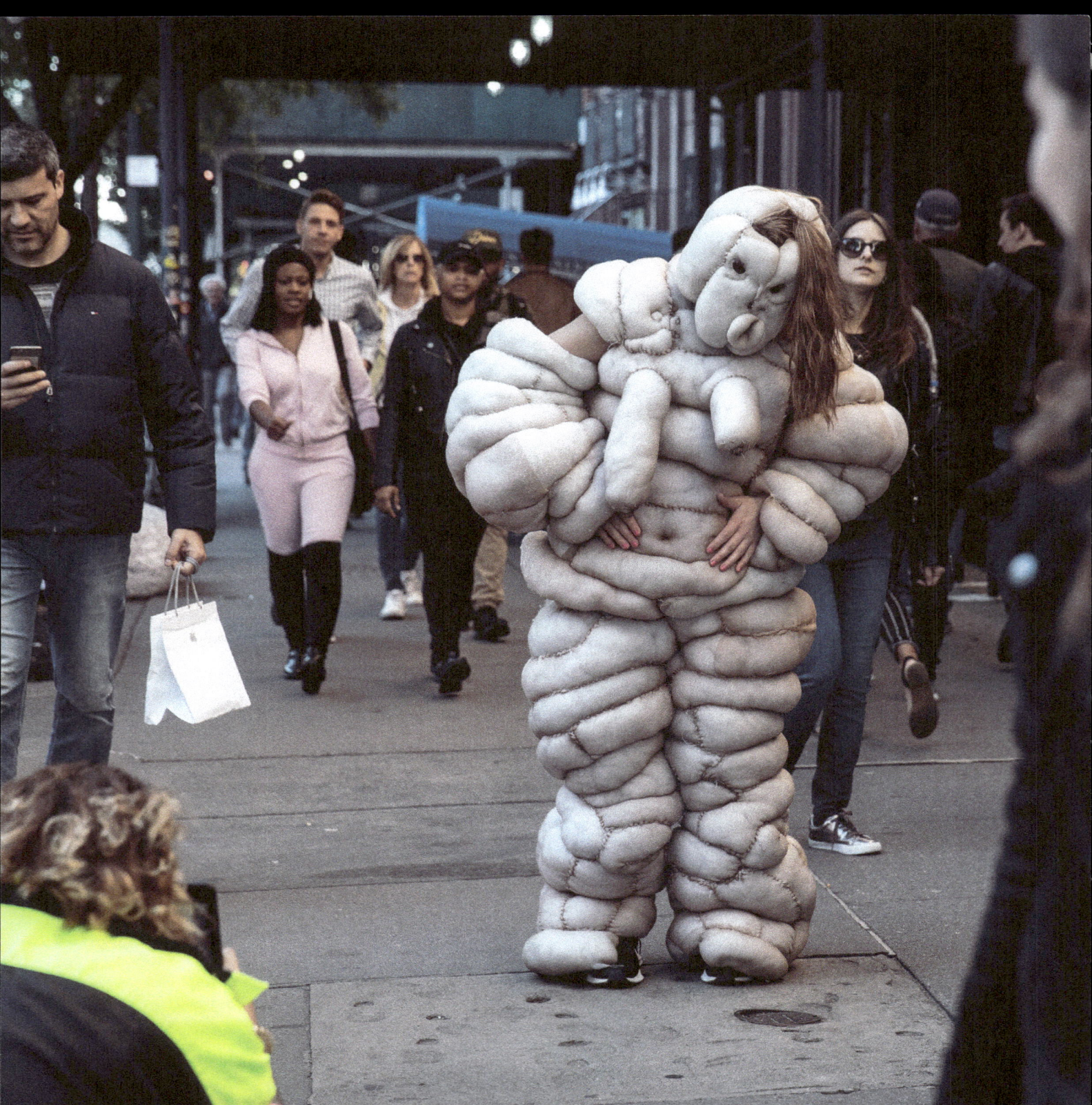

Kasie Campbell:
We are Revealed

This project dealt with the vulnerabilities and anxieties the artist experienced when they became the object of someone else's gaze.

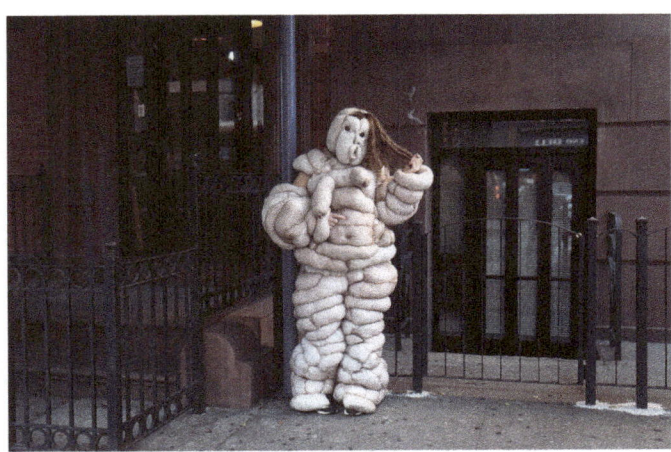

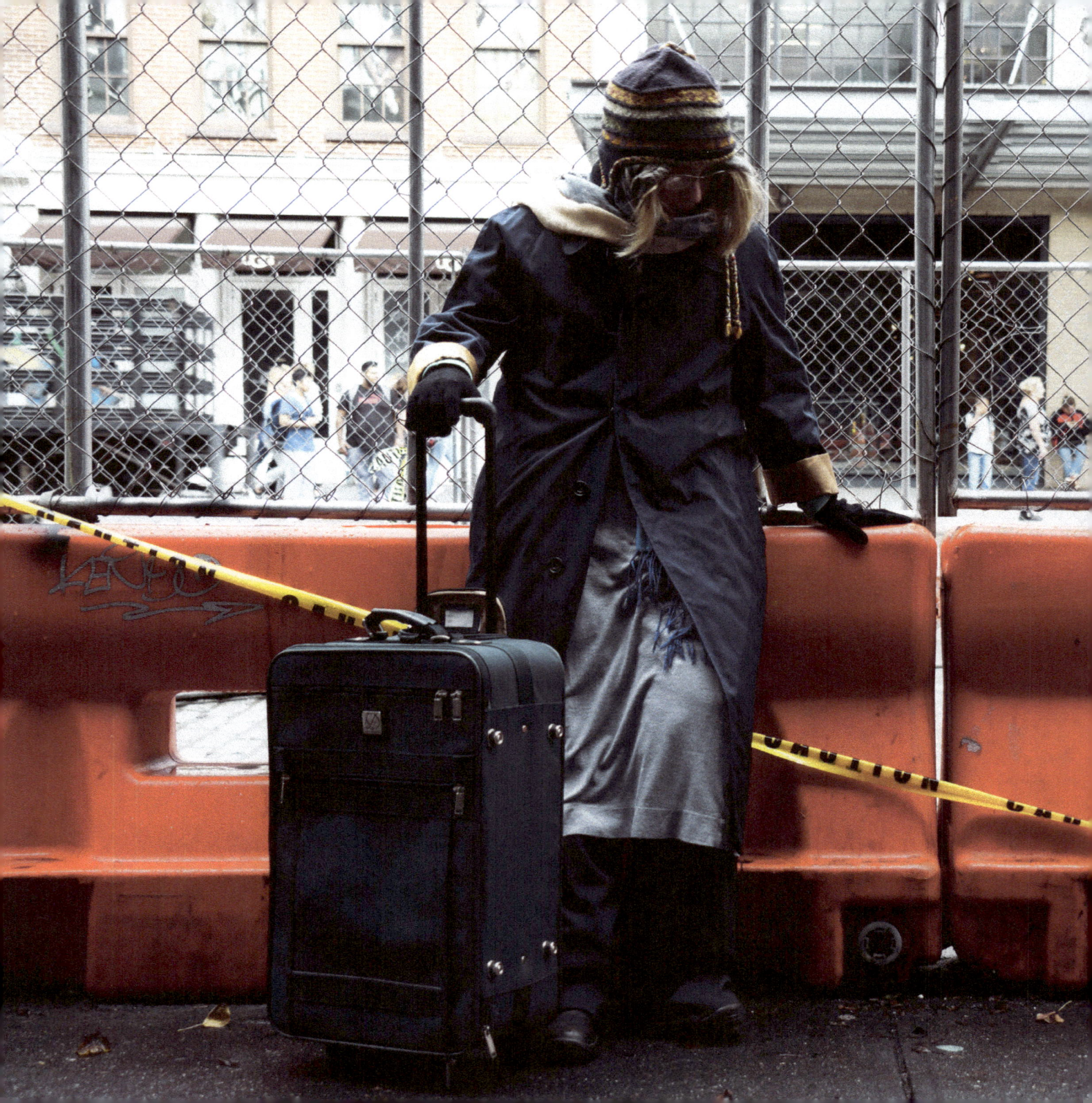

Stacey Cann:
Shield

This project was a reaction to the suggestion that we can protect ourselves through clothes that make us disappear.

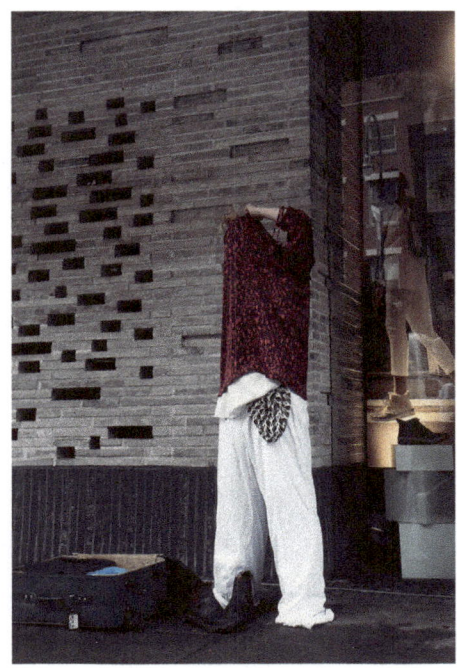

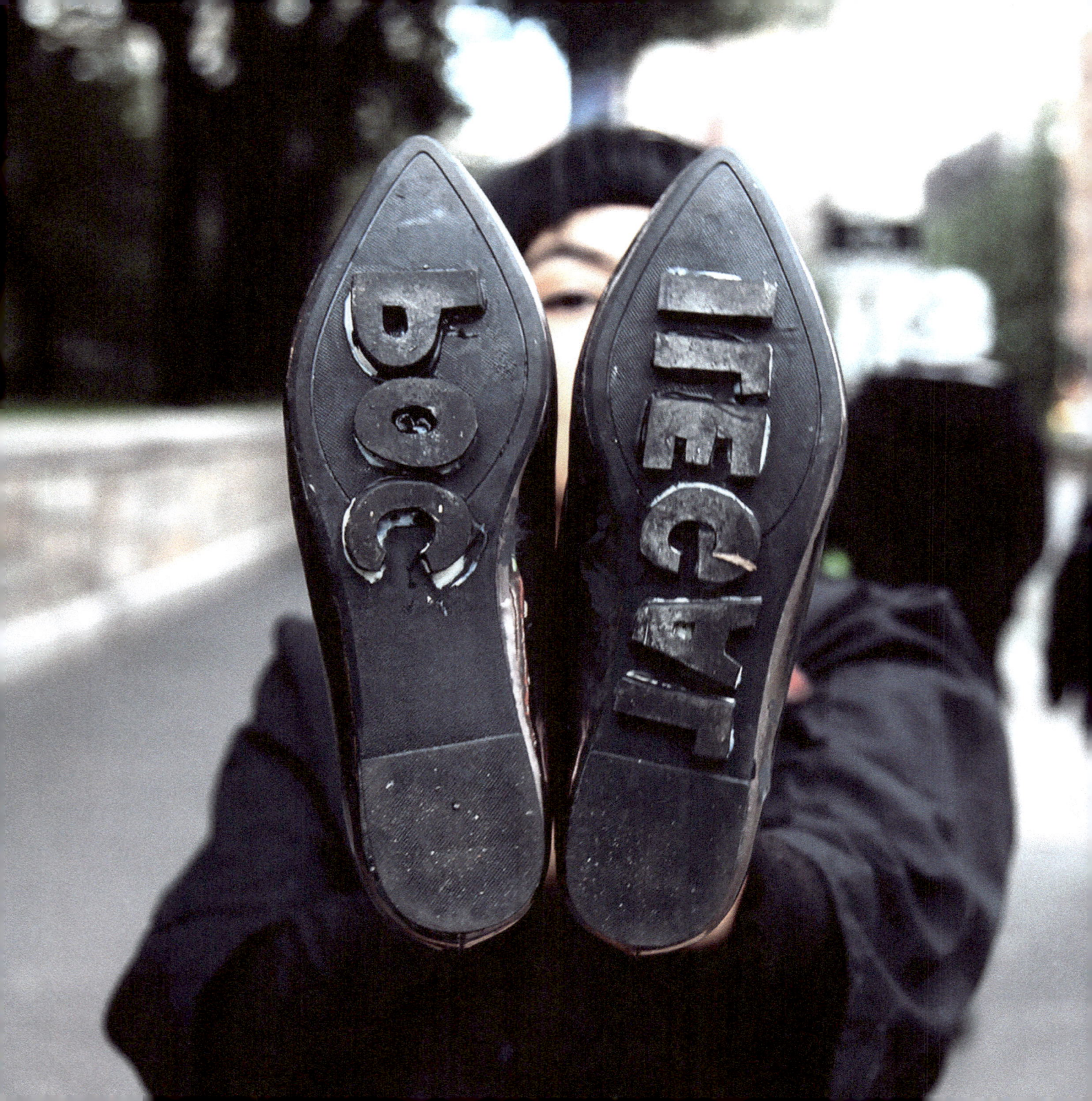

Deborah Castillo:
Alien Stamped

A body of work that addressed the stereotypes attached to immigrants and those without power.

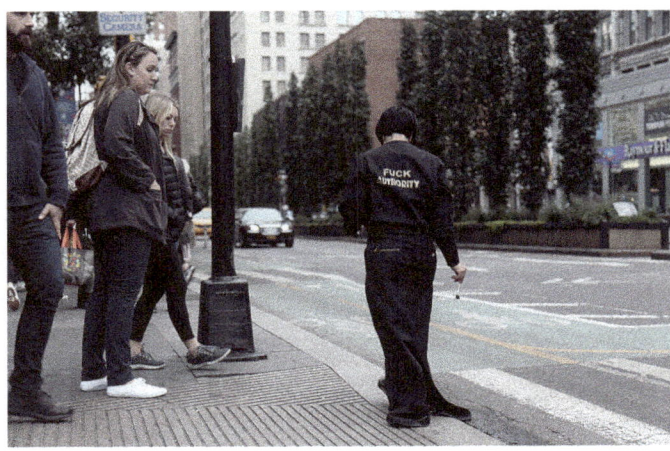

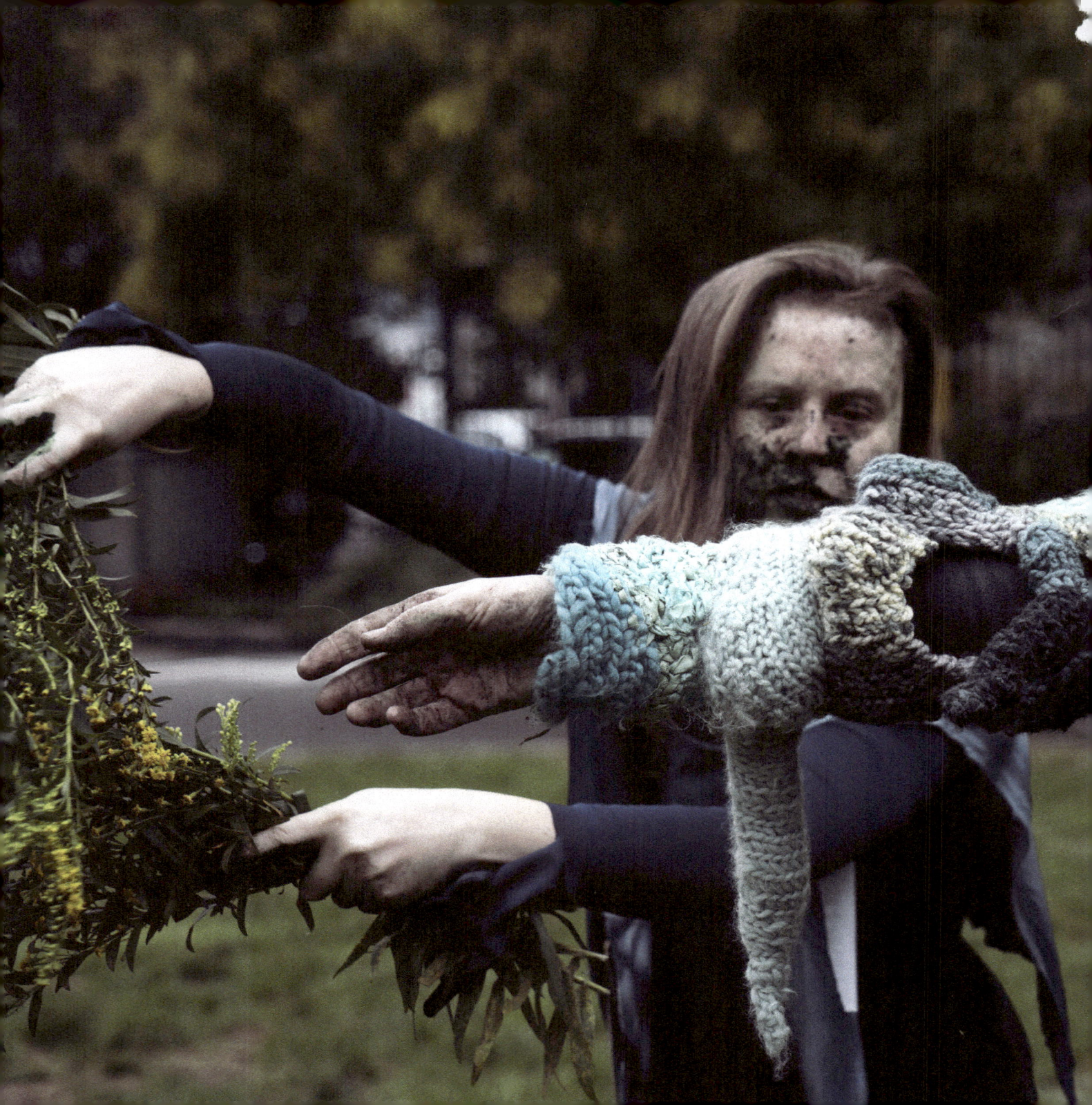

Donna Cleary & Kathy Halfin:
Hell Hath No Fury

This performance embodied angry, powerful Female Goddesseses Kali and Cailleach during an era of pussy grabbing and #metoo confessionals.

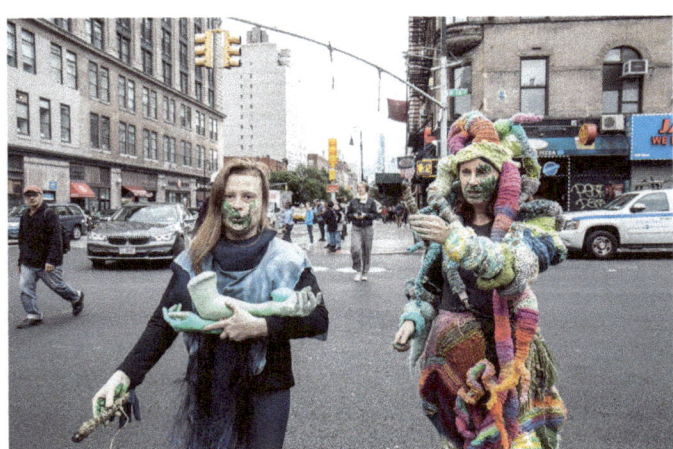

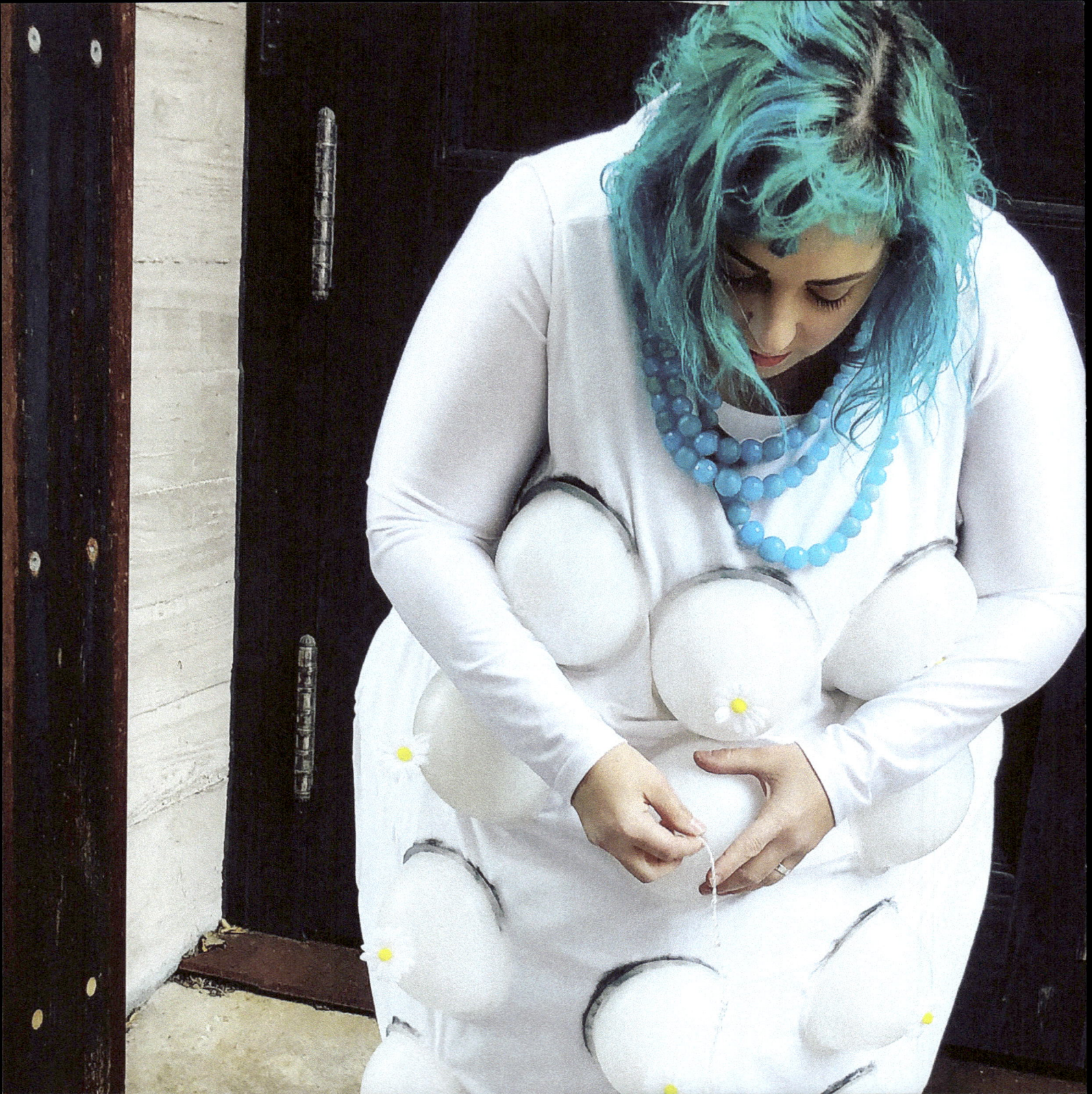

Don't Move:
Kat Cope, Kate Frazer Rego & Kelly Savage:
Don't Move

This project explored themes of sexism, body standards, oppression and the anxiety that comes from these stressors.

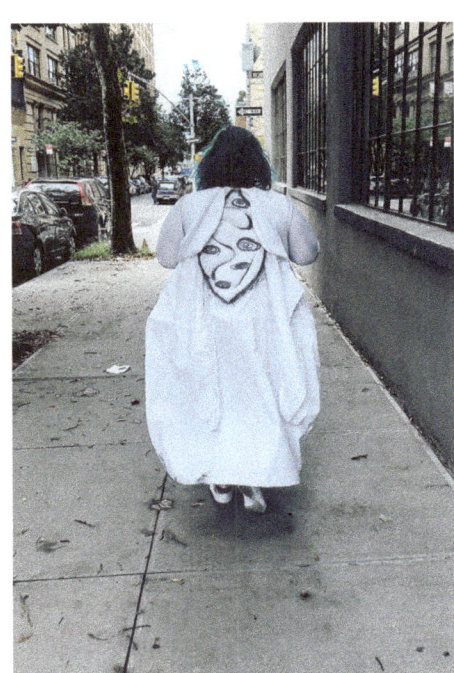

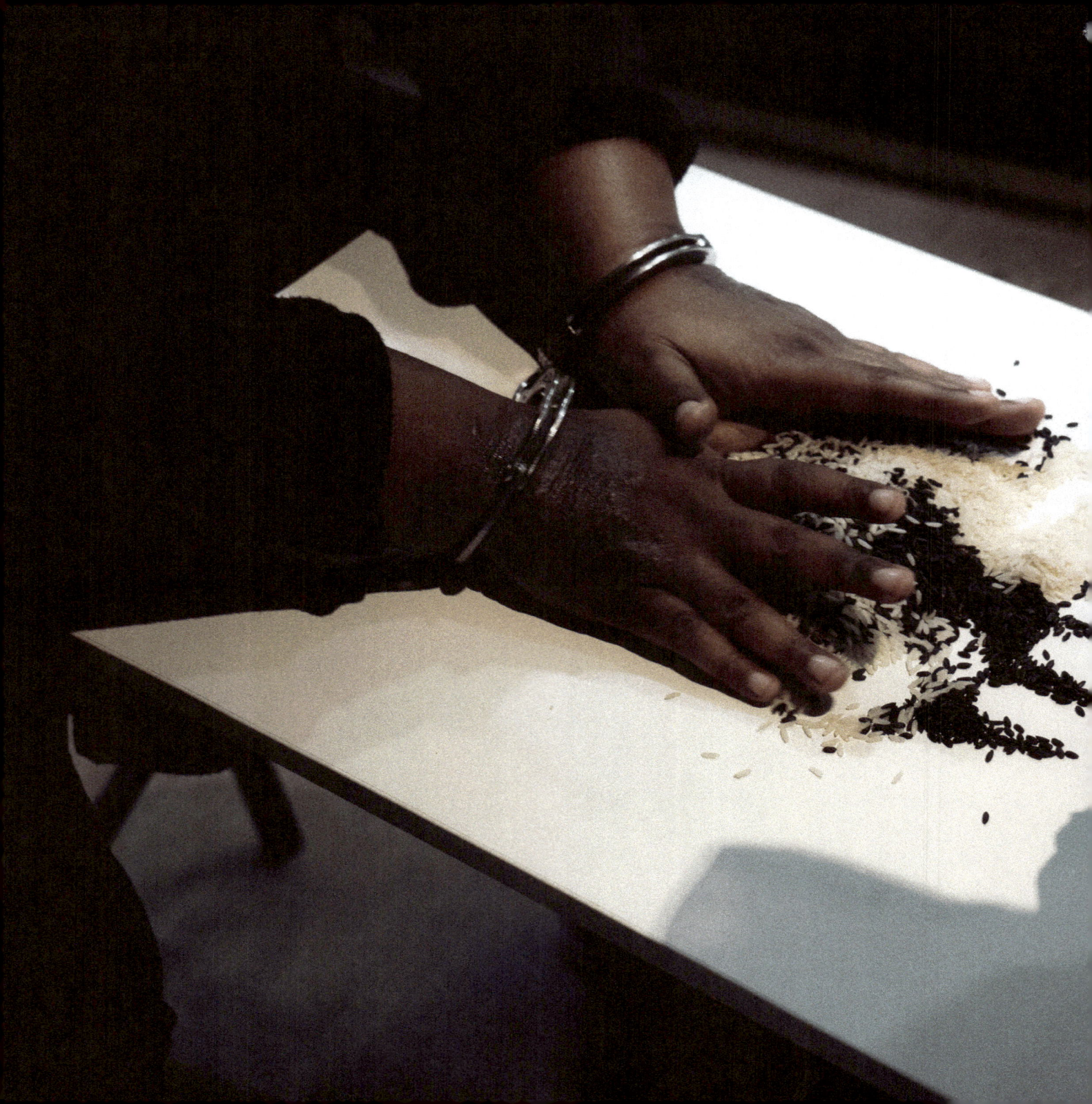

Dominique Duroseau:
Rap on Race with Rice

Using a small table and chairs, two to three participants performed the action of splitting rice with the artist as a conduit for discussing race issues.

Catherine Feliz:
Say it With Flowers

This work examined the boundless commodification of flowers and feminized labor under late capitalism.

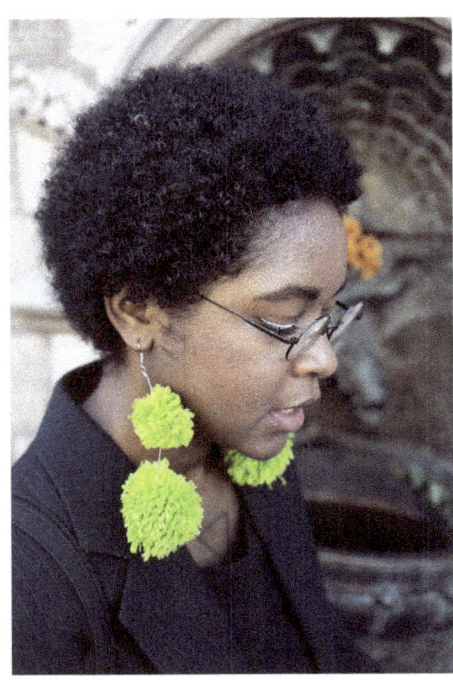

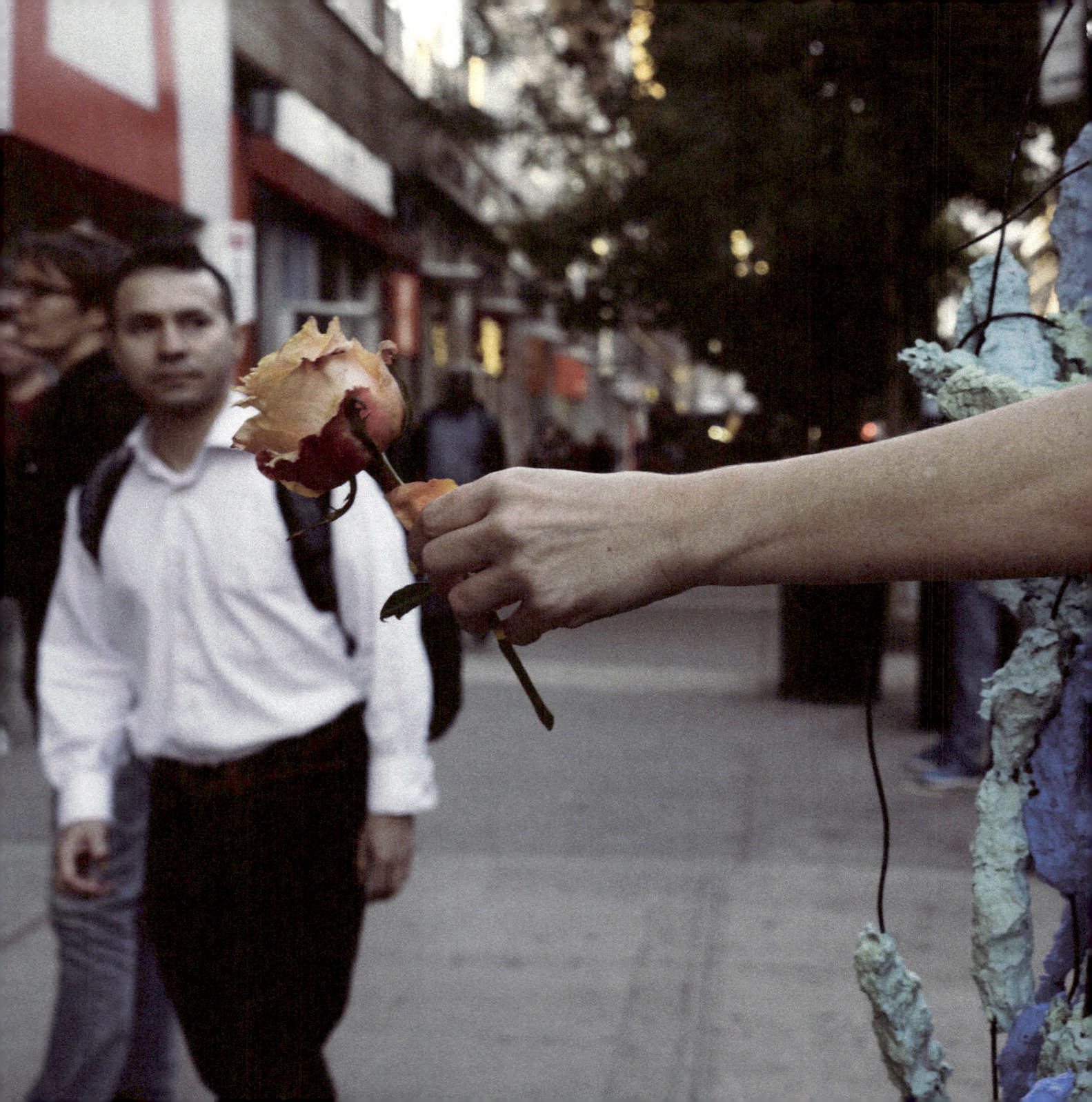

Dakota Gearhart:
Untangling Myself From The Mess Culture Has Made

A performance in which the artist wore 100 intestinal-like cords made from electrical wire and confetti.

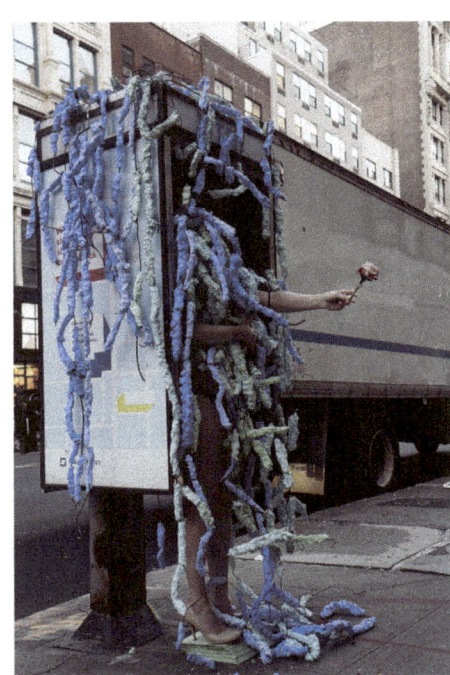

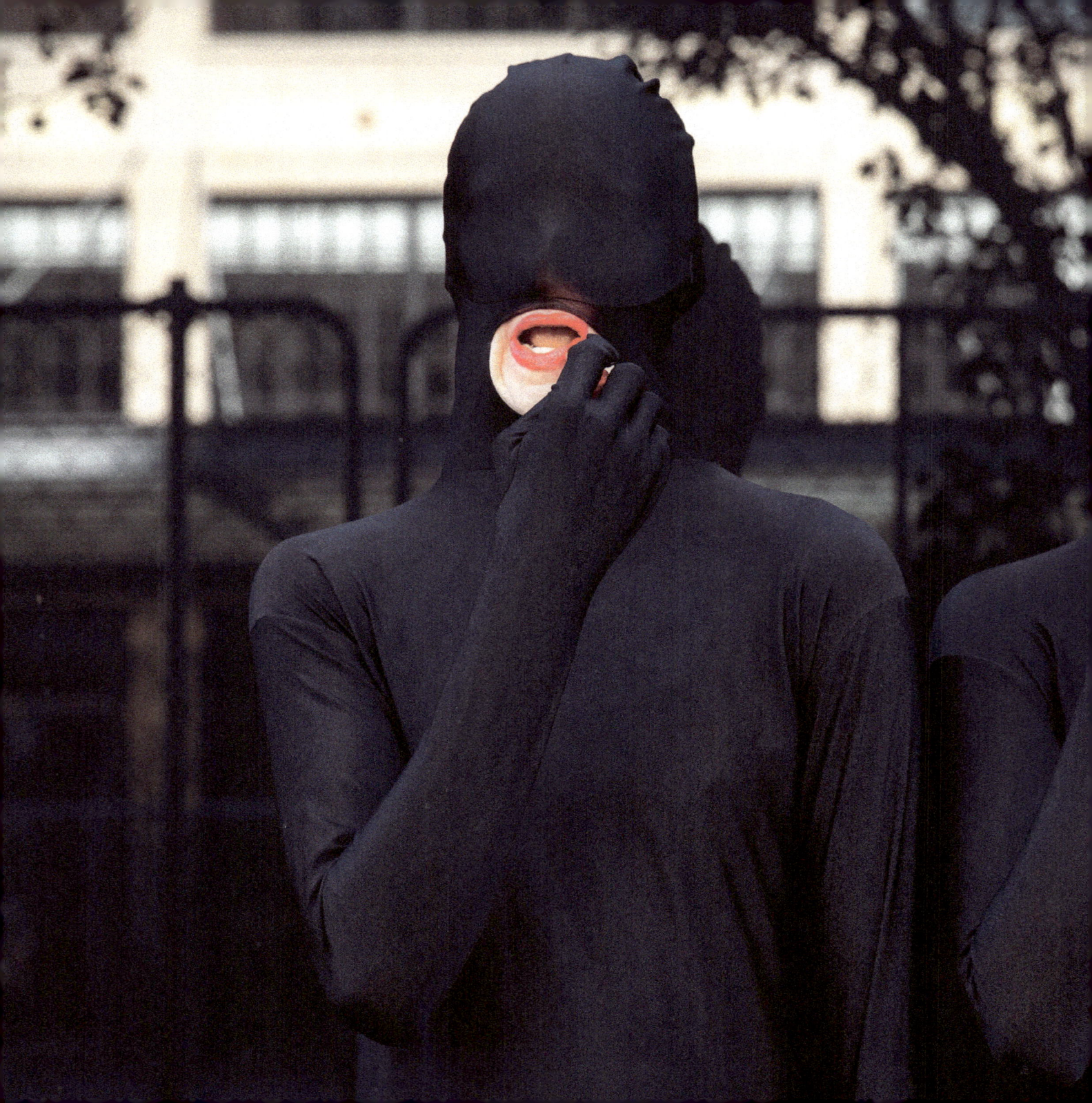

Maryam Monalisa Gharavi:
Mutual Recognition System (Concerning Max Factor) and Kiss Mark

This project reimagined Max Factor, Jr.'s female workers automating kissing to test the indelibility of his red lipstick.

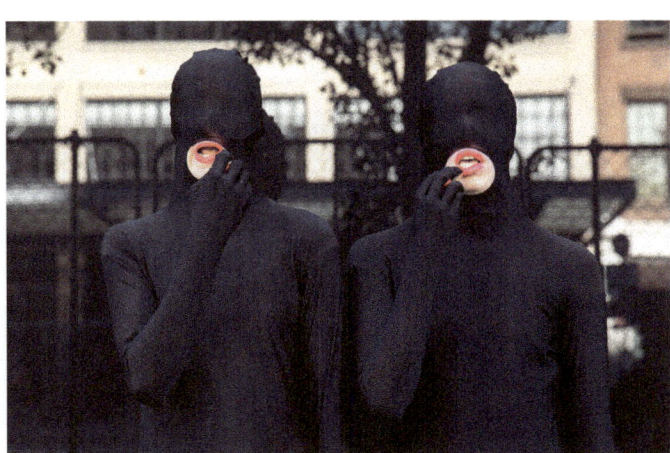

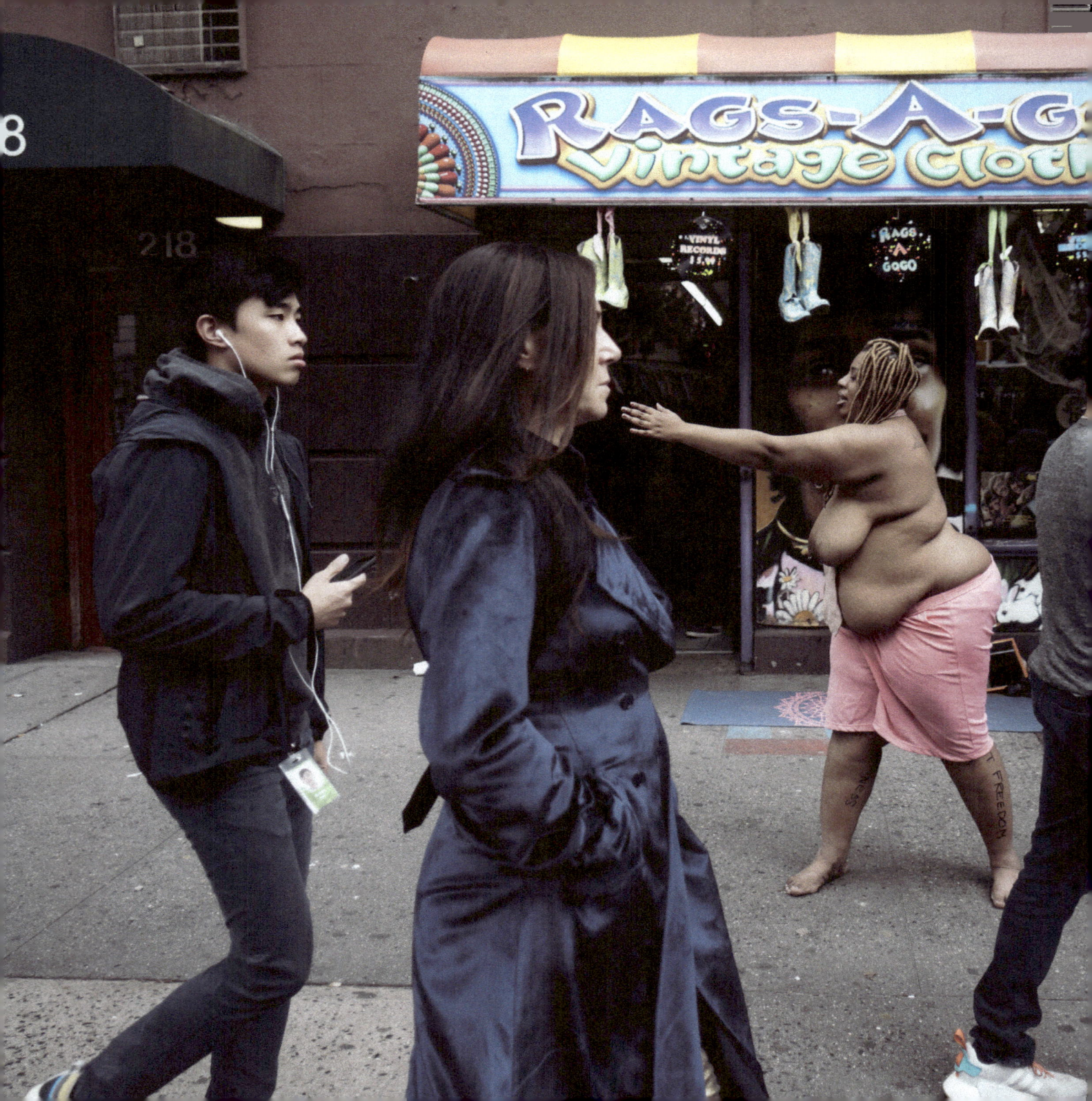

Nicole Goodwin:
Ain't I A Woman (?/!): Kingston Legacy

This performance referenced the quest for "equality" underlying Sojourner Truth's 1851 speech "Ain't I a Woman."

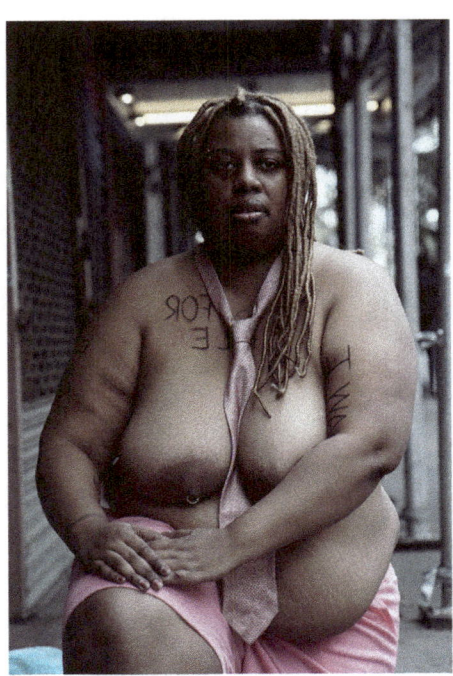

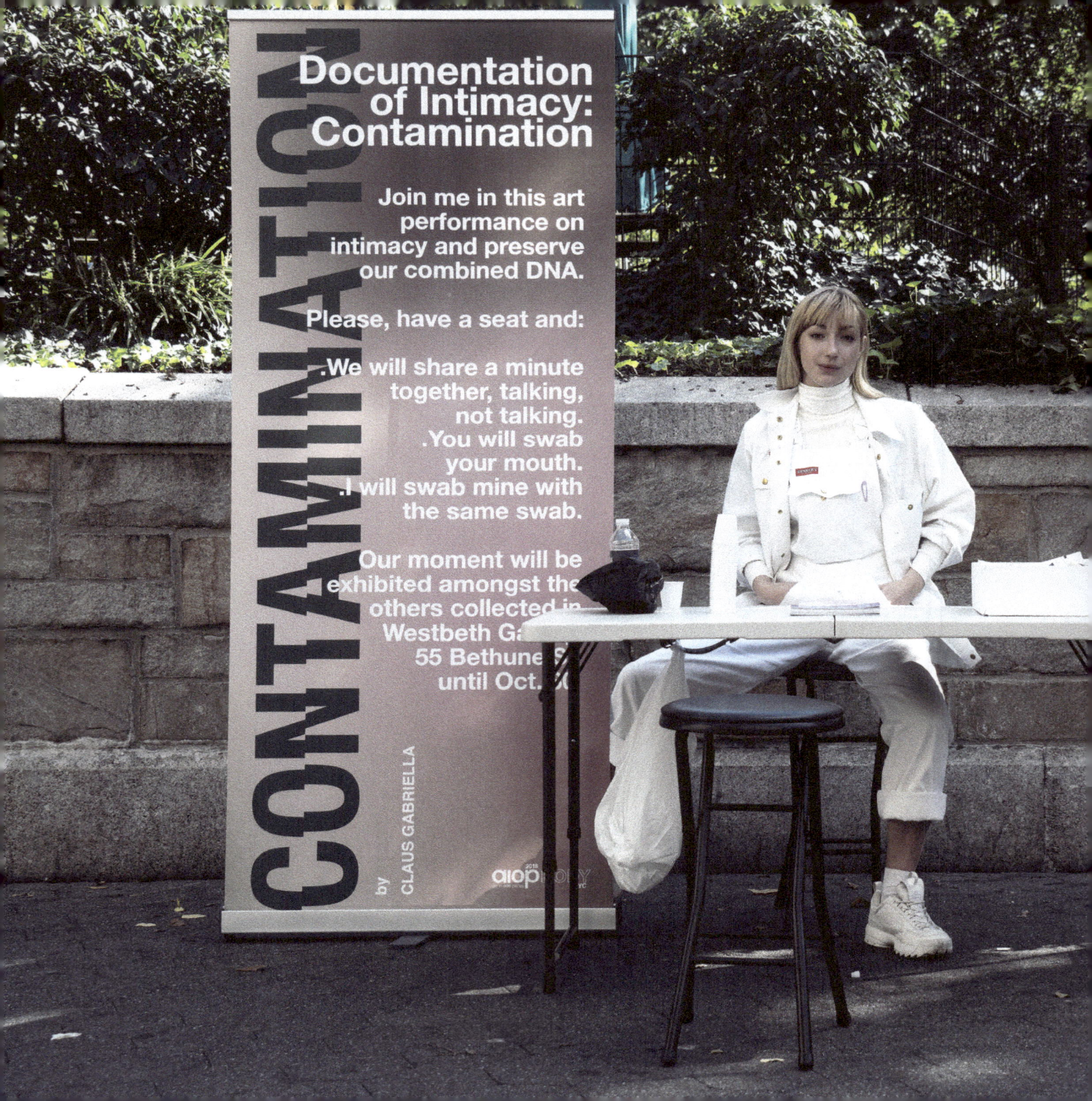

Claus Hedman:
Documentations of Intimacy: Purchased and Contaminated

This series is an ongoing project which preserves and conceptualise interactions of intimacy.

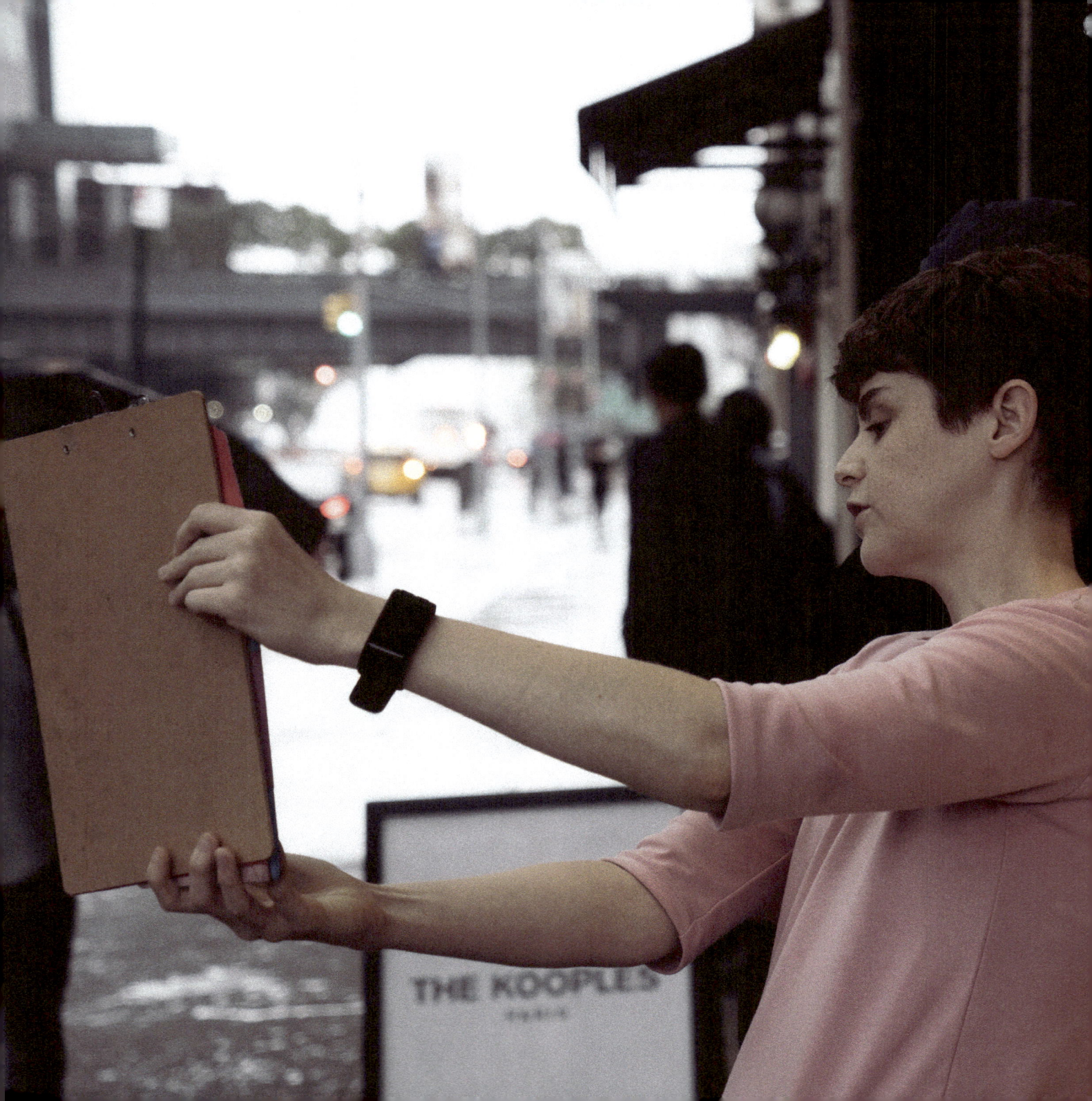

Martha Hipley:
ur best selfie

This iteration from a series of digital tools explored reclaiming personal identity with creativity while also raising awareness of the dangers of face and location tracking software. This latest web app allowed visitors to 14th Street to have fun making fantastical selfies that were designed to defeat the current facial recognition algorithms used by most social media apps.

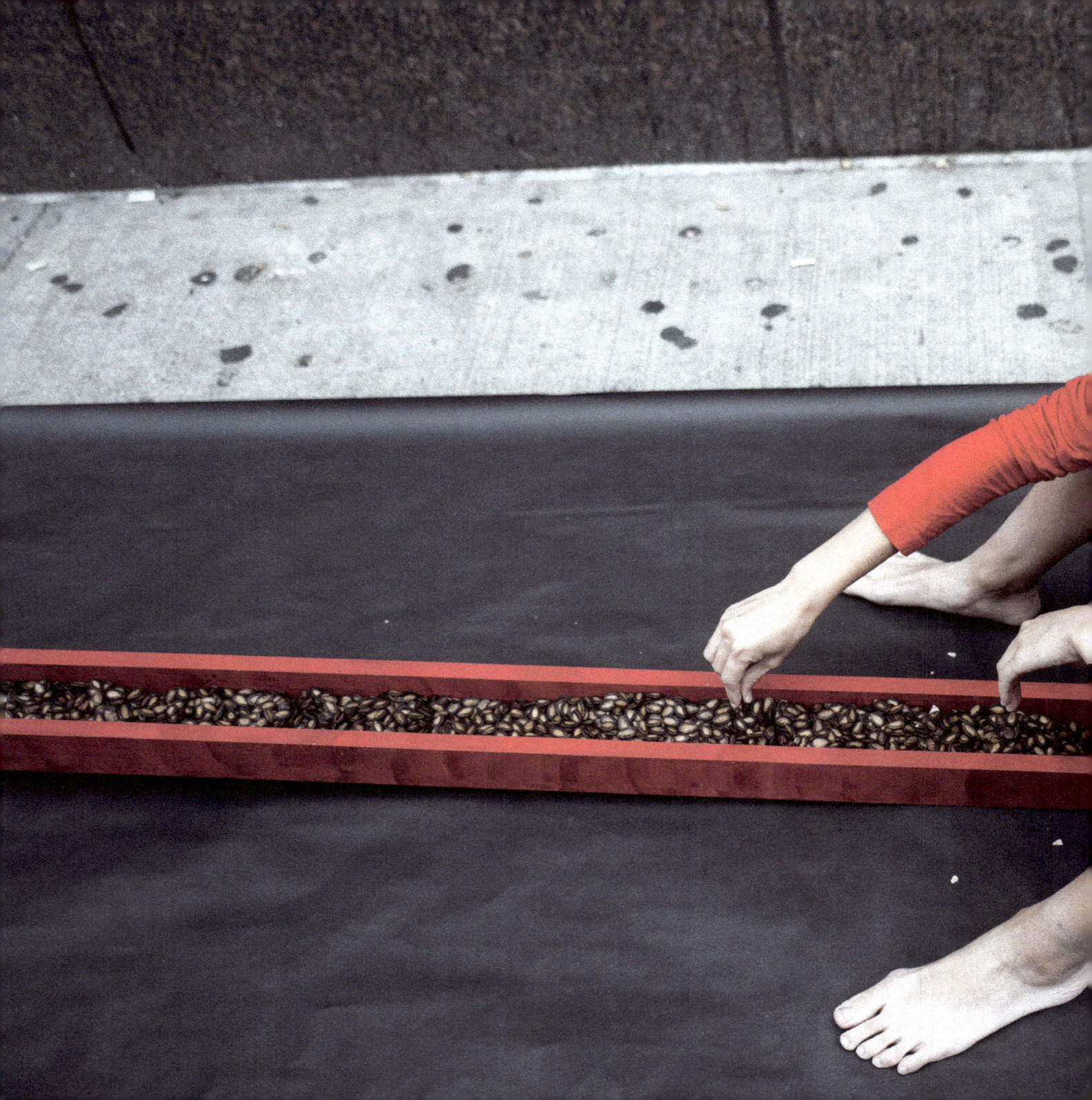

Pei-Ling Ho:
Absence of Three

This work created a scene and construction which gave the audience an imagination to experience the absence of family.

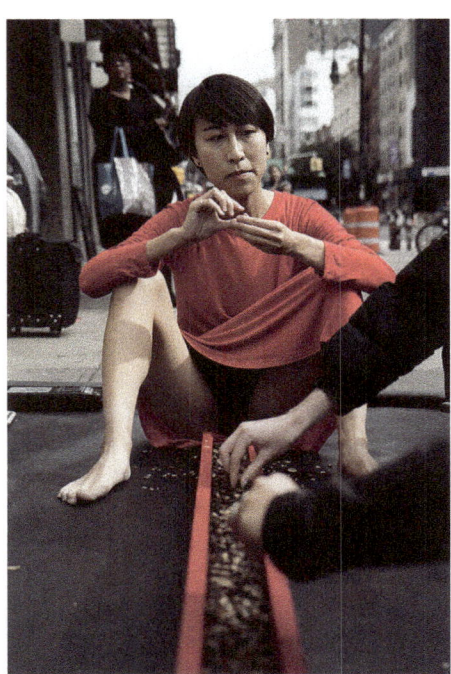

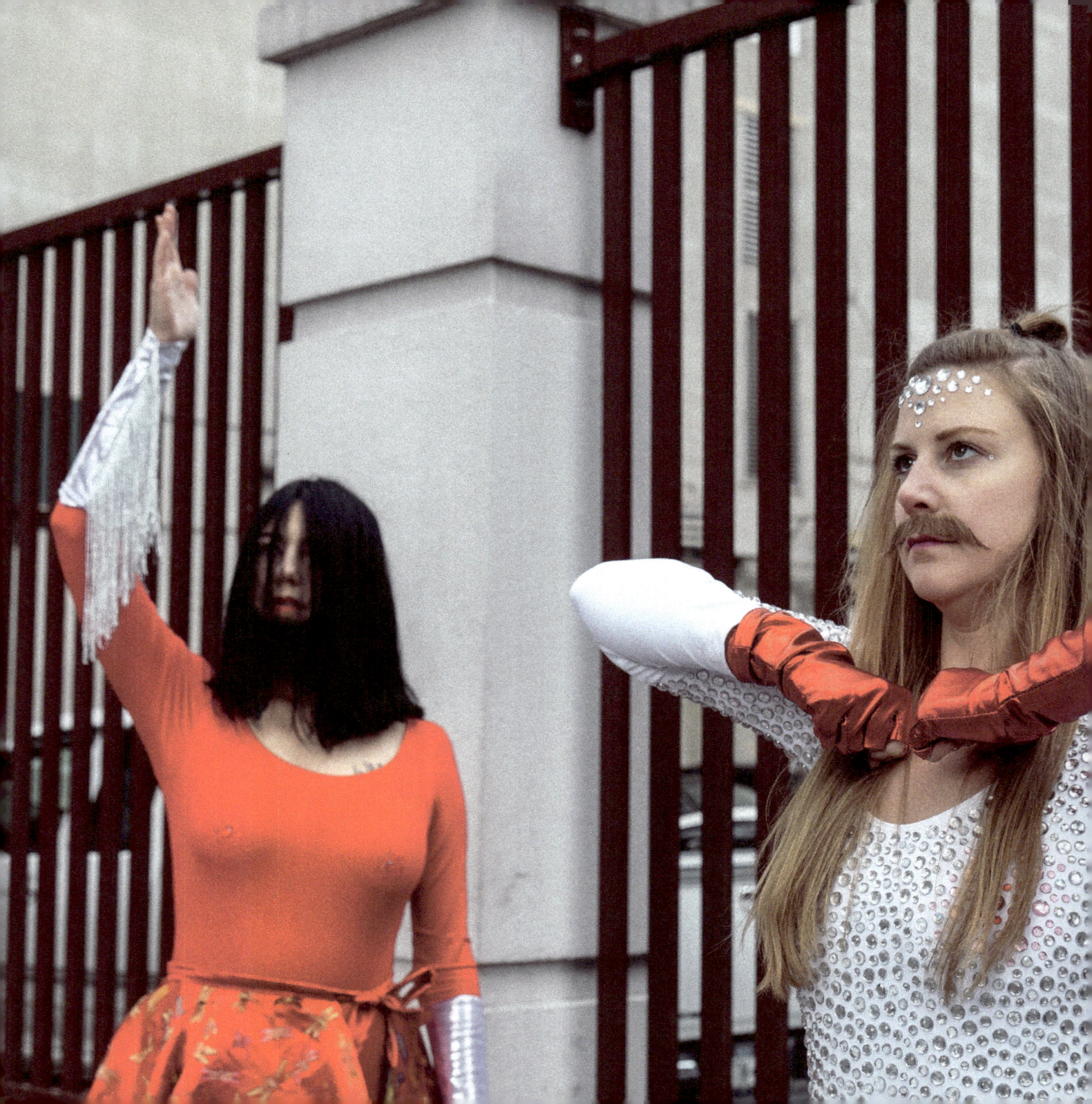

Kinsfolk:
Venus & Mars

This project investigated the relationship and connectivity of Venus and Mars and gender through movement and costume.

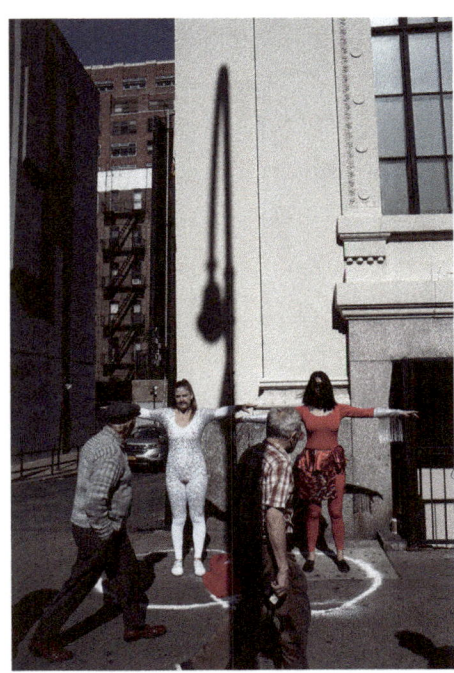

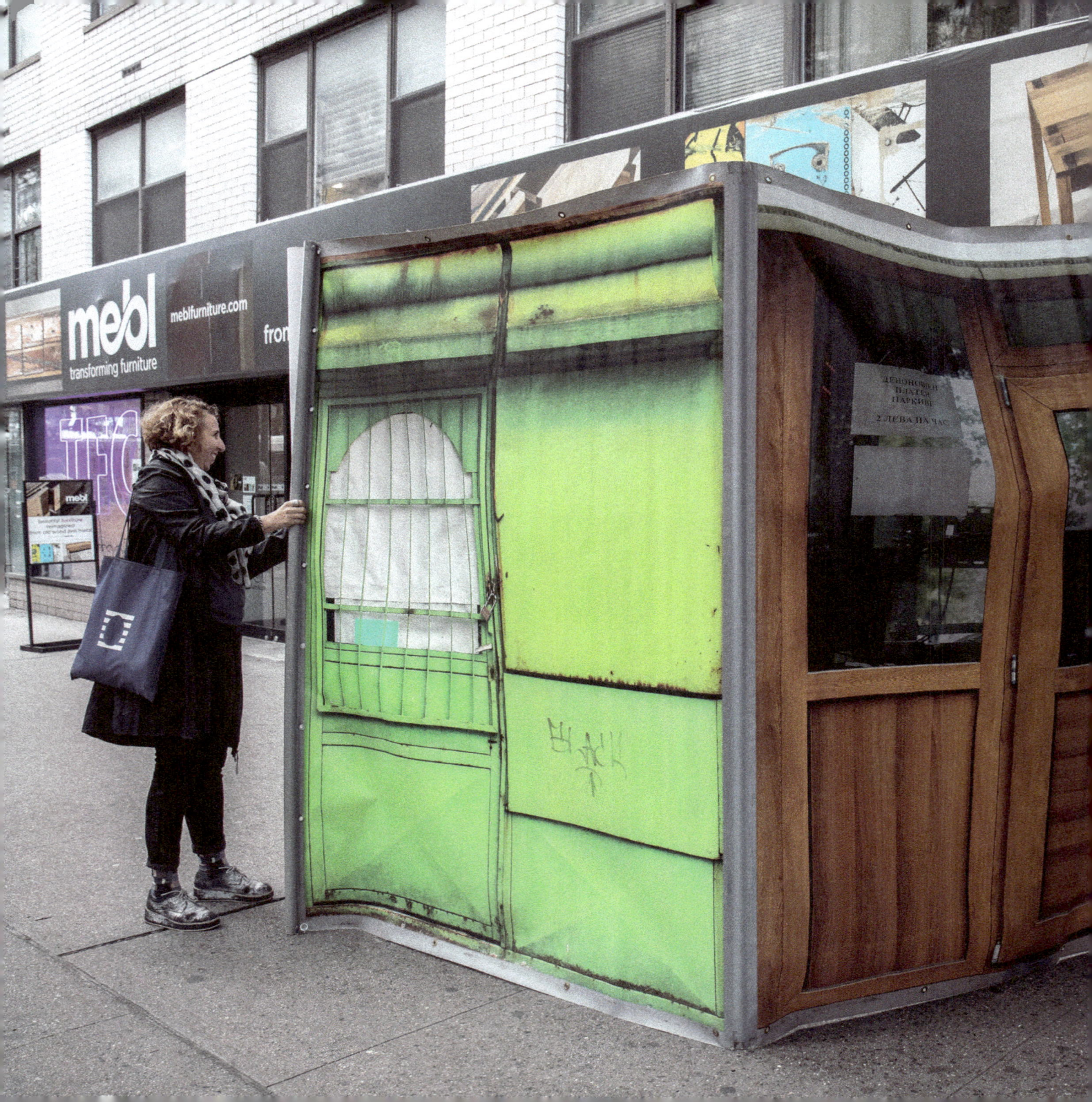

Daniela Kosotva:
Monuments of Incomplete Transition

This project conceived in 2010 with artist Miryana Todorova, explored the themes of mobile citizenship, hybridity, temporary occupation, and (re)construction.

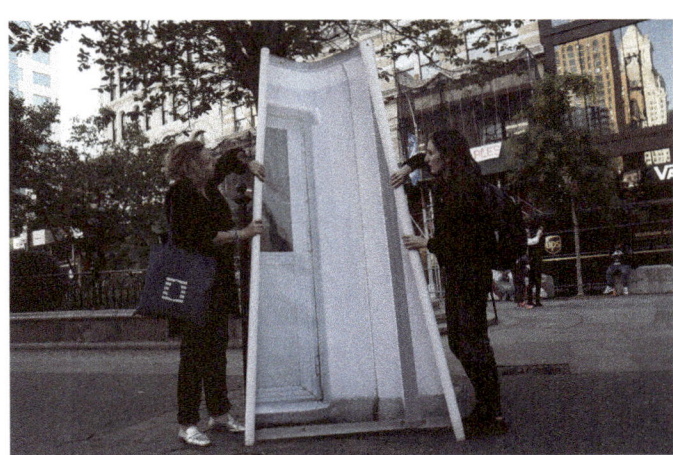

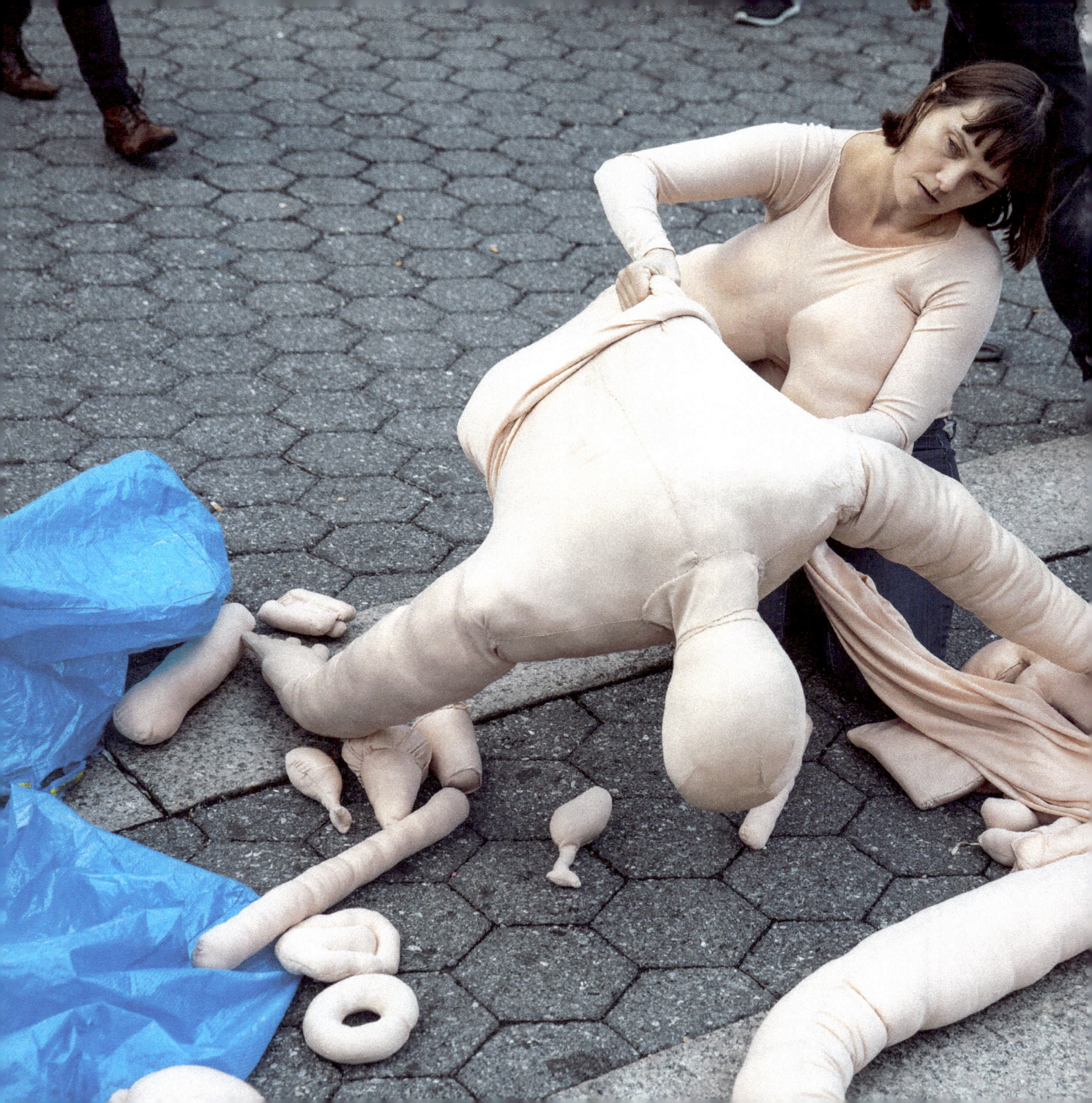

Luiza Kurzyna:
You Are What You Eat

This work explored what happens when the weight of everything you consume - food, ideas, news, ads... reaches the bursting point?

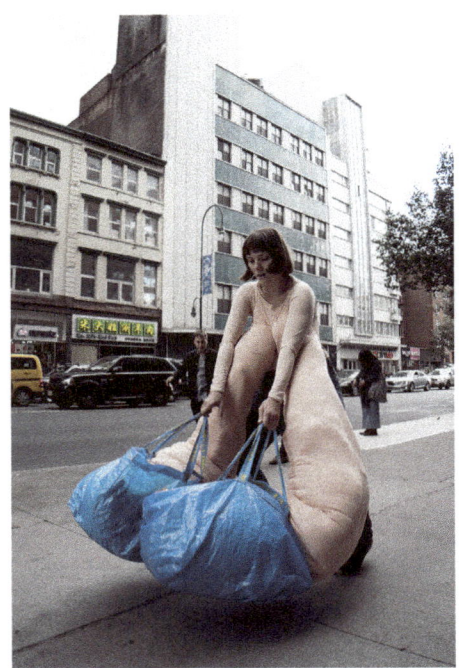

Joanne Leah:
Shock Corridor

An outdoor mural and video installation acted as a mirror showing the public response to images of the human body.

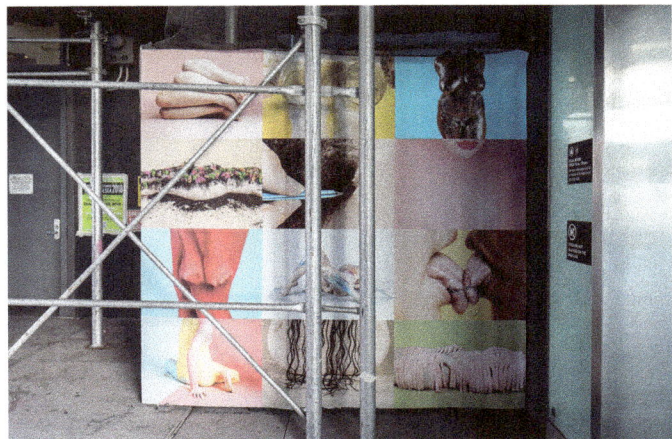

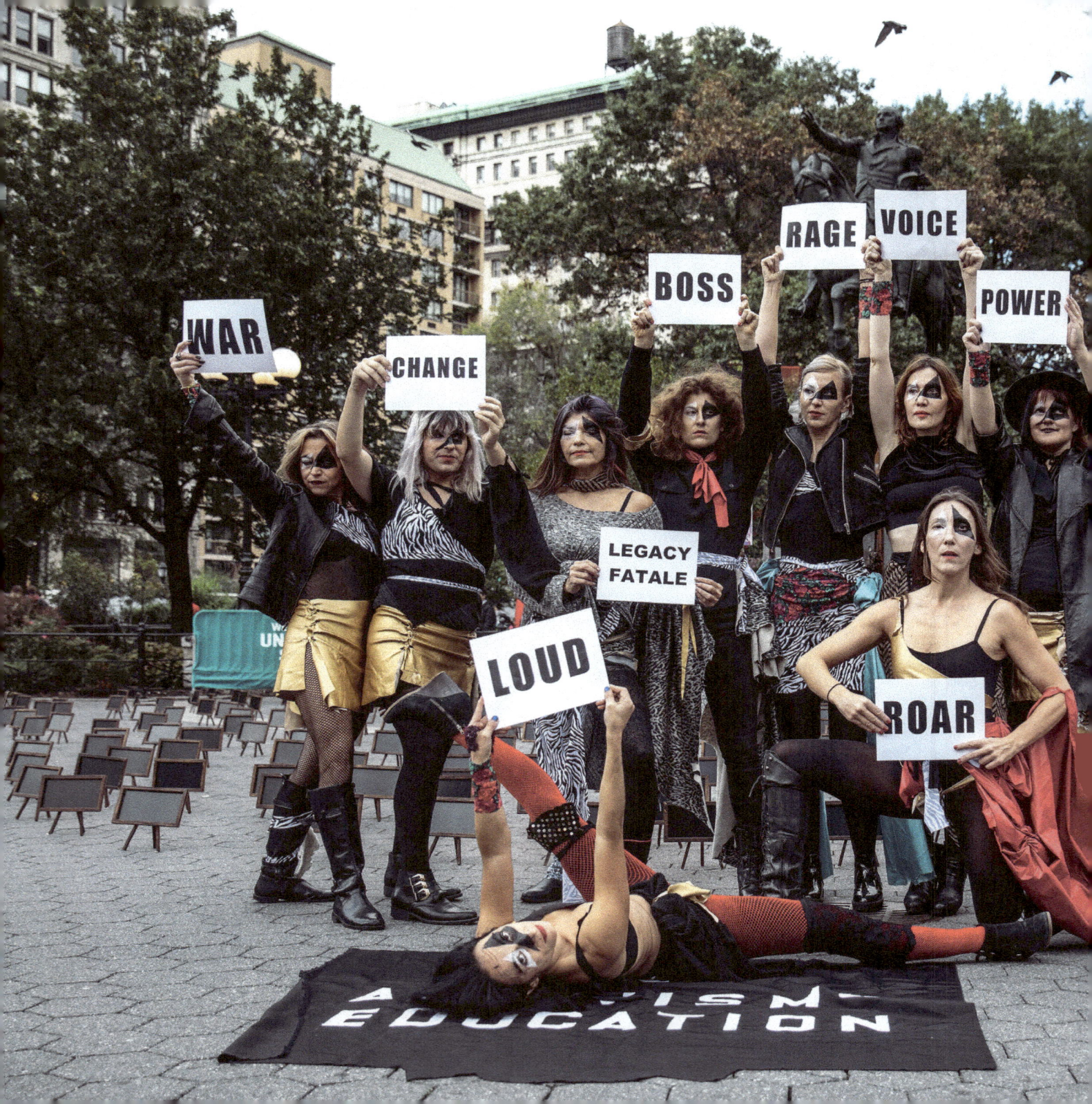

Legacy Fatale:
Tug of War at Beauty Bar

In the spirit of the Suffragettes movement, Legacy Fatale presented *Tug of War at Beauty Bar*. Beauty Bar is one of the last remaining staples of East Village culture resisting gentrification. Legacy Fatale invited the audience to a choreographed protest/war game happening outside the Beauty Bar, that then moved indoors to an abstract performance followed by a musical act: *What Would Tilda Swinton Do*.

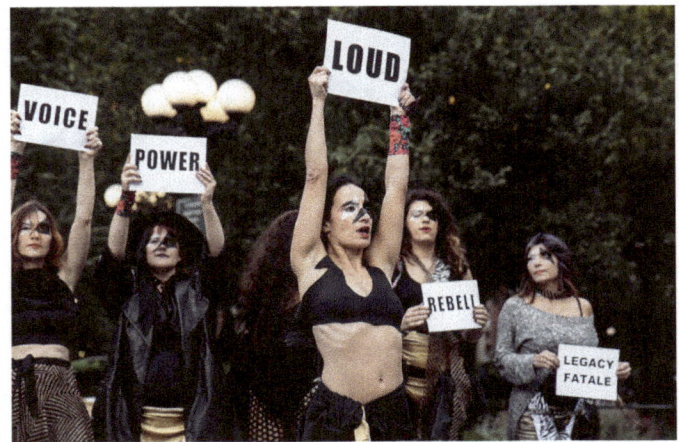

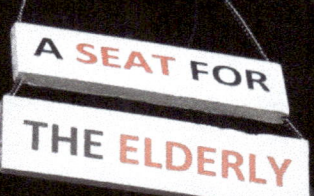
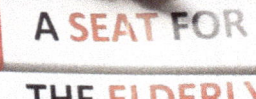

LuLu LoLo:
A Seat For The Elderly: The Invisible Generation

This performative project focused on the fragility of the aging body walking with a chair strapped to her body the artist offered a seat to the elderly invisible generation.

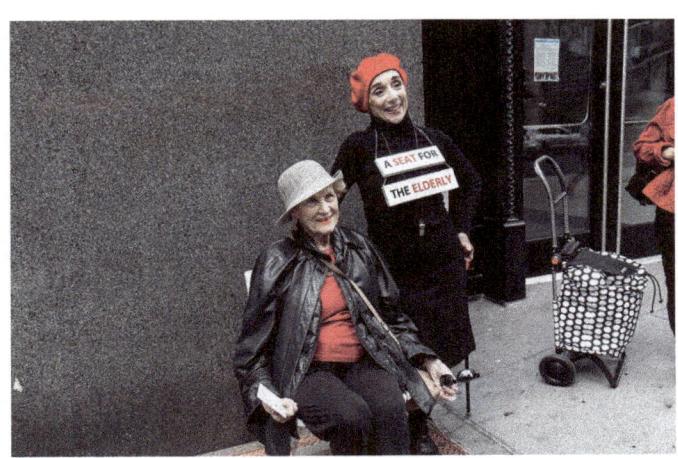

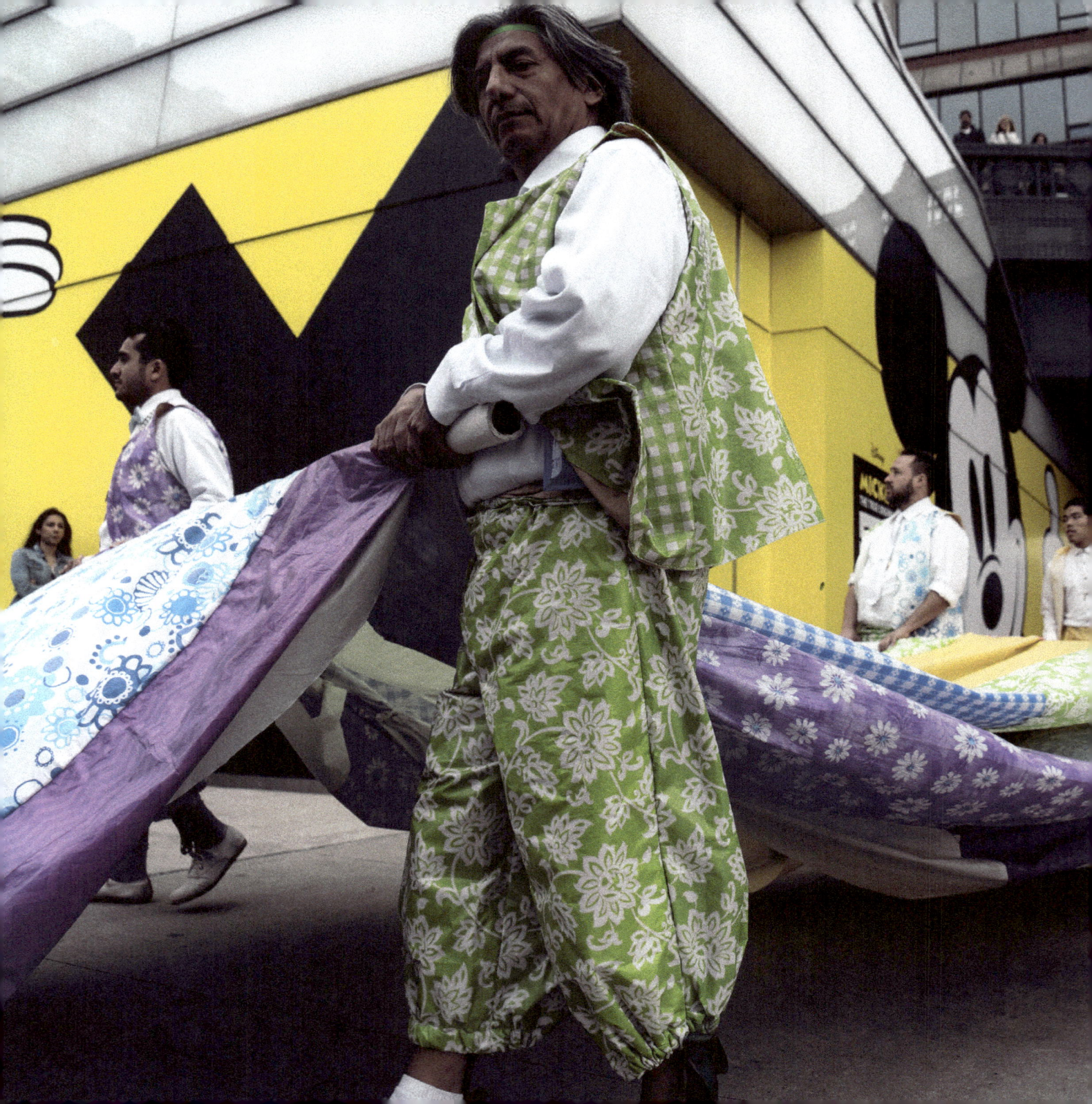

Jodie Lyn-Kee-Chow:
The Picnic: Harvest of the Zephyr

This durational performance took place along the length of 14th Street beginning of the eastside culminating in a picnic with the public at 14th Street Park on the far westside. This work was made possible, in part, by the Franklin Furnace Fund supported by Jerome Foundation, The SHS Foundation, and the New York City Department of Cultural Affairs in partnership with the City Council.

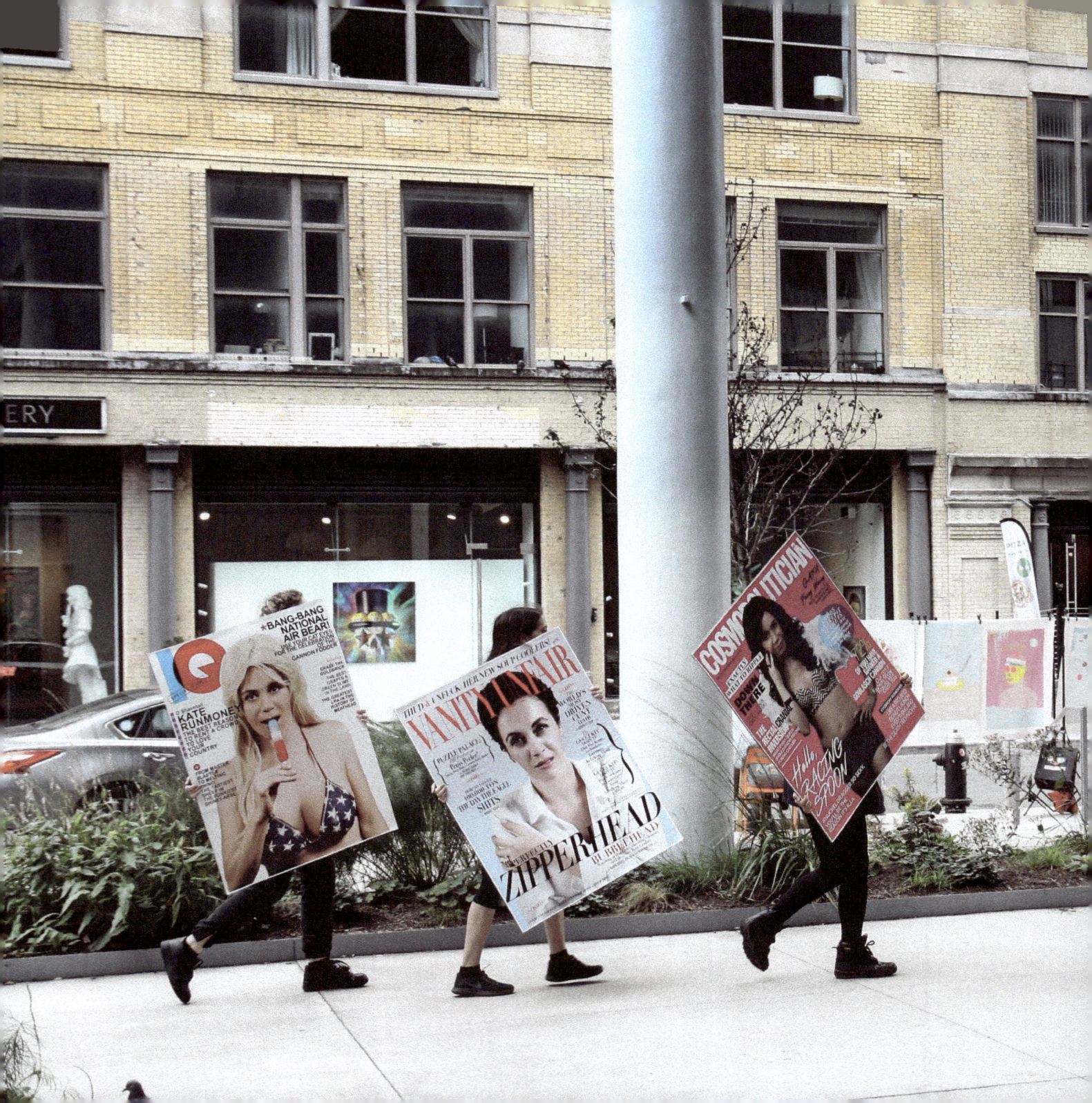

Nadja Verena Marcin:
Cover Girls

A poster series which played upon the animosity of said photographic avatars and the viewer's human experience.

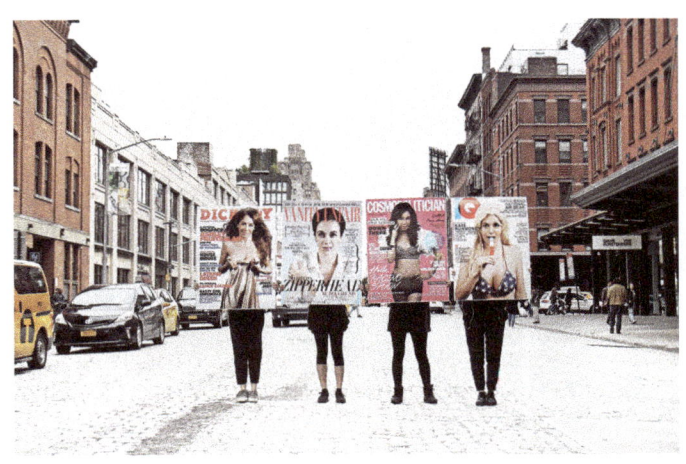

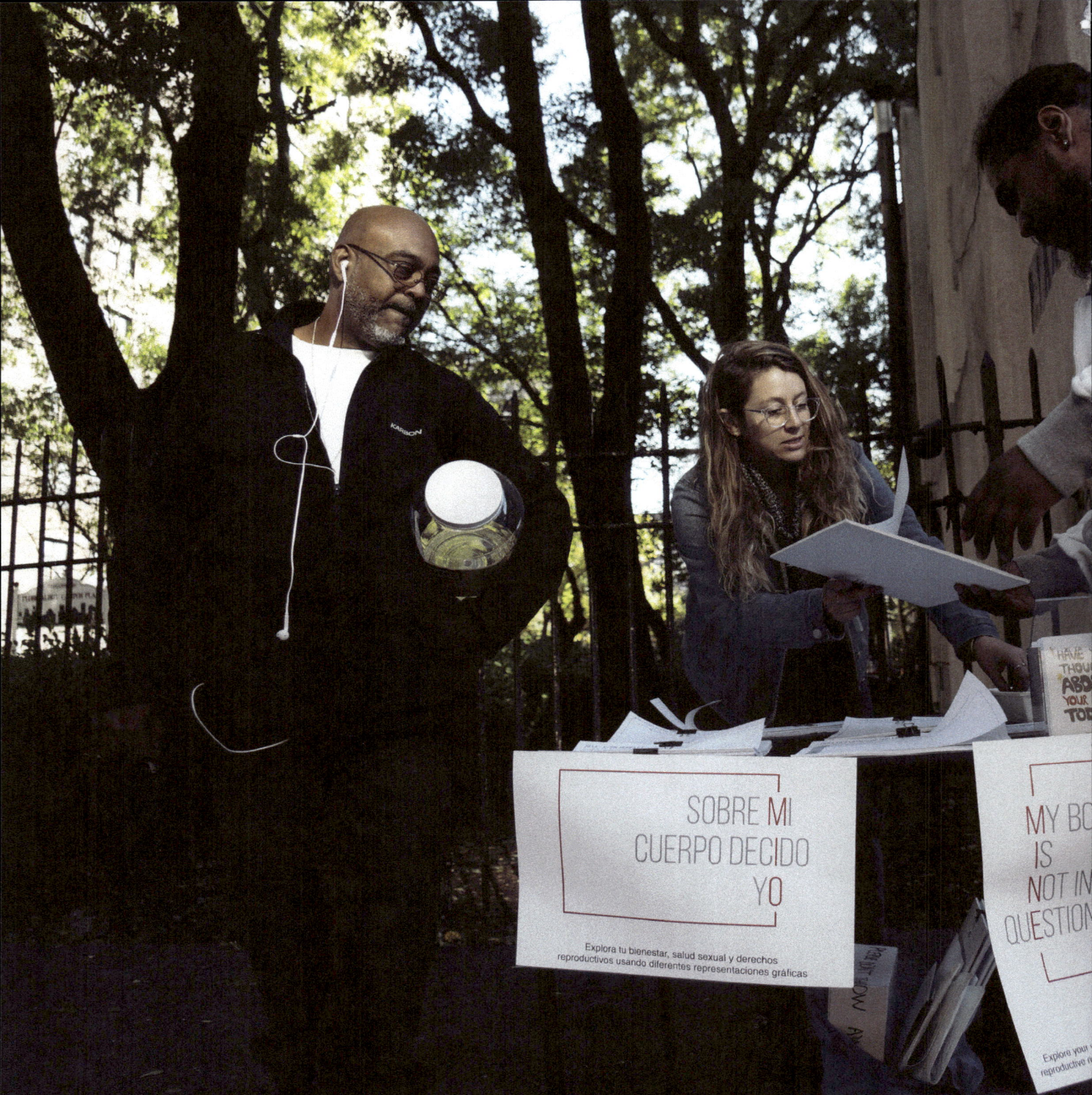

Daniela Mekler:
My Body Is Not In Question

This project invited people to explore their connection to reproductive rights and wellbeing through different prompts.

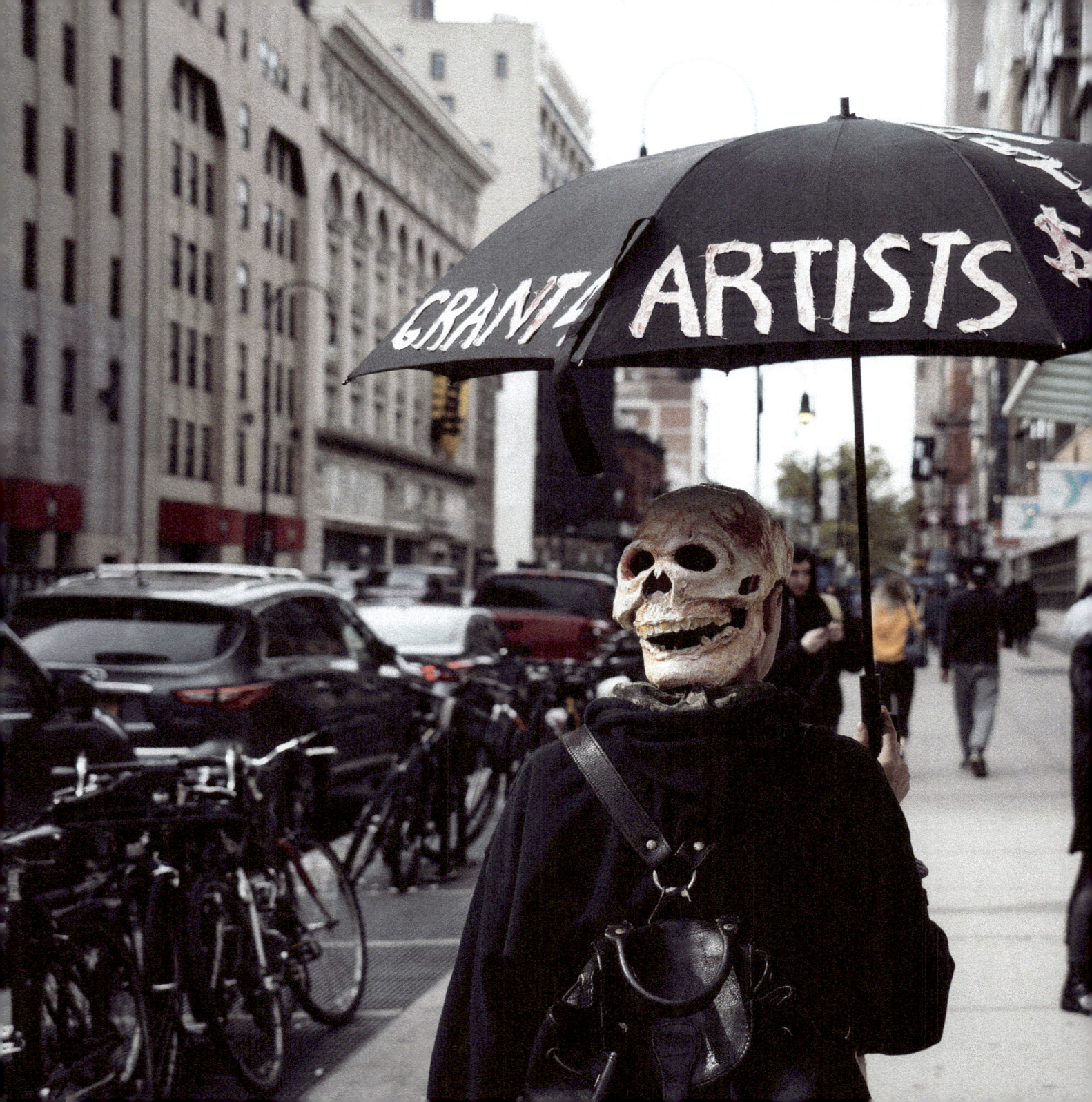

Esther Neff:
Public Grant TBA Body Of Institution

This interactive work performed institution as a verb achieved by an emergent public bodily.

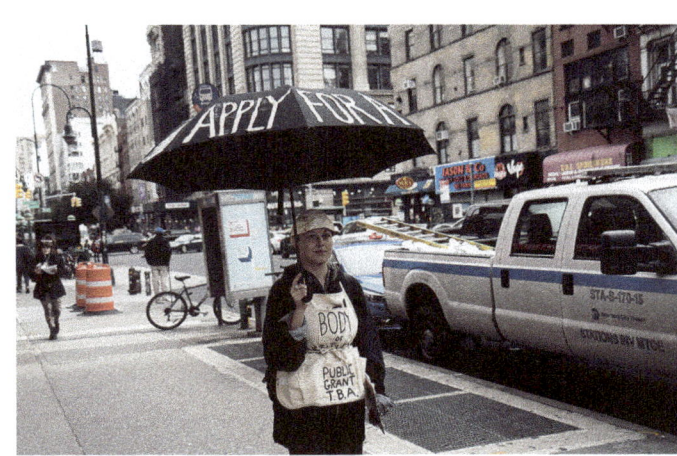

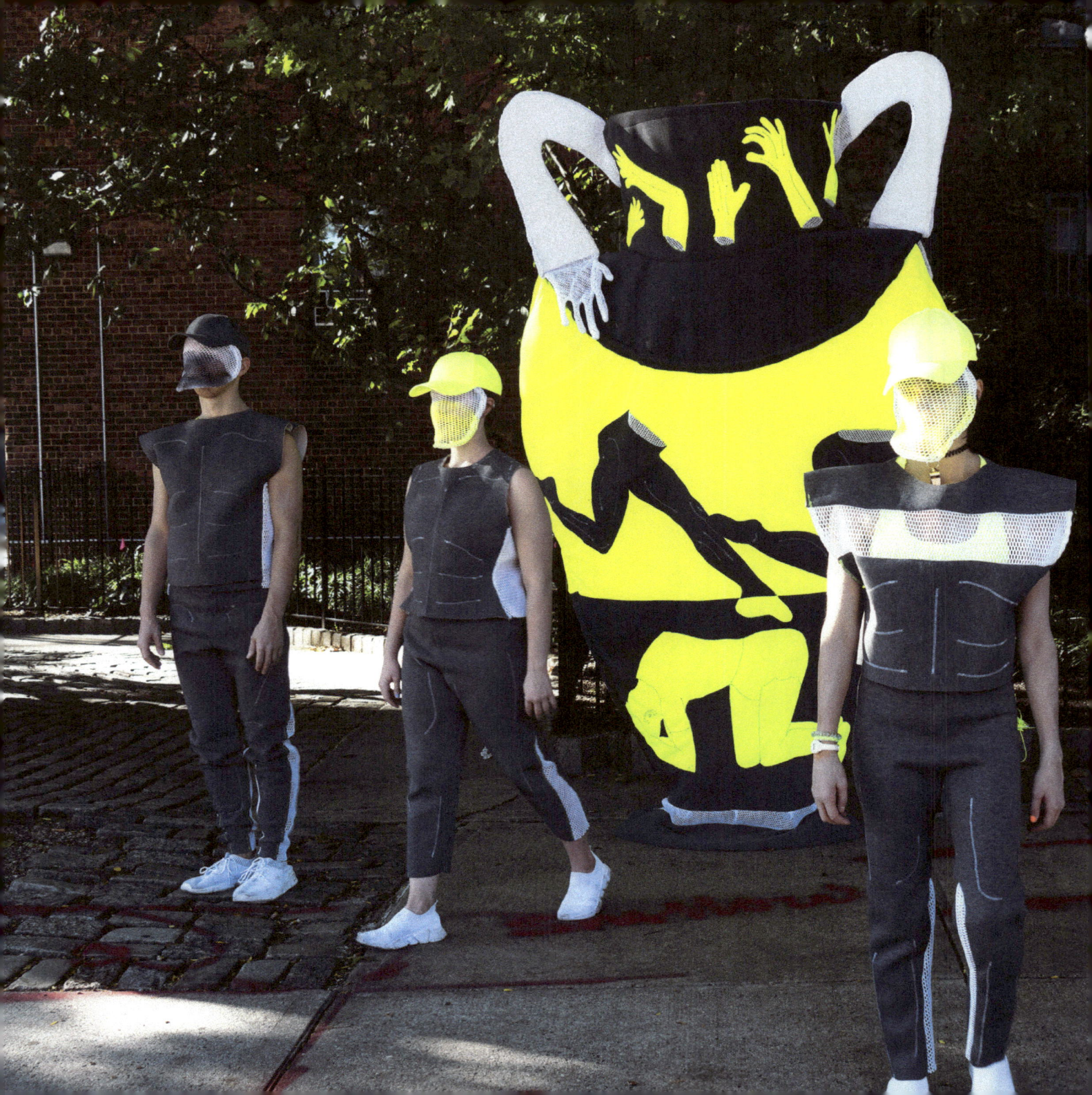

Rose Nestler:
Gymnasia Hysteria

This work explored the cult of masculinity through spotlighting society's age old obsession with sports and physical fitness.

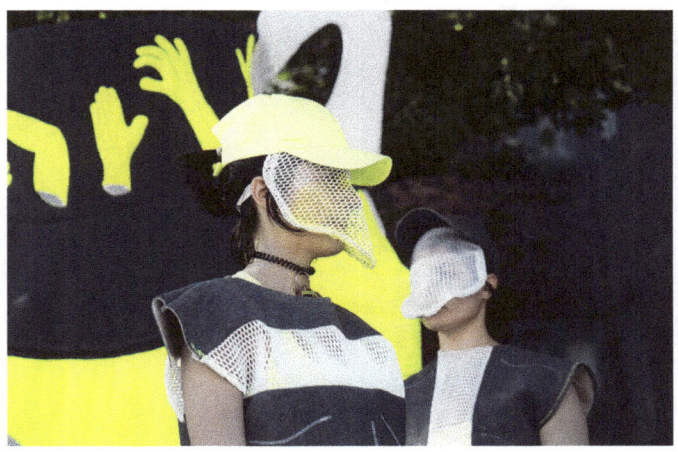

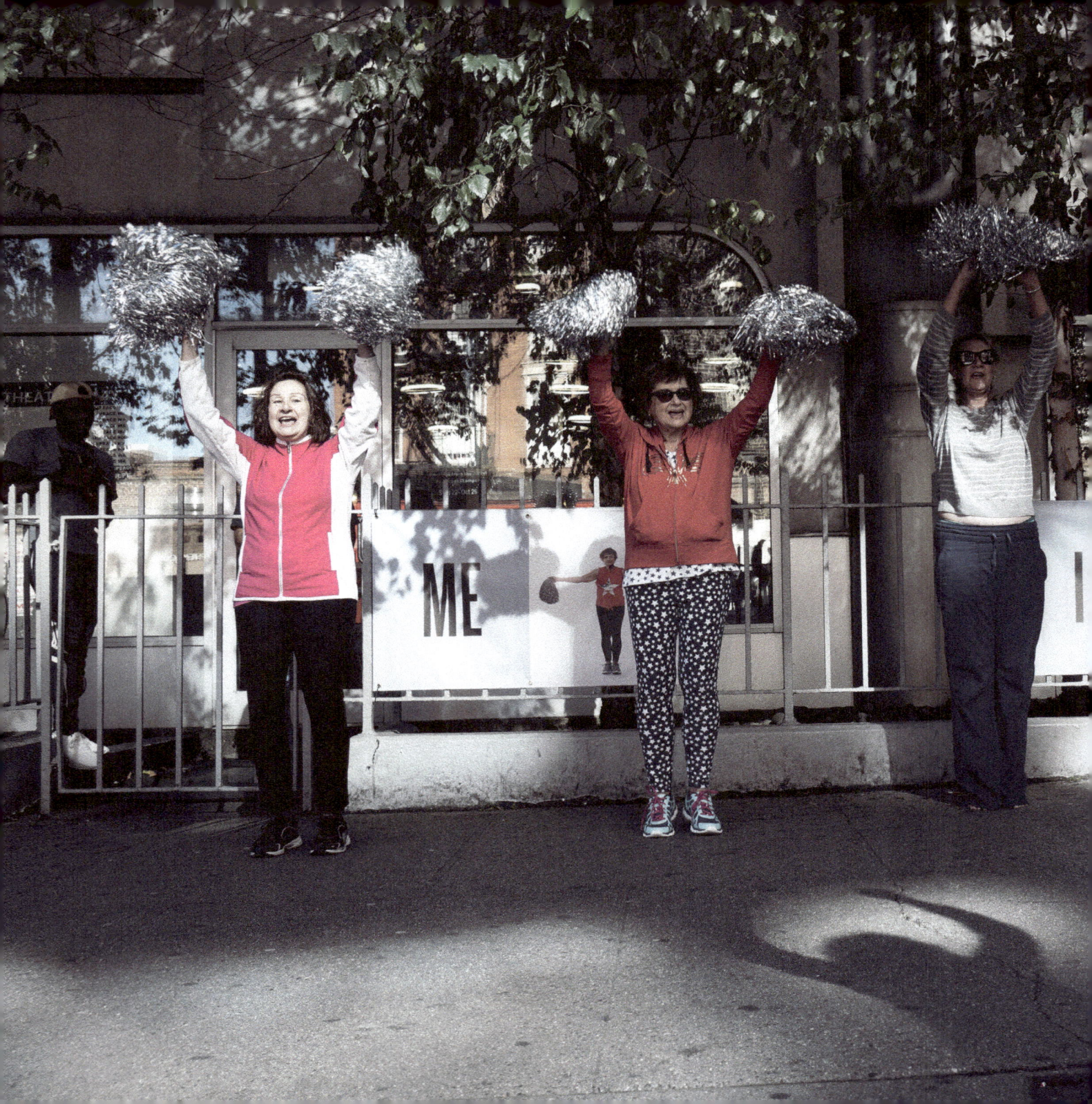

Laura Nova:
Silver Sirens

This squad of senior citizen cheerleaders championed age justice and healthcare issues.

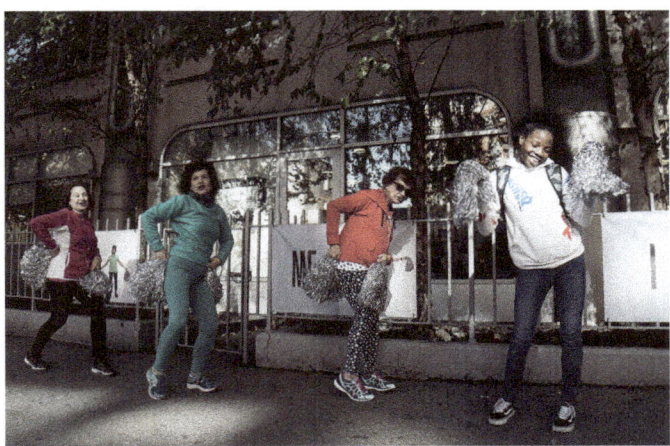

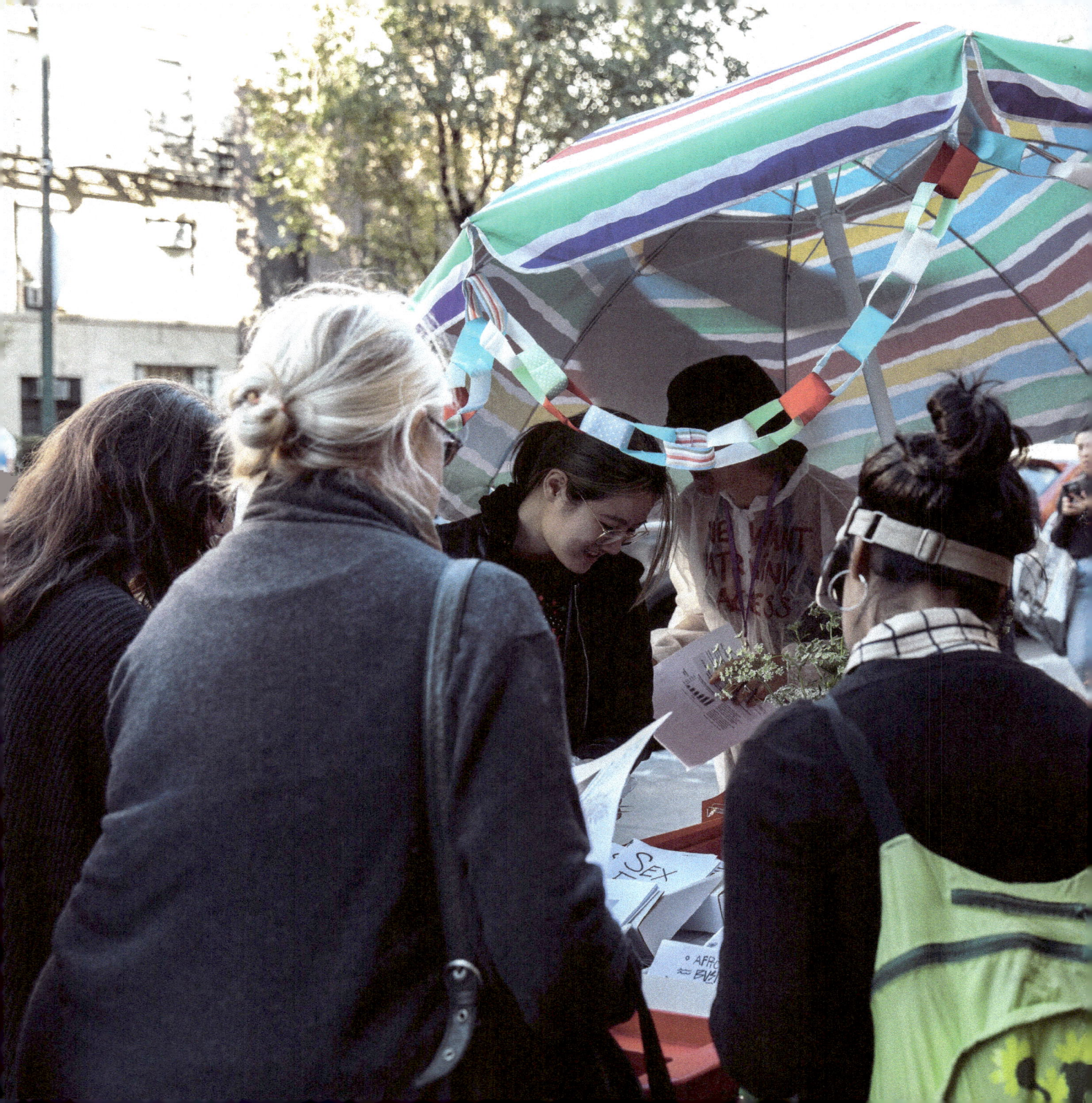

No Wave Performance Task Force: Christen Clifford & Amy Finkbeiner: *Flower Kart*

This mobile performative installation was a Matriliny Access Station for Un-Patriation & Re-Distribution of Information, Knowledge, & Supplies Toward Re-Possession of Our Bodies.

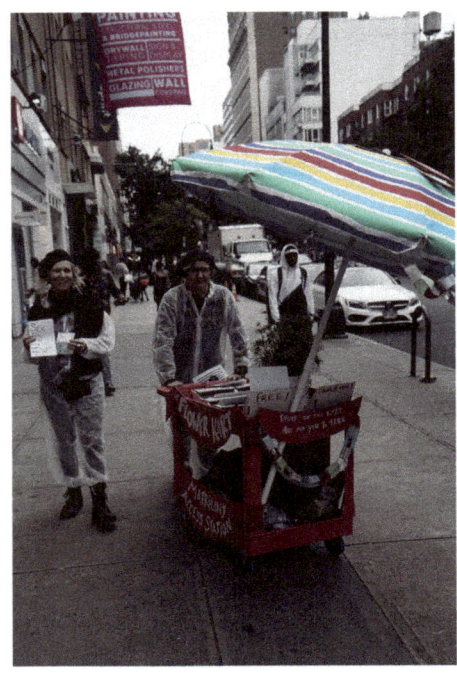

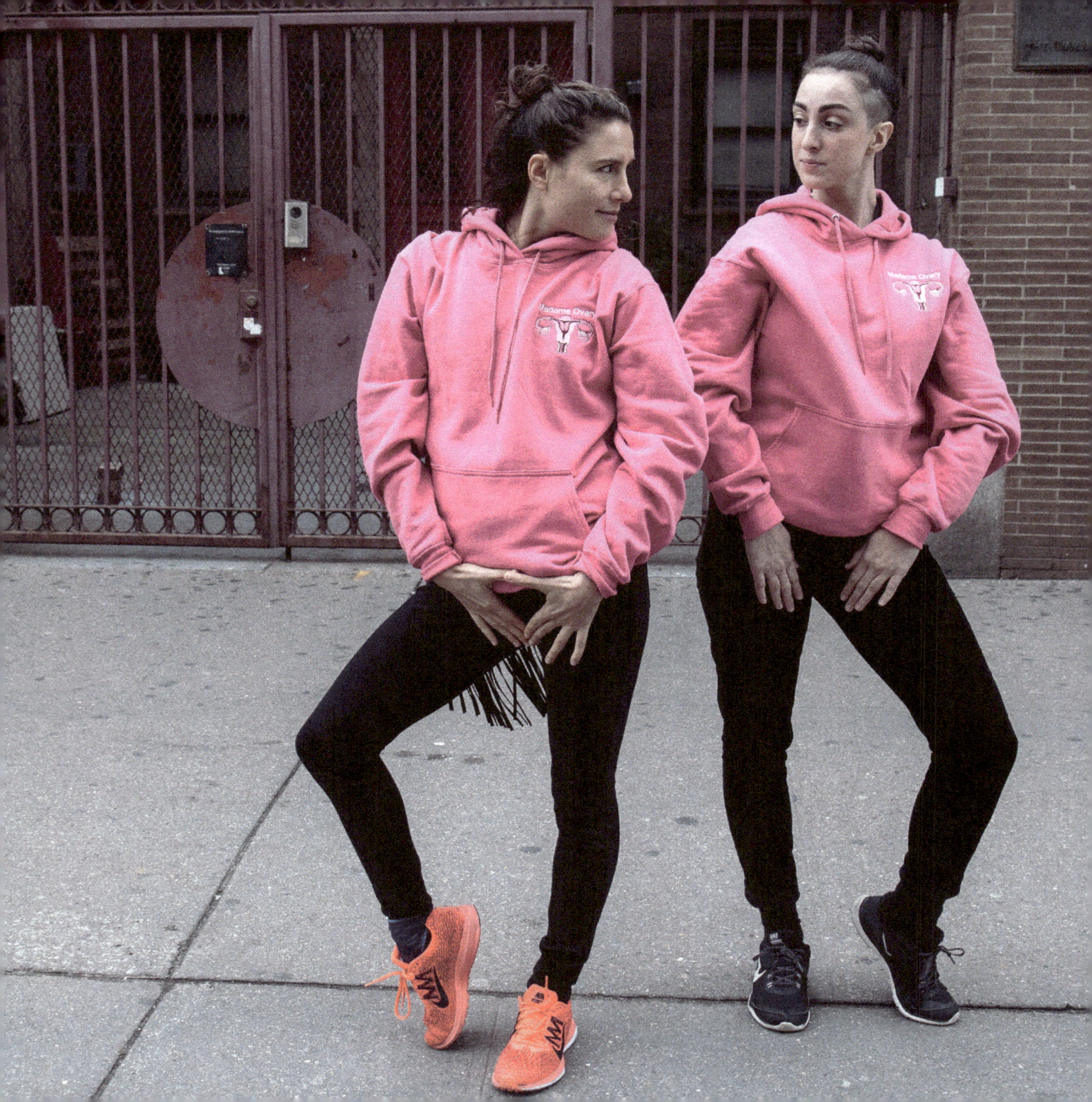

Jody Oberfelder:
Madame Ovary

Audiences and passerby on 14th Street interacted with Madame Ovary exploring the body as a site for agency, intuition, and birth.

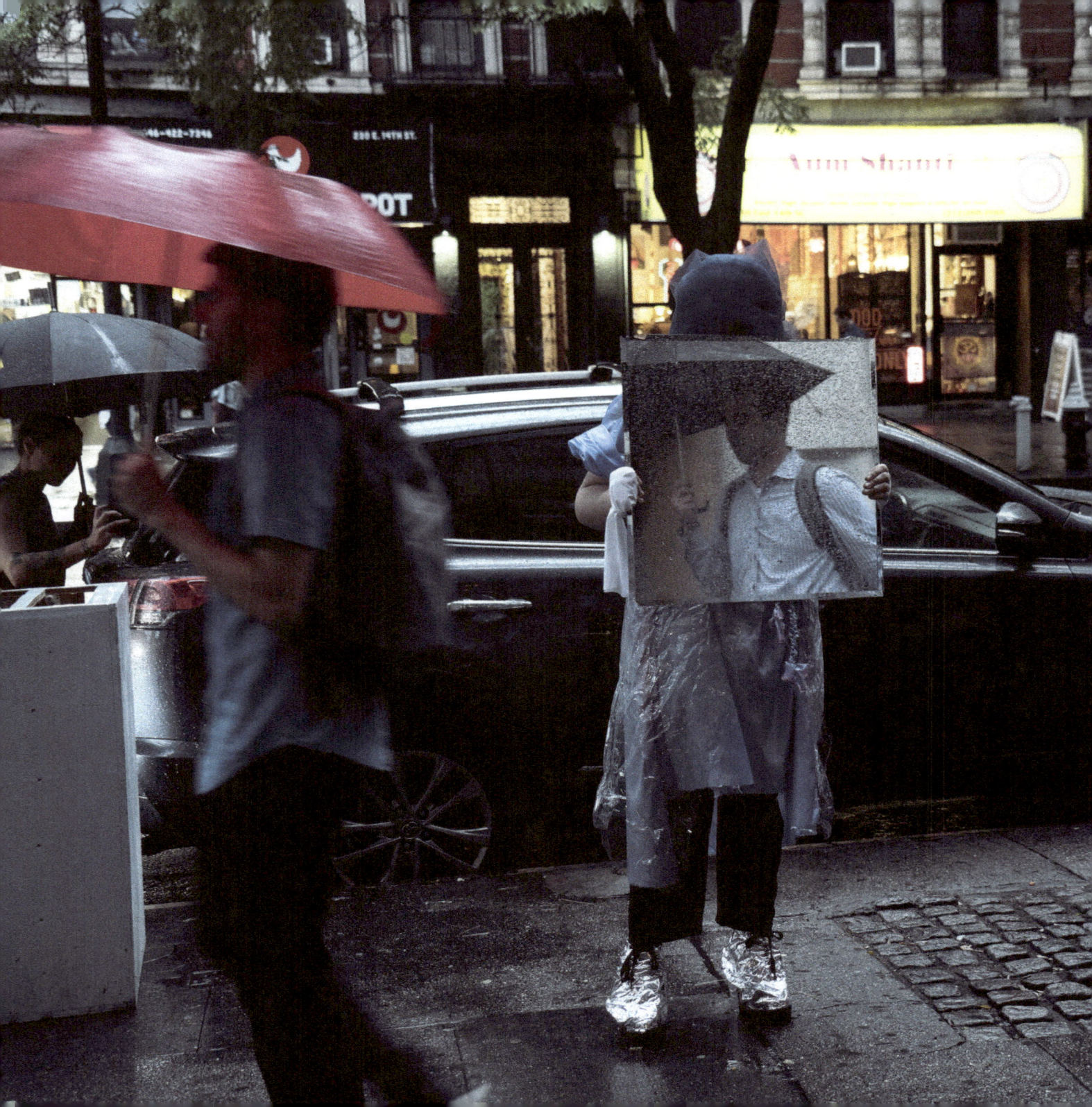

Sierra Ortega:
[you]phoria

This work invited an affective investigation of body and gender dysphoria by transforming perceived monstrosity into surreal beauty.

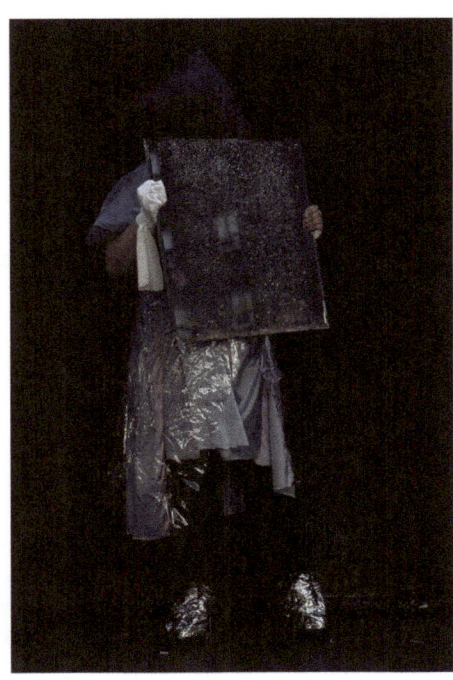

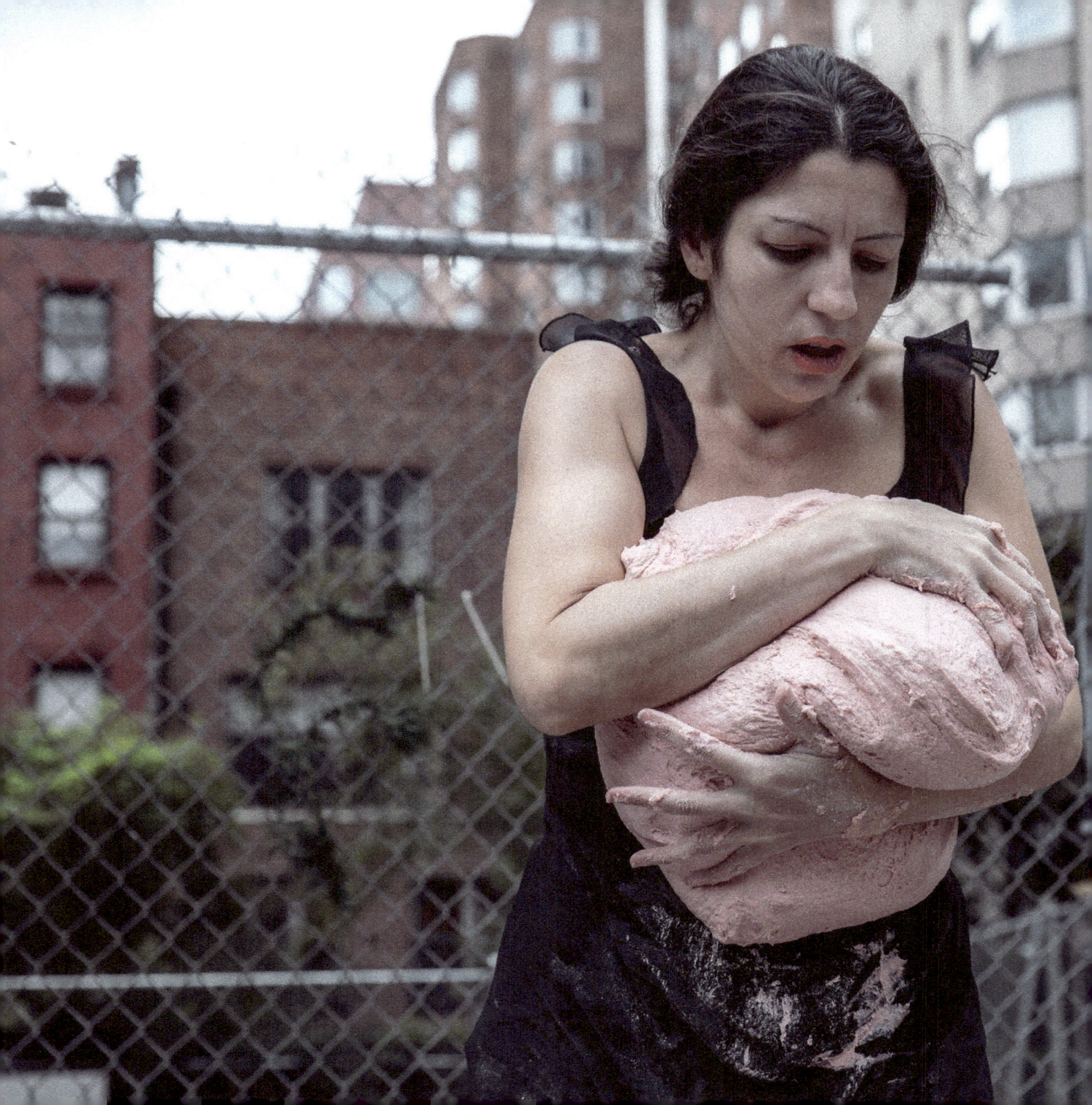

Verónica Peña:
A Matter Of...

This project proposed the use of a malleable "matter" to de-categorize the self, practice liberation in the public space, and promote empathy.

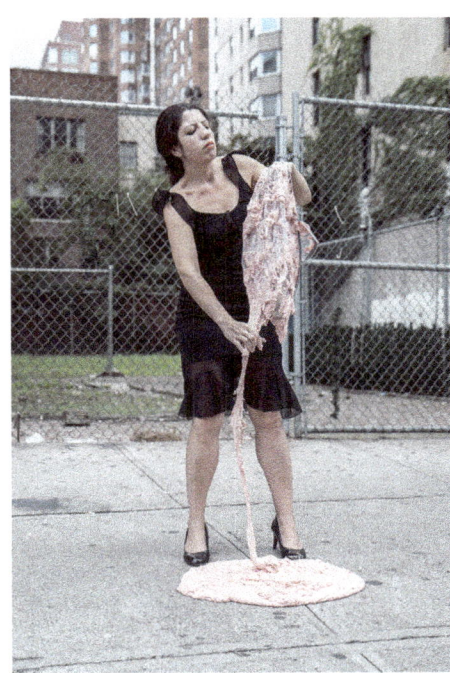

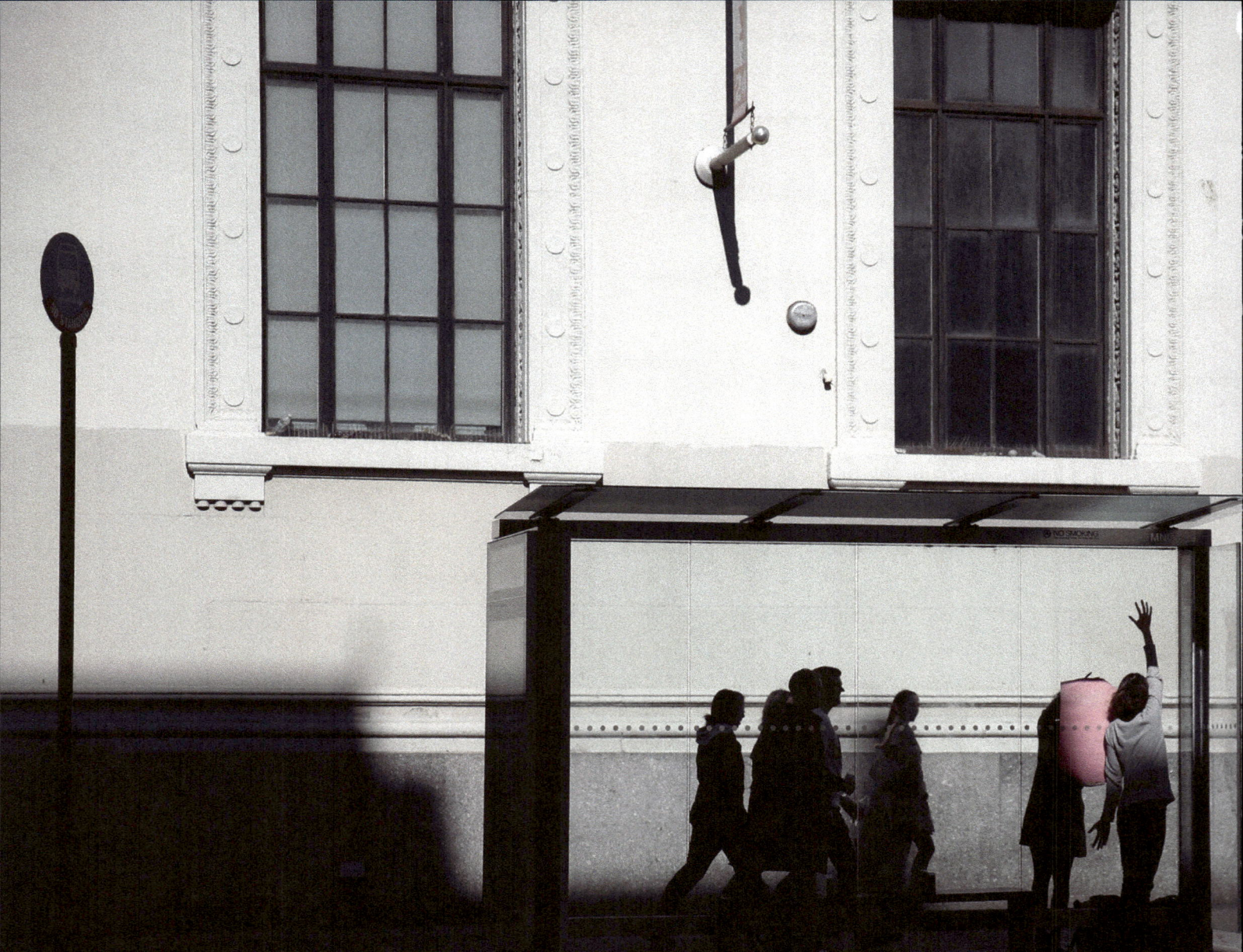

Maya Pindyck
re/touch

This project reactivated Bruce Nauman's *Body Pressure* (1974) on a bus stop wall in an attempt to repair the isolating impacts of capitalism on NYC's body.

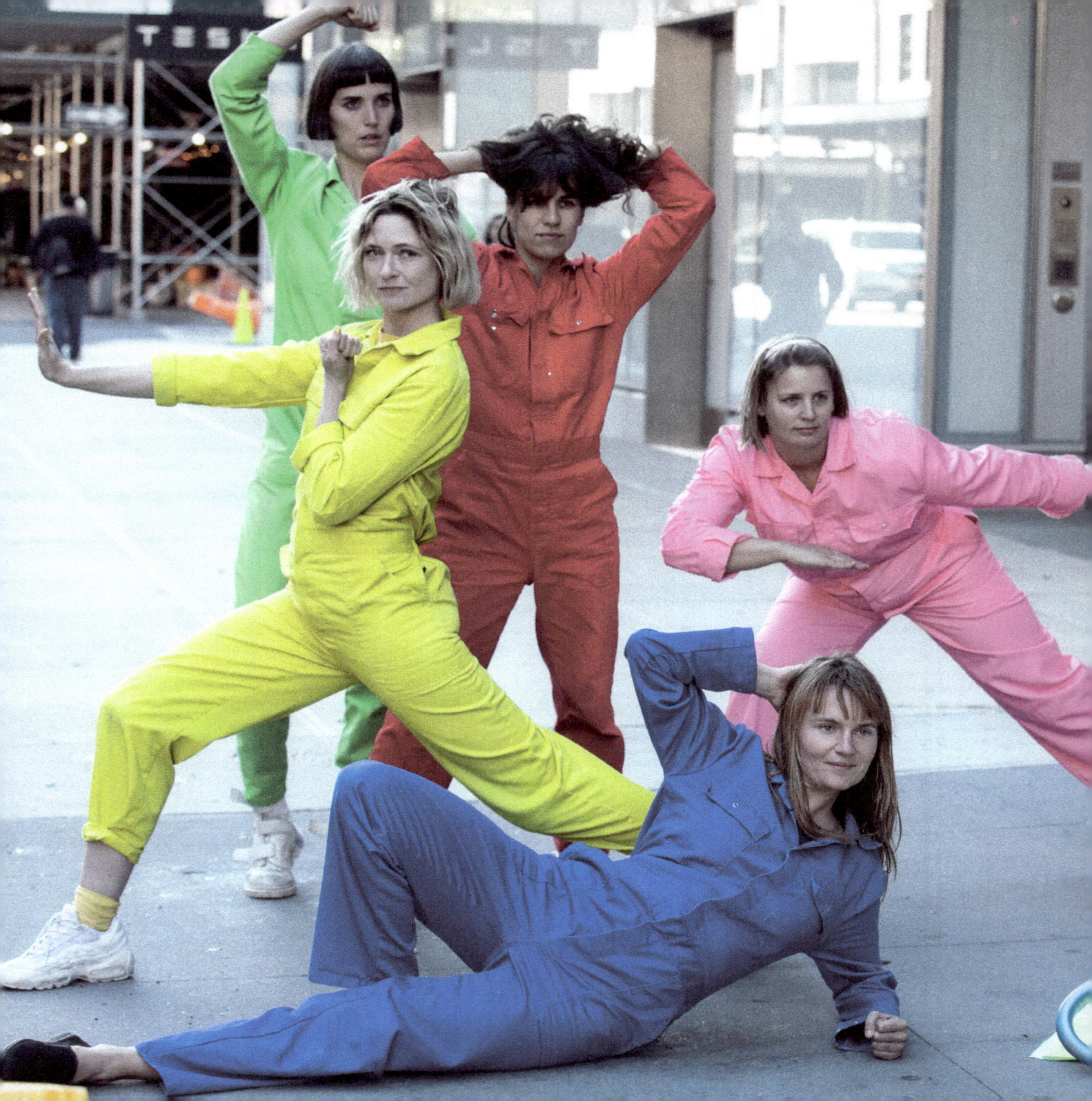

Questions Collective:
Foundation

In a series of actions on 14th Street, the collective explored the cosmetic role of the artist in gentrification by performing cosmetic enhancements on the street.

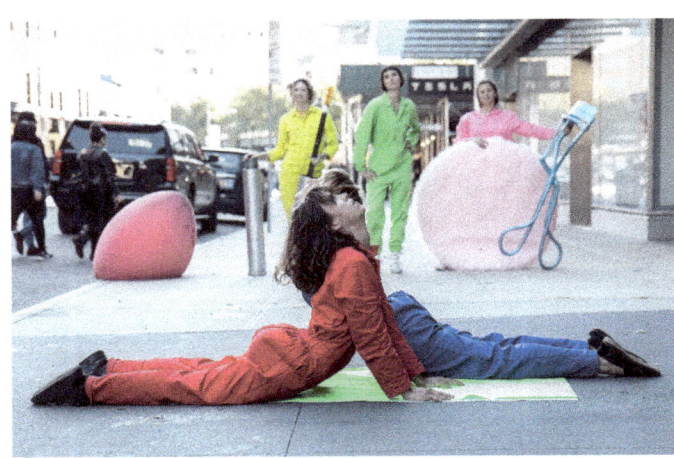

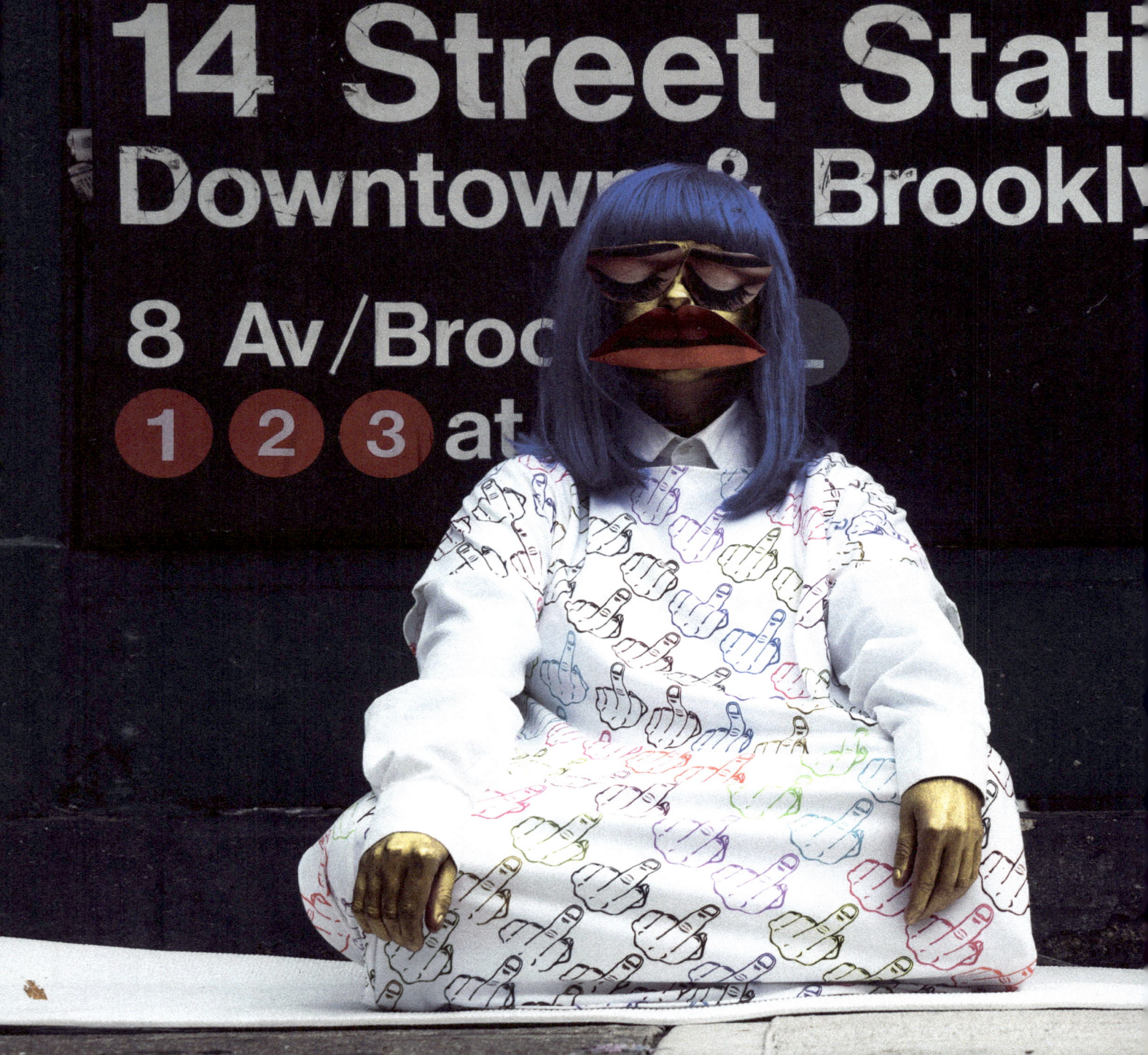

Yali Romagoza:
Meditating My Way Out of Capitalism and Communism: 12410 Days of Isolation

This work was performed to approach trauma and displacement.

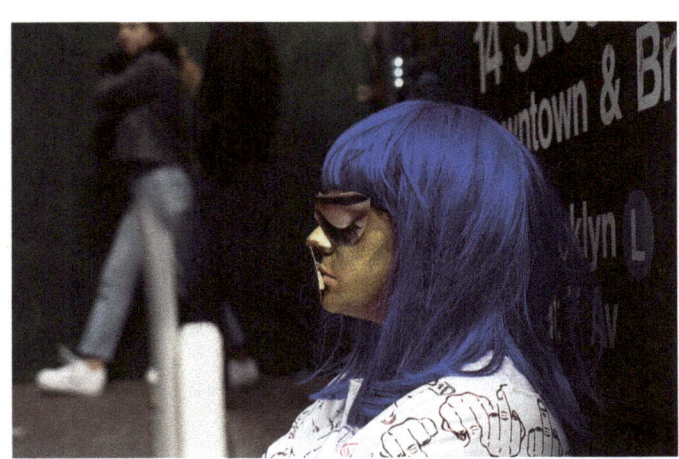

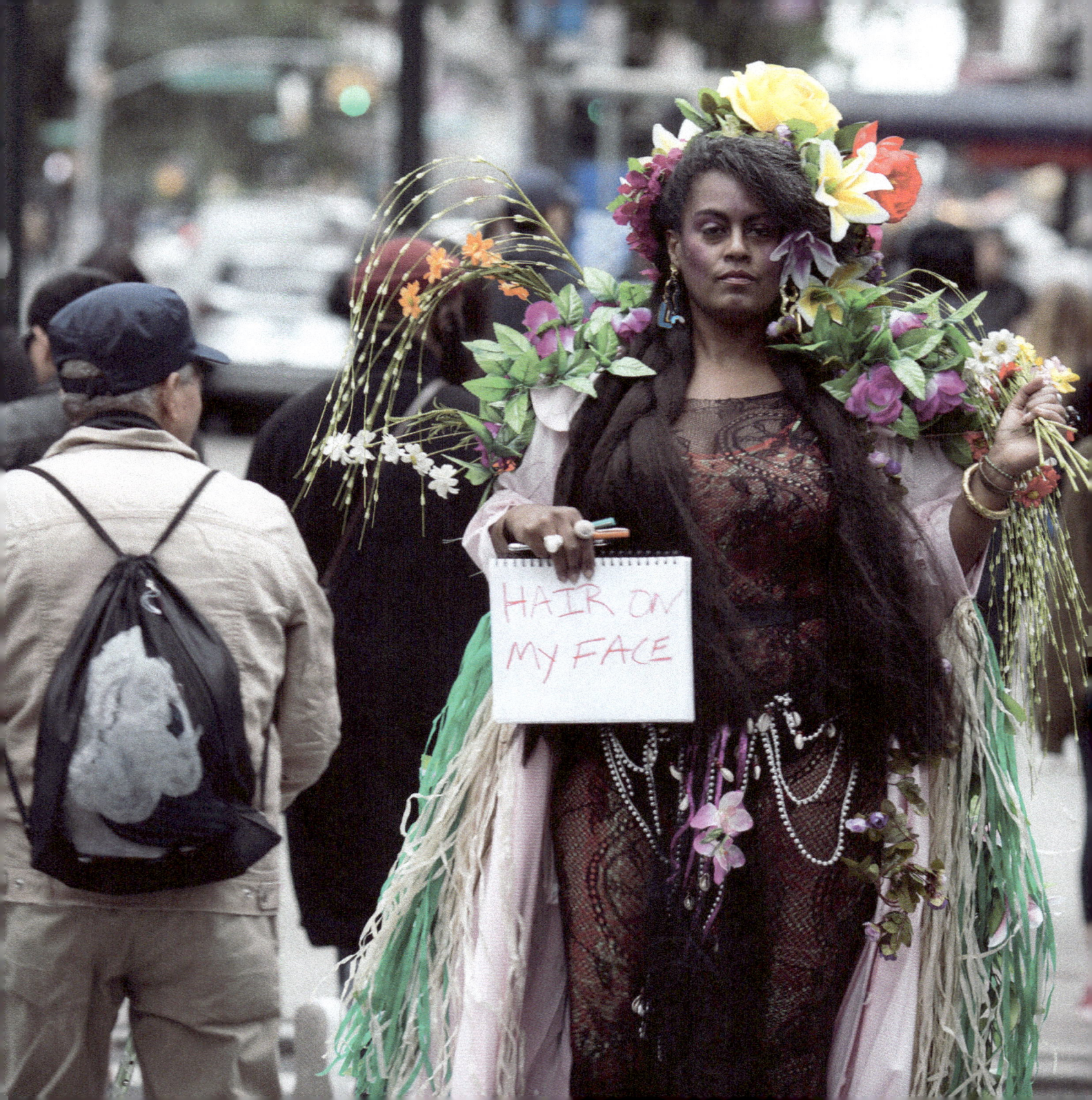

Clarivel Ruiz:
Synophrys and Other Hairy Things

This project allowed for the affirmation of a woman's body as hers and hers alone to say what is beautiful.

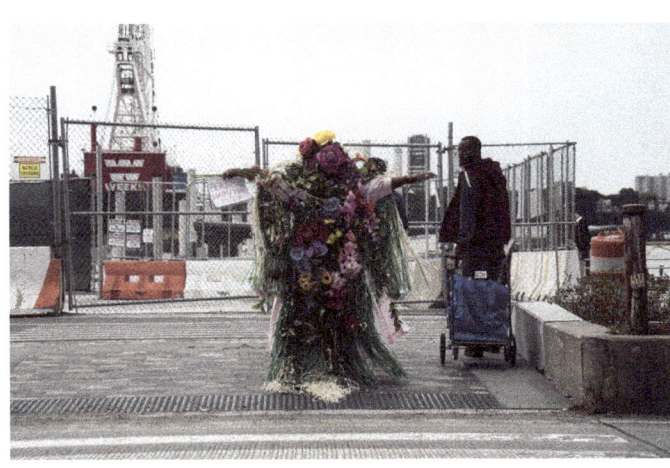

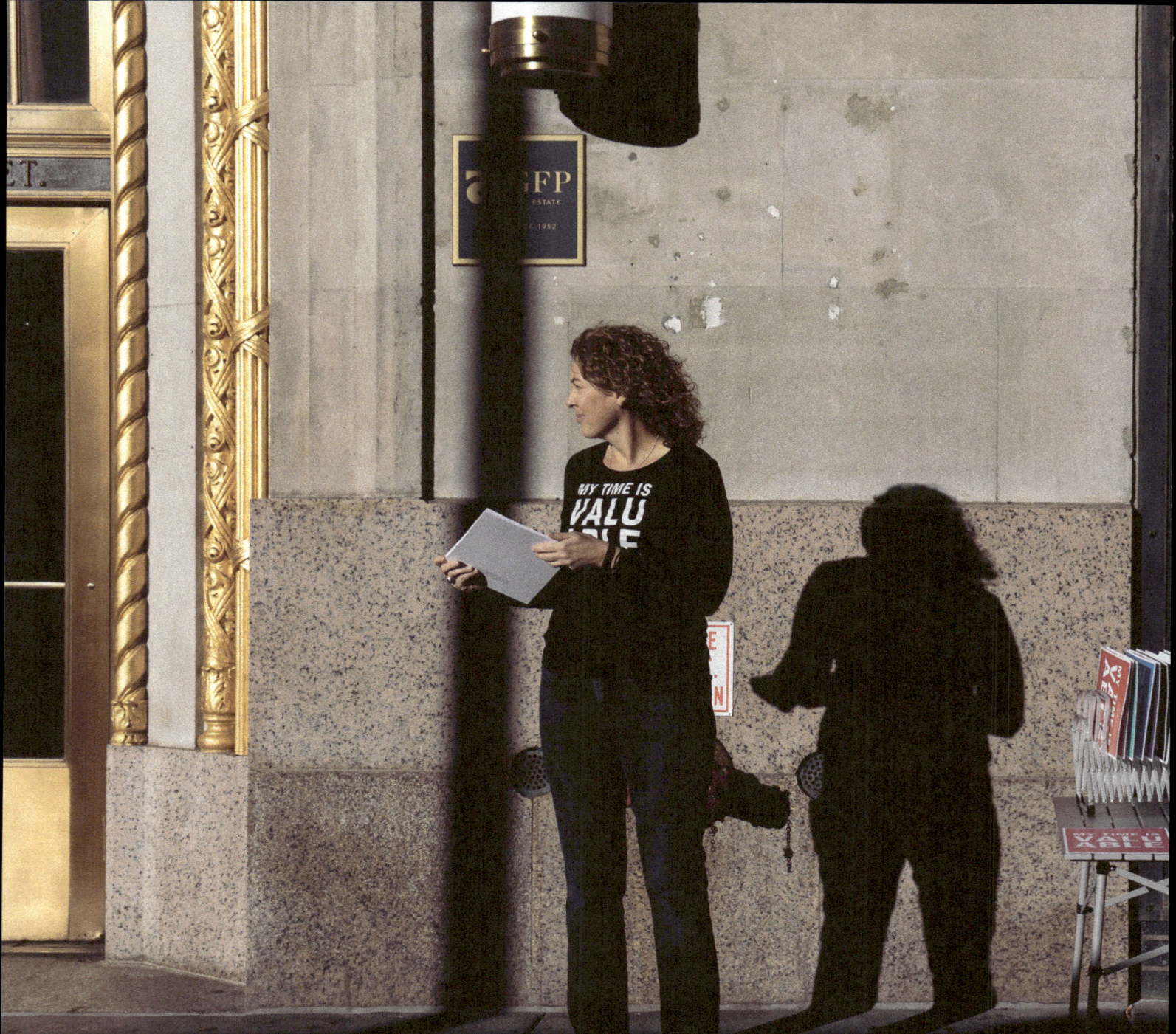

Jody Servon:
My Time is Valuable

This participatory project for women, girls, non-binary and female identifying people made visible the value of their time.

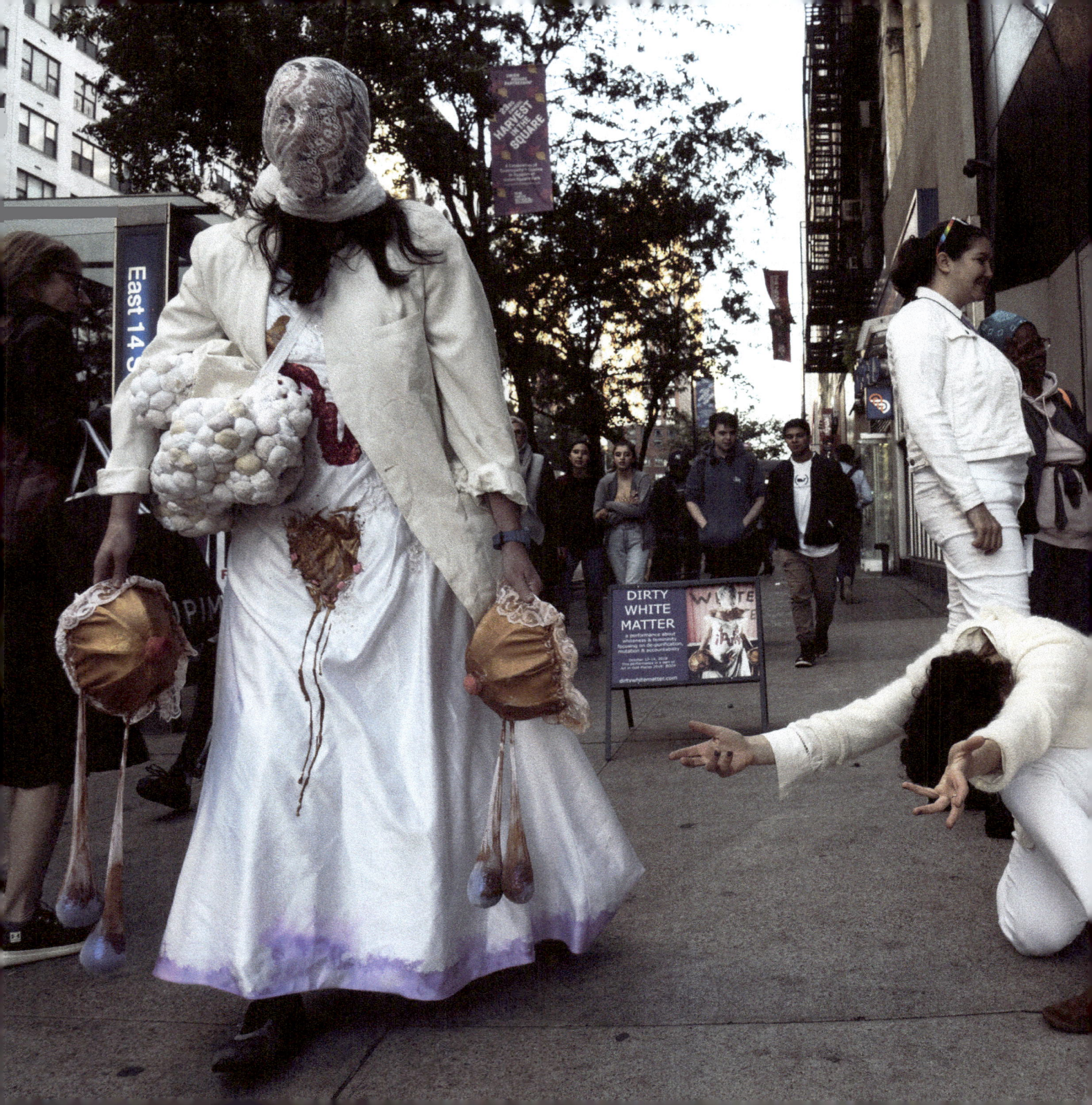

Meg Stein:
Dirty White Matter

This interactive project explored and mutated cultural ideas of whiteness and femininity using sculpture, performance and group discussion.

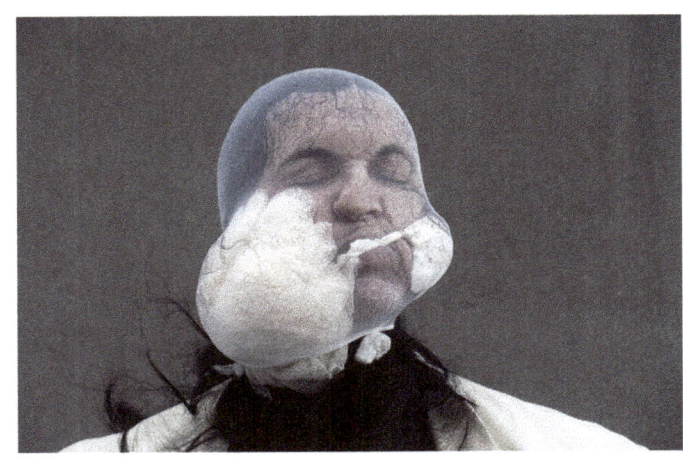

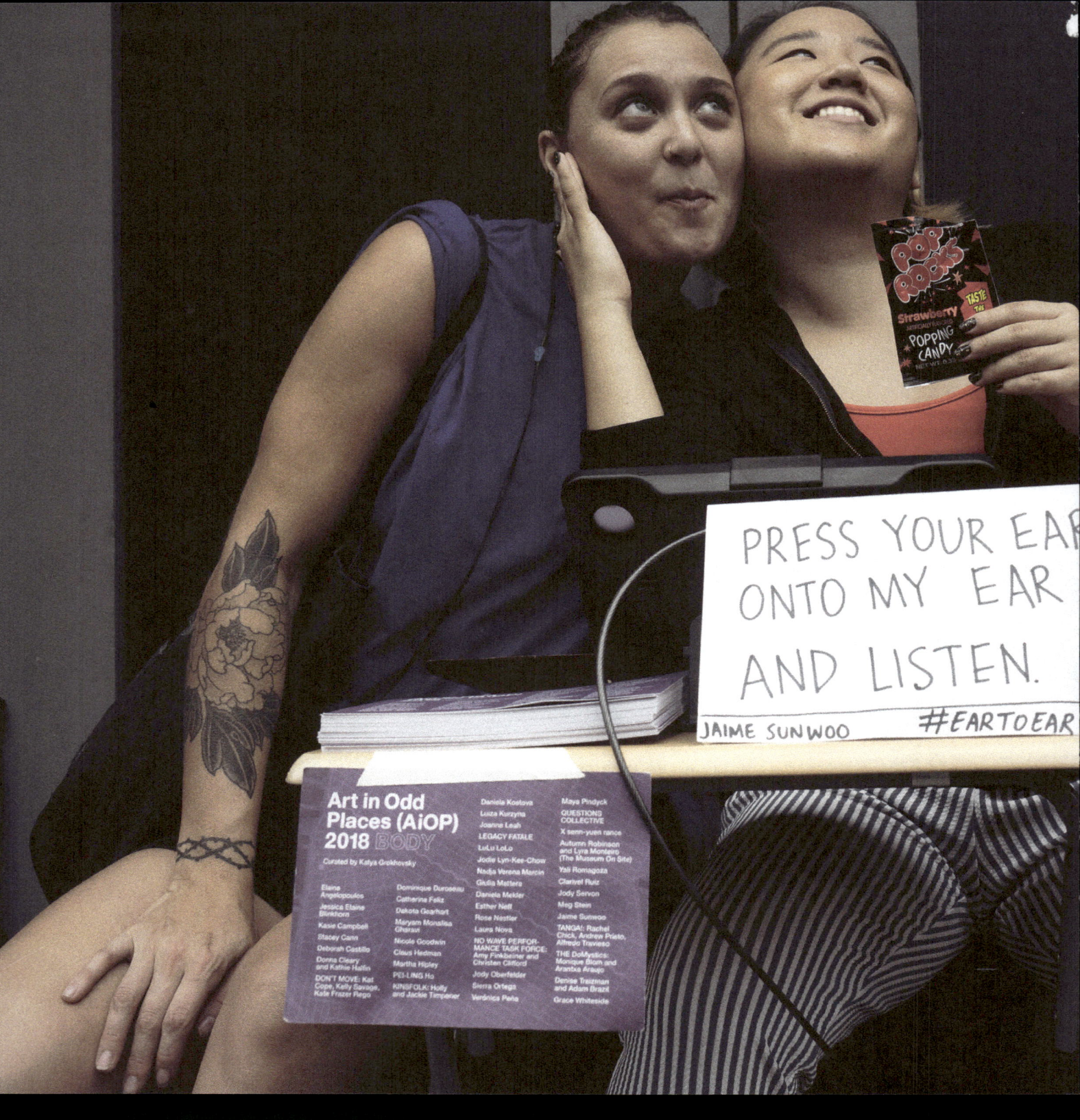

Jaime Sunwoo:
Ear to Ear

This participatory project invited people to touch ear to ear while eating – to experience textures aurally and orally.

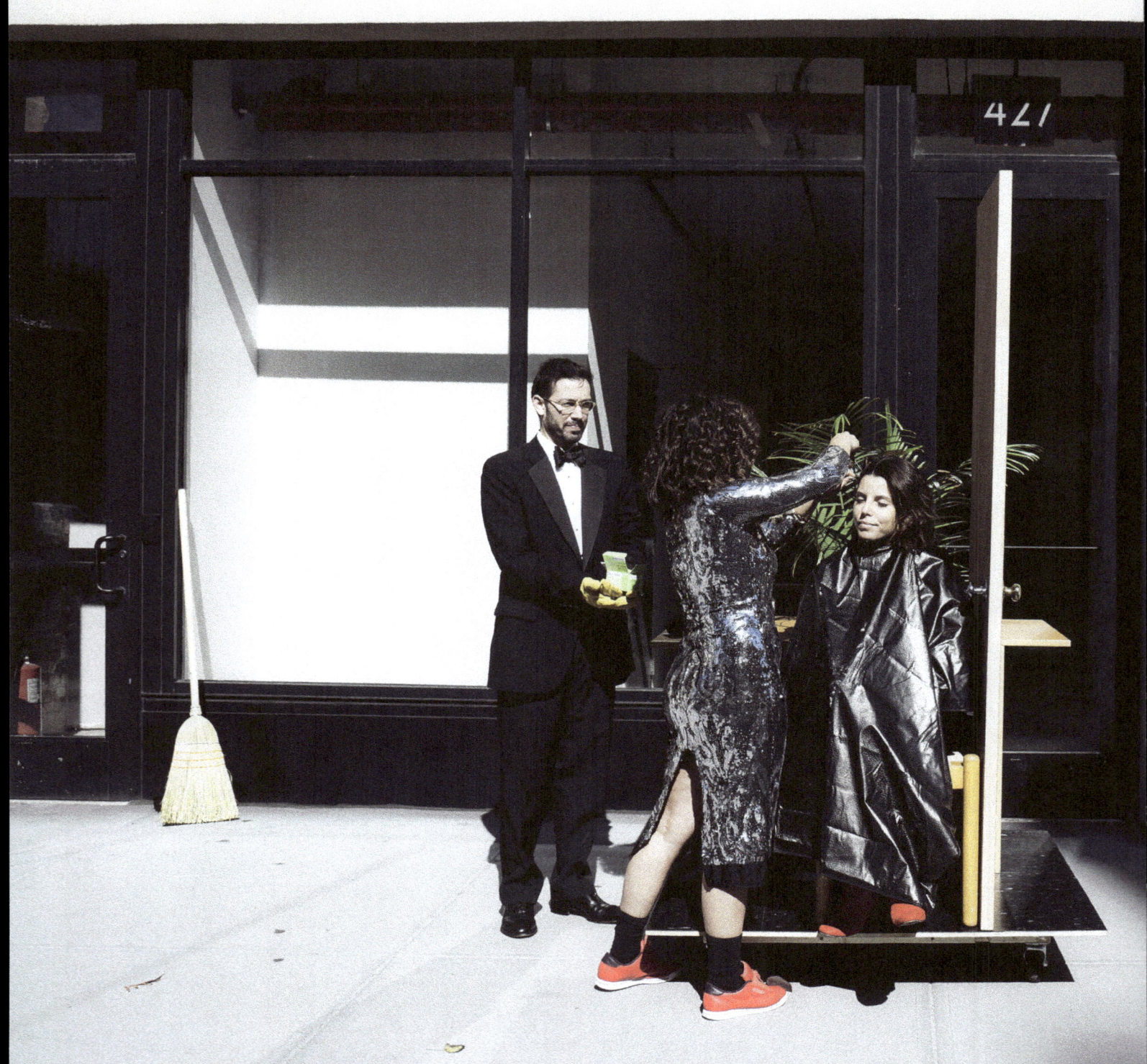

TANGA!: Rachel Chick, Andrew Prieto & Alfredo Travieso:
HERness

This project took all ephemera from their performance/public styling sessions to the gallery to be arranged in a contained installation.

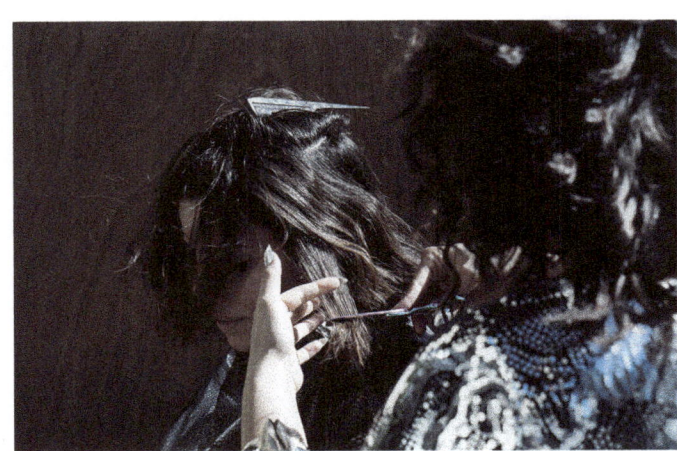

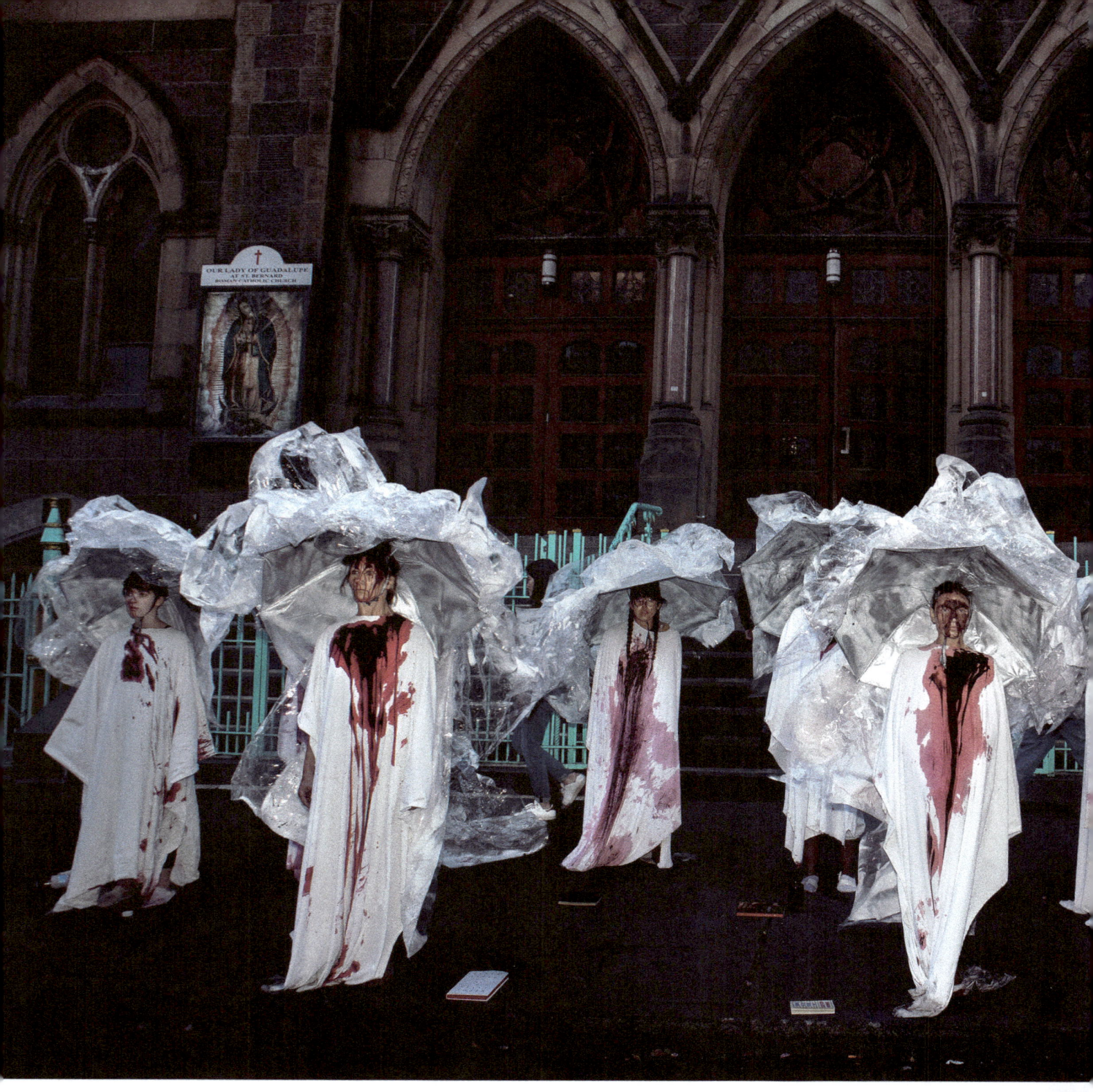

The Do-Mystics: Arantxa Araujo & Monique Blom
(Un)folding

This collaborative performance reflected the notions of femininity, (in)visibility, labor and the multiplicity of selves.

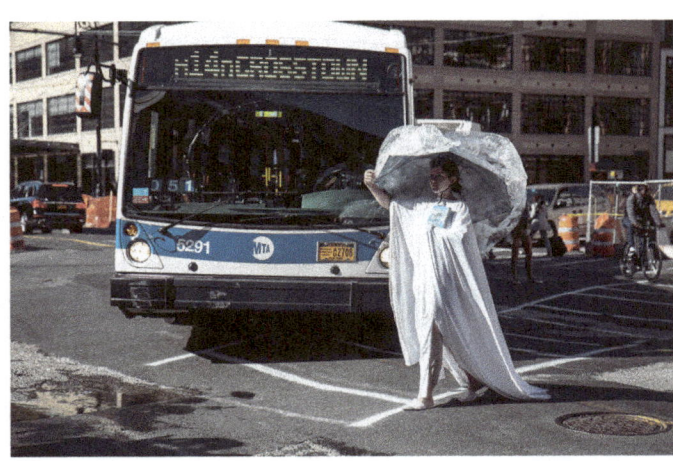

The Museum on Site:
Washington's Next!

This project was a reply to the President's post-Charlottesville tweet, "Robert E Lee, Stonewall Jackson - who's next, Washington, Jefferson? So foolish!"

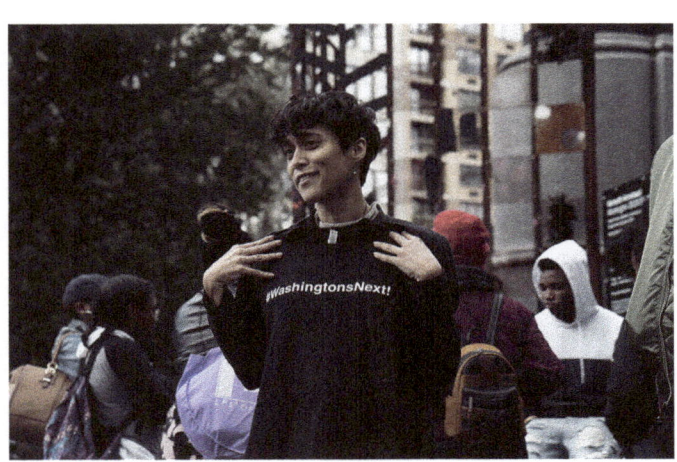

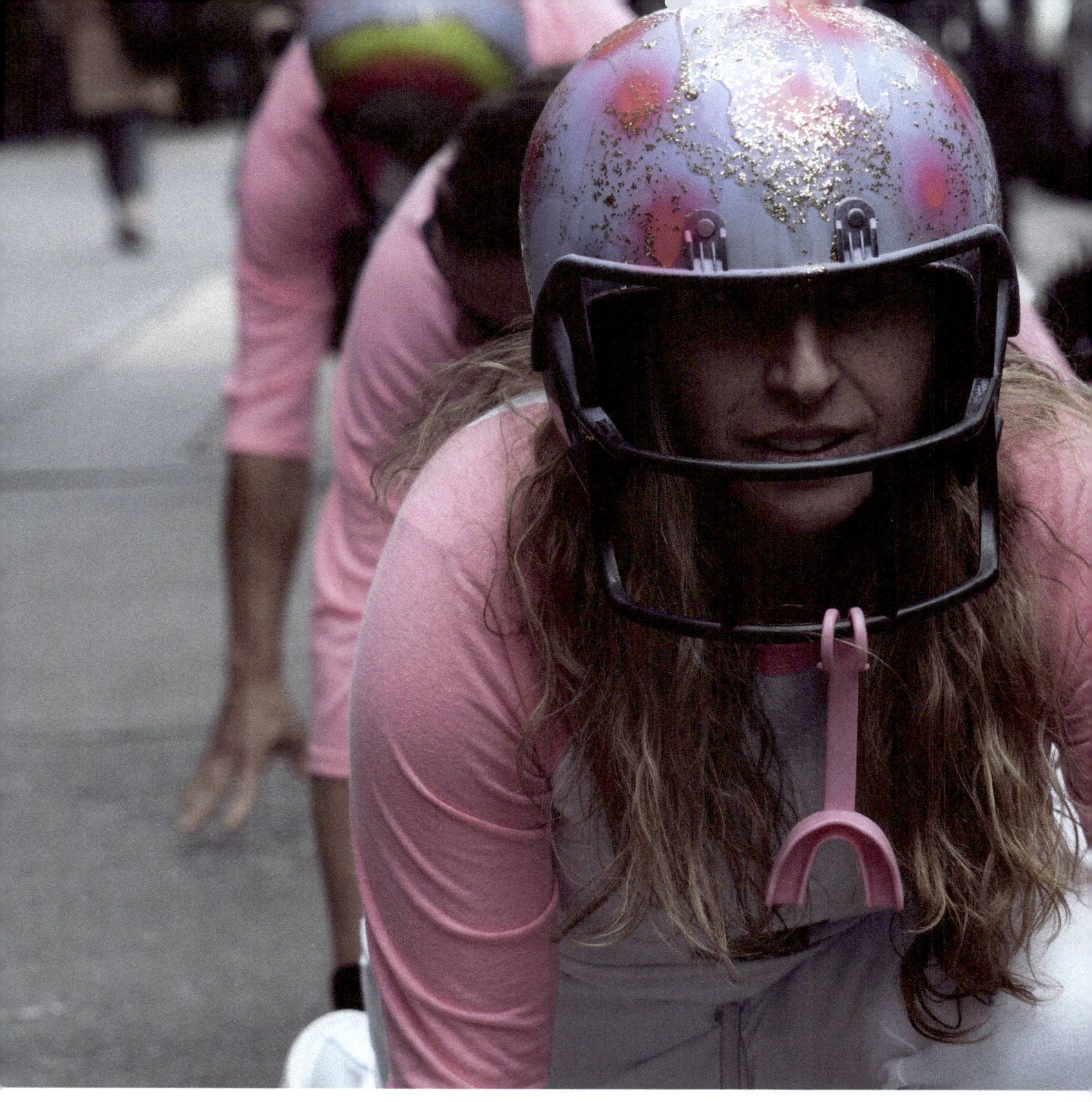

Denise Treizman and Adam Brazil
Off the Grid-iron

This project challenged the segregated practice of sport in America through ceramics, vibrancy, ritual and playful engagement with the public.

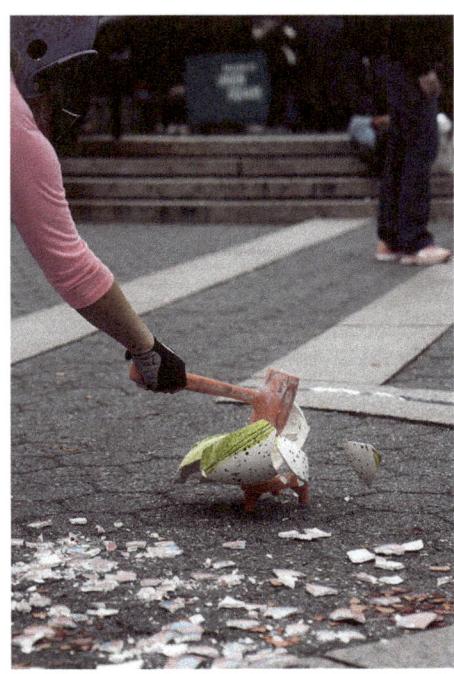

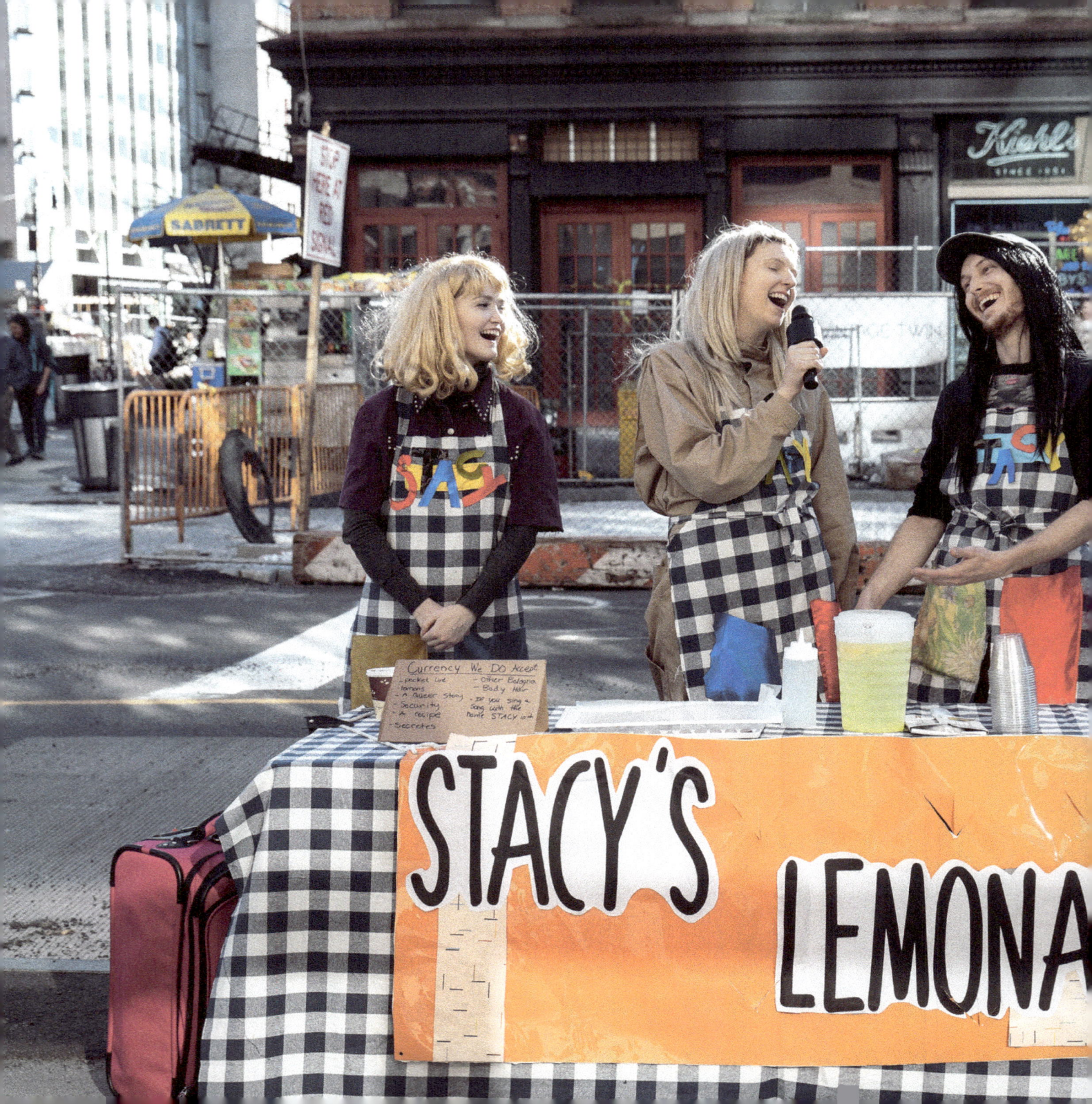

Grace Whiteside:
Stacy's Lemonade aka Dyke Water

This mobile body and mind rehydration station and absurd bake sale was staged by queers for queers in an attempt to defer from 14th Street's hyper-consumerist, heteronormative status quo.

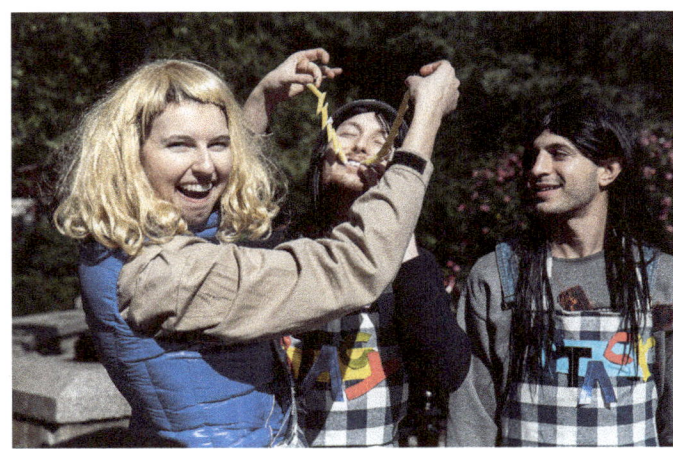

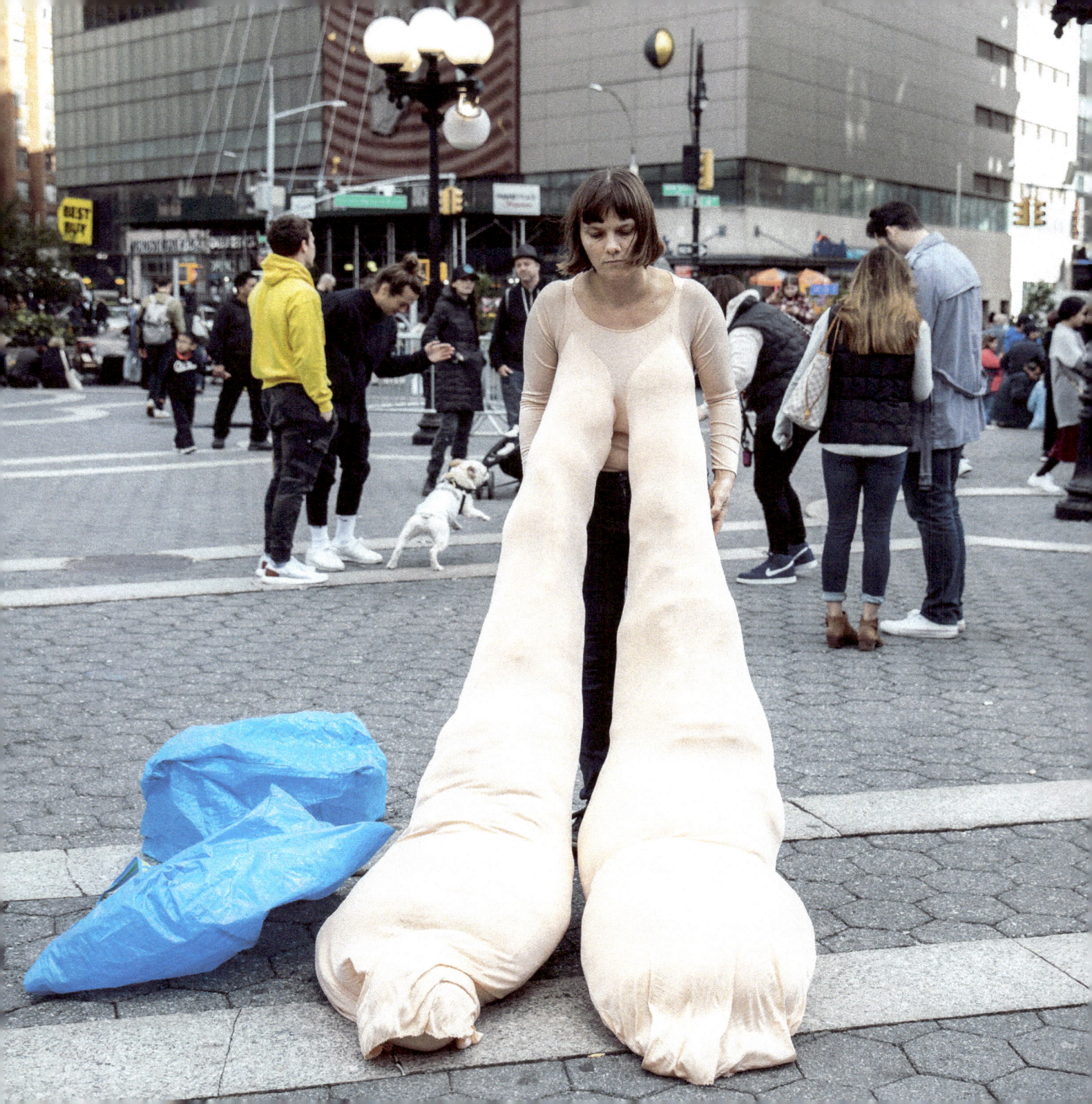

Artist Biographies

Elaine Angelopoulos lives and works in New York City. She is an artist with an interdisciplinary approach that bridges her studio practice with audience participation, with select installations and performances. Her work has been exhibited in New York, the United States, and in Europe. Angelopoulos received a Franklin Furnace Fund/Jerome Fellowship in 2014/15. Recently, her work was included in Aegean, a group exhibition, curated by Georgia Lale, at AAA3a Gallery in the Bronx, New York.

Jessica Elaine Blinkhorn is a visual artist and performance artist based out of Atlanta, GA. She is a full-time instructor in the Fine Arts for Georgia State University and Perimeter Colleges. She has performed throughout Atlanta, in Chicago's Rapid Pulse Performance Festival, and, most recently, the Inverse Performance Festival in Fayetteville, AR. Her work has been hailed "abrasively insightful," "an educational exploration," and "satirical sadism."

Kasie Campbell is a visual artist working in Edmonton AB. Through her work, Campbell aims to address the anxieties and vulnerabilities felt when she becomes the object of someone else's gaze, pushing and pulling the simultaneous attraction/repulsion paradox. Campbell has exhibited at Grounds for Sculpture in Hamilton NJ, Mana Contemporary in Chicago IL, Mana Contemporary in Jersey City, NJ and across Alberta, Canada in traditional and alternative gallery spaces.

Stacey Cann is an artist living in Edmonton, Alberta, Canada. She uses performance and installation as a way of exposing elements of her daily existence, and pushing these daily activities to the brink of absurdity.

Deborah Castillo is a Venezuela-born, New York based multidisciplinary artist. Her work has been exhibited at Museum of Arts and Design, NYC, Cornell University, NY, New Museum, NYC, Rufino Tamayo Museum, Mexico city, Escuela de Bellas Artes, Bolivian Biennial SIART, Bolivia, Caja Sol, Sevilla, UCLA, Los Angeles, ICA, London, UK, Smack Mellon, The Broad Museum and many others.

Donna Cleary and Kathy Halfin have both received MFA's in Fine Arts from the School of Visual Arts, have exhibited extensively in New York City including Freight and Volume, Petzel Gallery, A.I.R, Gallery, Bronx Museum, NARS Foundation. They have been reviewed in the New York Times, Medium, ArtFile, have attended residencies at MASS MoCA, Vermont Studios, Mildred's Lane, etc and won the Paula Rhodes Memorial Award for Master degree candidates, whose work is deemed exceptional by their chair and faculty.

Don't Move is a feminist artist collective formed in 2018. Kat Cope is a mixed media artist who lives and works in Brooklyn, NY. She received her BA from Mount Holyoke College and her MFA from UMass Dartmouth. Kelly Savage is a community based artist and social worker. She holds a BFA from Brooklyn College and a MSW from Hunter College. Kate Frazer Rego is a fiber artist living on the east coast. She received her BFA from UMass Dartmouth, and her MFA from Boston University.

Dominique Duroseau is an interdisciplinary artist who's practice explores themes of racism, socio-cultural issues, and existential dehumanization. Exhibitions, performances, and screenings include SATELLITE ART, PULSE Play in Miami; The Kitchen, Brooklyn Museum, El Museo del Barrio, Rush Arts Gallery, Smack Mellon in NY; Newark Museum, Index Arts, PES, Gallery Aferro in NJ. Recent talks and exhibitions include: panelist at Black Portraiture[s] at Harvard, lecture at Vassar and Solo at A.I.R Gallery.

Catherine Feliz is an interdisciplinary artist, full spectrum doula, and community medicine-maker born and raised in NYC (occupied Lenape territory) . Her multimedia projects are personal reflections on the social-political constructions of power and knowledge. Through applying the languages of visual desire and the practices of care, they're interested in imagining new narratives of place that center the experiences of politicized bodies.

Dakota Gearhart uses video, photography, and installation to examine the built environment and how it is perceived through technology and mythology. Her work has been shown at The Bronx Museum of Art, Tacoma Art Museum, Disjecta Contemporary Art Center, Henry Art Gallery, and Taiyuan Normal University. She has completed residencies with Queens Museum Studio Program, Residency Unlimited, NARS Foundation, the Wassiac Project, and The Bronx Museum AIM Program. She lives and works in Brooklyn, NY.

Maryam Monalisa Gharavi is an artist, poet, and theorist whose work explores the interplay between aesthetic and political valences in the public domain. Exhibitions and performance venues include Nottingham Contemporary, Pioneer Works, Serpentine Cinema, Framer Framed, Townhouse Gallery of Contemporary Art, Experimental Media and Performing Arts Center, Women and Performance, among others. Bio (Inventory Press, 2018) is her latest book publication.

Nicole Goodwin is a writer/poet/performer living and working in New York City. Her body performance project "Ain't I a Woman (?/!)" is a three year project discussing Black physical presence and movement in public/live spaces, as well as a radical push for Black body love and acceptance everywhere.

Claus Hedman's work accentuates viscerality and materialises interactions, emotions, and the subjective experience. She is born and raised in Sweden and is currently based in Amsterdam, where she continues her research and provocation of physical and conceptual discomfort.

Martha Hipley is an artist and programmer working in digital and paint, occasionally under the brand everyoneisugly. Her work explores identity formation through the lens of fandom culture and nascent sexuality. In addition to being awarded a Rhizome microgrant for her project "Untitled Twitter Hack," she is also the second best web surfer in the world.

Pei-Ling Ho (Taiwan) is an interdisciplinary artist. Through performance, video and mixed media, PEI-LING explores questions of gender identity, conflict between exotic and local culture and the legitimacy of parents under social system. She has had group exhibitions include ITINERANT: the annual Performance Art Festival in NY, SATELLITE ART SHOW in Miami, 29th Festival Les Instants Vidéo in France and more.

Kinsfolk examines themes of identity, agency + memory. As women we are placed in a box + our work is as a way to escape it. We explore issues of gender divides + expectations, + judgments placed on appearance. We explore our connection as sisters + women + investigate how our identity is shaped by each other, our history + DNA. The syntheses, separation + repetition of these themes drive us towards challenging society's views of the female experience + create new structures that exist fully within.

Daniela Kostova is an interdisciplinary artist who holds M.F.A. from Rensselear Polytechnic Institute, NY and the National Art Academy, Sofia. Her work is exhibited at venues such as Queens Museum of Art (NY), Kunsthalle Wien (Austria), Institute for Contemporary Art (Sofia), Centre d'art Contemporain (Geneva), Antakya Biennale (Turkey), Fondazione Sandretto Re Rebaudengo, (Torino), Kunsthalle Fridericianum (Kassel) and others. Kostova is Director of Curatorial Projects at Radiator Gallery.

Joanne Leah is an artist whose works explore themes of sexuality, isolation and identity. Her recent exhibitions include a solo booth at Scope Art Show in NYC, 'ACID MASS' at Not For Them Gallery in Long Island City, 'NSFW: Female Gaze' at the Museum of Sex, and a public mural project with Save Art Space in Hell's Kitchen. She founded the organization ArtistsAgainstCensorship.com, which is currently collecting resources and the stories of artists who have experienced social media censorship.

Luiza Kurzyna's solo projects include BRIC Garage Door Video Series and +/- Project Space at Soho Gallery. Her work has been exhibited at Kunstraum Gallery, Governor's Island Art Fair, Outlet and the New Britain Museum of American Art, among others. She has completed residencies at Ox-Bow, I-Park Foundation, Santa Fe Art Institute, ChaNorth and the Contemporary Arts Center. She is a recipient of the 2015 BRIC Media Fellowship and currently teaches at Parsons the New School for Design.

LuLu LoLo is an international performance artist/playwright/actor, a veteran of AIOP performing as "Mother Cabrini, Saint of the Immigrants" AIOP 2017: SENSE;"Joan of Arc of 14th Street: Where are the Women?": AIOP 2015: RECALL; "Loretta, the Telephone Operator," AIOP 2013:Number; "The Gentleman of 14th Street": AIOP 2011:RITUAL; and "14th Street NewsBoy": AIOP 2009:SIGN. LuLu was a 2013 Blade of Grass Fellow and a Lower Manhattan Cultural Council Writer in Residence (2008).

Legacy Fatale is a performance art project exploring concepts of territorialities, female empowerment and the politics of resistance. Directed by artist Coco Dolle since 2008, the group garners an international roster of dancers, artists, healers and creatives, integrating social practices with modern dance vocabulary. Legacy Fatale has performed at international venues including at The Queens Museum (NYC), Grace Exhibition Space (Brooklyn), Radical Wonder Women Festival (Manchester, UK).

Jodie Lyn-Kee-Chow (b. Manchester, Jamaica) is an interdisciplinary artist showing internationally with a BFA w/ honors from NWSA University of Florida, and a MFA from Hunter College, CUNY. Awards include Culture Push, Franklin Furnace, Rema Hort Mann (A.C.E), and N.Y.F.A. Lyn-Kee-Chow often explores performance and installation art, which draws from the nostalgia of her homeland, folklore, fantasy, consumerism, spirituality, and nature's ephemerality.

Nadja Verena Marcin is a German-born artist who lives and works in New York, USA and NRW, Germany. She graduated from the Visual Art Department of New Genre, School of the Arts at Columbia University, New York in 2010, after obtaining a Diploma of Fine Arts from the Department of New Media at Academy of Fine Arts Münster. Marcin's work has been presented extensively nationally and internationally.

Daniela Mekler is a Colombian/Costa Rican visual artist and educator. She recently completed her graduate studies at the Steinhardt School of Education, Culture and Human Development at New York University. She is committed to exploring the connection between contemporary art, critical education, and community based collaboration and the role that they play in social reform.

Esther Neff is the founder of PPL (Panoply Performance Laboratory). Working through organizational, discursive, relational and social processes, Neff's performance work has been materialized through forms of opera, thinktank, installation, and public gathering. She lives and works at the PPL lab site in Brooklyn.

Rose Nestler is an interdisciplinary artist focusing in sculpture and video. She received her MFA degree from Brooklyn College in 2017. Her work has been exhibited at galleries including, Underdonk, Smack Mellon, CRUSH Curatorial, CUCHIFRITOS, L.O.G. in Chapel Hill, NC and Beverly's Pop-Up at Good Weather Gallery in Little Rock, AK. In January 2018 she had her first solo show at Ortega y Gasset Projects in Brooklyn, NY. This summer she was a Fellow at Lighthouse Works on Fishers Island, NY.

Laura Nova is an artist, athlete and educator who makes work that is action-oriented and site-specific, encouraging both activist and active audience participation. Her work takes the form of websites, workshops, photos, videos, installations and performances that often involve cardio, comedy and cooking to connect audiences and invite people into these experiences.

Christen Clifford is a performance artist, writer, professor, mother, and core member of No Wave Performance Task Force. Recent work includes Interiors: We Are All Pink Inside. Clifford curates Experiments and Disorders at Dixon Place. Amy Finkbeiner's multidisciplinary works explore sexuality, religion, and identity. She recently performed in ITINERANT Performance Art Festival. Finkbeiner received a MFA from the School of Visual Arts and attended Skowhegan School of Painting and Sculpture.

Jody Oberfelder Projects create art that connects to and illuminates everyday life. Whether on a proscenium stage, in a film, or installation, the work transforms an audience's experience from passive voyeurism into intimate engagement. Since 2013, her immersive work has focused on the body: 4Chambers (2013-14) toured the heart, followed by The Brain Piece (2015-2018). Madame Ovary is the third in this trilogy. Research from AIOP will culminate in performances May 15-19 at the Flea Theater.

Sierra Ortega is a multidisciplinary performance artist based in Queens, NY. They received an MA in performance studies from NYU in 2016 and an MA in rhetoric from Hofstra U. in 2015. Using materially disruptive practices generated from their own affective life as an anxious bipolar, their work investigates notions of queerness, alienation, and alterity in the search for meta-utopian post-capitalist futures. They are currently a TMT Institute Fellow and the Target Margin Theatre in Brooklyn, NY.

Verónica Peña is an interdisciplinary artist from Spain based in the United States. Her work explores the themes of absence, separation, and the search for harmony through Performance Art. Peña is interested in migration policies, cross-cultural dialogue, and women's empowerment. Her work has been featured at Times Square, Armory Show, Hemispheric Institute, Queens Museum, Smack Mellon, and Triskelion Arts, amongst others. She is a recipient of the FRANKLIN FURNACE FUND 2017-18.

Maya Pindyck works in multiple disciplines and examines intimate intersections of memory, movement, and language. She is the author of the poetry collections Emoticoncert (Four Way Books, 2016), Friend Among Stones (New Rivers Press, 2009), and a chapbook, Locket, Master (Poetry Society of America, 2006). Her work has been exhibited in various public places, galleries, and pop-up spaces. Raised in Massachusetts and Tel Aviv, she lives in Brooklyn, NY.

Questions Collective is an all female collective based in Amsterdam with complementary skills. Creating epic dream realities with theater, dance, music and design. They zoom in on an existing structures in order to distill and enlarge them. All their work is site specific, colourful, surreal and playful. They deconstruct reality in order to create something new and experience the world around us differently. Questions Collective recreates reality brick by brick.

Yali Romagoza is a Cuban-born artist based in NYC. She holds an MFA in Fashion from the School of the Art Institute of Chicago and a BA in Art History from the University of Havana. Her works have been included at Gothenburg Biennial, Havana Biennial, Liverpool Biennial, Links Hall Theater, White Box, Teatro LATEA, The Border. Romagoza has been granted awards and residencies such as Cátedra Arte de Conducta, Bétonsalon Centred'art et de recherché, NYFA Immigrant Artist Mentoring Program.

Clarrivel Ruiz is a daughter of the land called Kiskeya Ayiti Bohio (aka Hispaniola aka Dominican Republic and Haiti), a land colonized but never conquered , raised in New York City on the ancestral bones and covered shrines of the Lenape people. My artist practice delves into understanding the historical myths that have been created to subvert and oppress people of color and to heal wounds created by racial divides. Merging various arts forms to unravel the destruction created by colonialism.

Jody Servon creates collaborative and socially engaged projects that encourage public interaction and personal exploration. She invites people to reveal who they are and how they've lived, and, for others who witness these stories to discern our similarities and what makes us unique. Her projects have been included in publications, exhibitions, and as public works in the US, Canada, and China. Servon is a professor at Appalachian State University in North Carolina.

Meg Stein is based in Durham, NC, and has exhibited at Victori + Mo, A.I.R. Gallery, Vox Populi, GIAF, Greenhill Gallery, the Neon Heater, and the Spartanburg Museum of Art. She's been in residence at Yaddo, Hambidge, Haystack, PLAYA, the Atlantic Center for the Arts, and the Virginia Center for the Creative Arts. She was awarded the Garland Fellowship, the Ella Pratt Emerging Artist Grant, and most recently, was selected as the NC Fellow for South Arts and the NC nominee for the Southern Prize.

Jaime Sunwoo is a Korean-American multidisciplinary artist from Brooklyn, New York. She combines video, audio, sculpture, and storytelling to create sensory performances in galleries, theaters, and public spaces. Her works are part playful, part tragic, and often examine food as a way to discuss identity, history, and death. Her projects have been featured at The Laundromat Project, STooPS, DUMBO Arts Festival, and FailSafe.

TANGA! is a collective of three artists whose work overlaps at themes such as the politics of domesticity, 21st century identity, and the current ubiquity of performance in everyday life. The group began working together as graduate students in the School of Visual Arts, Art Practice program.

The Do-Mystics is a feminist collective created by Arantxa Araujo and Monique Blom based in NYC, Mexico City and Saskatoon. Their work incorporates the use of new media, performance and socially engaged art. The collective explores themes through ritual processes of identity, gender, immigration and domesticity.

The Museum On Site (TMOS) is a project directed by Dr. Lyra Monteiro, who teaches History and American Studies at Rutgers University-Newark. TMOS creates site-specific, free public experiences that combine arts and humanities research in work that is accessible, engaging, and offers a new angle for understanding contemporary social issues.

Denise Treizman is an artist from Chile based in New York City with an MFA from the School of Visual Arts. Her work has been exhibited in several cities including Santiago, Buenos Aires, Shanghai, San Francisco, Chicago, Miami and New York. ADAM BRAZIL is an interdisciplinary artist and professor at Syracuse University. He is currently preparing works for his first solo exhibition in NYC at MEN gallery in the Lower East Side.

Grace Whiteside is a performer, glassblower and visual artist based in Brooklyn, NY. She received two BFA's in 2017 from Virginia Commonwealth University in sculpture and glassblowing. Her work has been showcased in multiple cities including, Richmond, VA, Brooklyn, NY and Florence, Italy. Recently, she performed her play "Stacy Makes a Cake" at Recess in which she wrote, directed and starred in. Grace often performs under an alter ego that goes by the name Stacy Wallman who has become a surrogate for her own body and experiences. Together, Gracie and Stacy question their orientation to self-love, queerness and otherness.

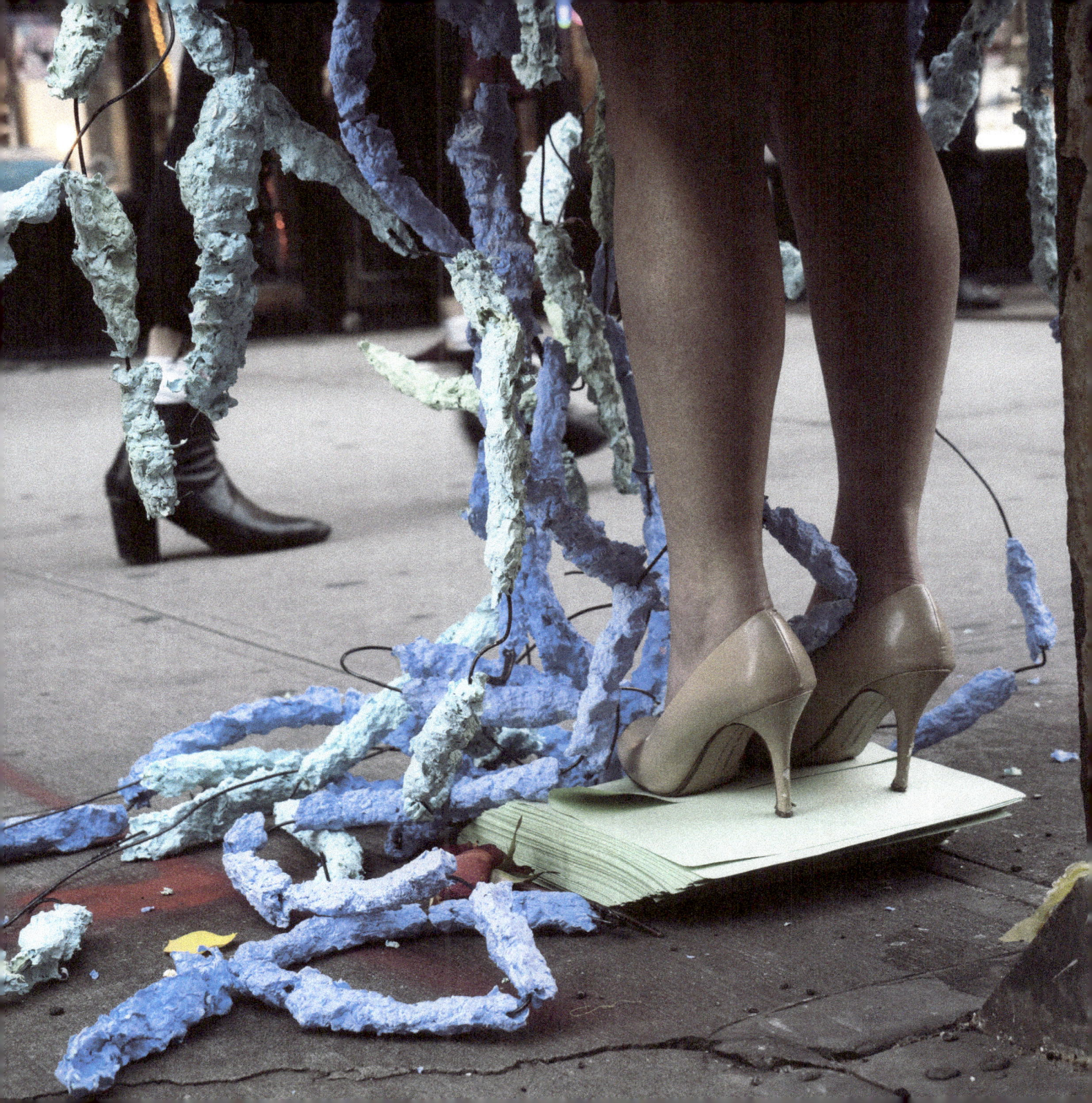

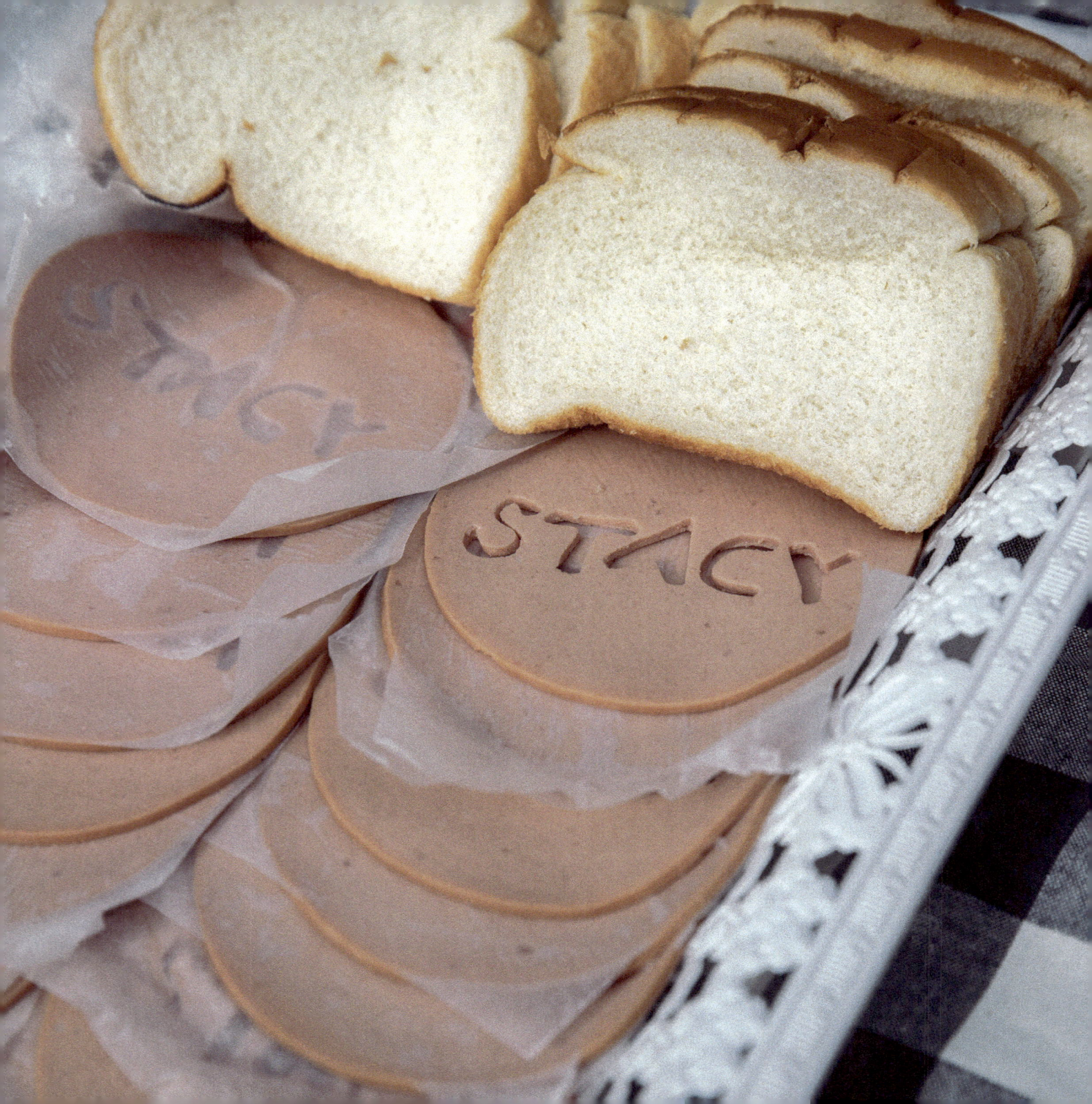

Contributor Biographies

Ed Woodham has been active in community art, education, and civic interventions across media and culture for over thirty-five years. A visual and performance artist, curator, and educator, Woodham employs humor, irony, subtle detournement, and a striking visual style in order to encourage greater consideration of – and provoke deeper critical engagement with – the urban environment. Woodham created *Art in Odd Places (AiOP)* to present visual and performance art to reclaim public spaces in New York City and beyond. *Art in Odd Places* has been produced in Los Angeles CA, Boston MA, Indianapolis IN, Greensboro NC, and Orlando, FL in the U.S.; Saint Petersburg, Russia, and Sydney, Australia. AiOP was selected as a representative in the U.S. Pavilion, *Spontaneous Interventions: Design Actions for the Common Good* at the Venice Architecture Biennale in 2012. Woodham teaches workshops in politically based public performances at NYU Hemispheric Institute for *EmergeNYC* and at School of Visual Arts for *City as Site: Performance and Social Intervention*. In 2017-18, he was an artist-in-residence at the Department of Art, University of Virginia in Charlottesville. In 2018, he performed an iteration of *The Keepers* at the Siren Festival's *Turning the Tide* commissioned by Transformer in Washington, DC.

Katya Grokhovsky is an artist, independent curator, educator and a Founding Artistic Director of *The Immigrant Artist Biennial* (*TIAB*) and *Feminist Urgent* (*FU*). Grokhovsky holds an MFA from the School of the Art Institute of Chicago, a BFA from Victorian College of the Arts, Melbourne University, Australia and a BA (Honors) in Fashion from Royal Melbourne Institute of Technology, Australia. Grokhovsky has received support through numerous residencies and fellowships including Art and Law Fellowship, NYC, The Museum of Arts and Design (MAD) Studios Program Residency, NYC, Wythe Hotel Residency, NYC, BRICworkspace Residency, NYC, Ox-BOW School of Art Residency, MI, Wassaic Artist Residency, NY, Atlantic Center for the Arts, FL, Studios at MASS MoCA, MA, SOHO20 Gallery Residency, NYC, BRIC Media Arts Fellowship, NYC, VOX Populi AUX Curatorial Fellowship, PA, NARS (New York Residency and Studio Foundation), NYC, Santa Fe Art Institute Residency, NM, Watermill Center Residency, NY and more. She has been awarded the Brooklyn Art Council Grant, NYC, NYFA Fiscal Sponsorship, ArtSlant 2017 Prize, NYC, Asylum Arts Grant, NYC, Dame Joan Sutherland Fund, NYC, Australia Council for the Arts ArtStart Grant, NYFA Mentoring Program for Immigrant Artists, NYC and others. In 2018, Grokhovsky was the lead curator of *Art in Odd Places* Public Art Festival 2018 and accompanying Exhibition at Westbeth Gallery, NYC. She has also curated exhibitions and performances at Lesley Heller Workspace, NYC, Parasol Projects, NYC, Kunstraum, Brooklyn, NY, Grace Exhibition space, Brooklyn, NY, Art Mora, NYC, L.I.C Arts, Queens, NY, VOX Populi, Philadelphia and others. Her artistic work has been exhibited extensively.

Stacy's Lemonade aka Dyke Water, Grace Whiteside, 2018

Katie Hector is an artist living and working in New York City. While maintaining a disciplined painting practice Hector is also an independent curator, writer, as well as the Founder and Co-director of Sine Gallery. She has worked to organize and fundraise a variety of projects include an international exhibition in 2017, multiple collaborative and environmental installations, and over two dozen group shows, screenings, pop up events, and panel discussions. She received her BFA from the Mason Gross School of the Arts at Rutgers University. Since then Hector was invited back to Mason Gross annually to lecture on the topic of professional development in the arts. Hector's work as an artist has gained her recognition through scholarships, residencies, and awards some of which include the 2017 Picture Berlin International Residency, the 2016 Merit-Based Scholarship from Urban Glass, the 2014 Scott Cagenello Memorial-Prize, and the 2013 Ruth Crockett Award.

Quinn Dukes is a multimedia performance artist and curator based in Brooklyn, NY. She has performed in galleries and festivals across the United States including Fountain Art Fair (Miami and NYC), Lumen International Video & Performance Festival, Wassaic Festival, Grace Exhibition Space (Brooklyn, NY), Local Project (Queens, NY) and Gallery Sensei (NYC). Dukes has received reviews in *Flash Art*, *NY Arts Magazine* and *WhiteWall Magazine* and written for blogs: *Art in New York City* and *Art in Brooklyn*. In 2014, Dukes created Performance is Alive, an online platform featuring current performance art practitioners from across the globe. She is an active advocate for higher education, human equality, environmental sustainability and preservation.

Nicole Goodwin is the author of Warcries as well as the 2018 Ragdale Alice Judson-Hayes Fellowship Recipient, 2017 *EmergeNYC* Hemispheric Institute Fellow, as well as the 2013-2014 Queer Art Mentorship Queer Art Literary Fellow. She has published articles "Talking With My Daughter..." and "Why is This Happening In Your Life..." on the *New York Times Motherlode Blog*. Additionally, her work "Desert Flowers" was shortlisted for Women's Playwriting International Conference in Cape Town, South Africa in 2015.

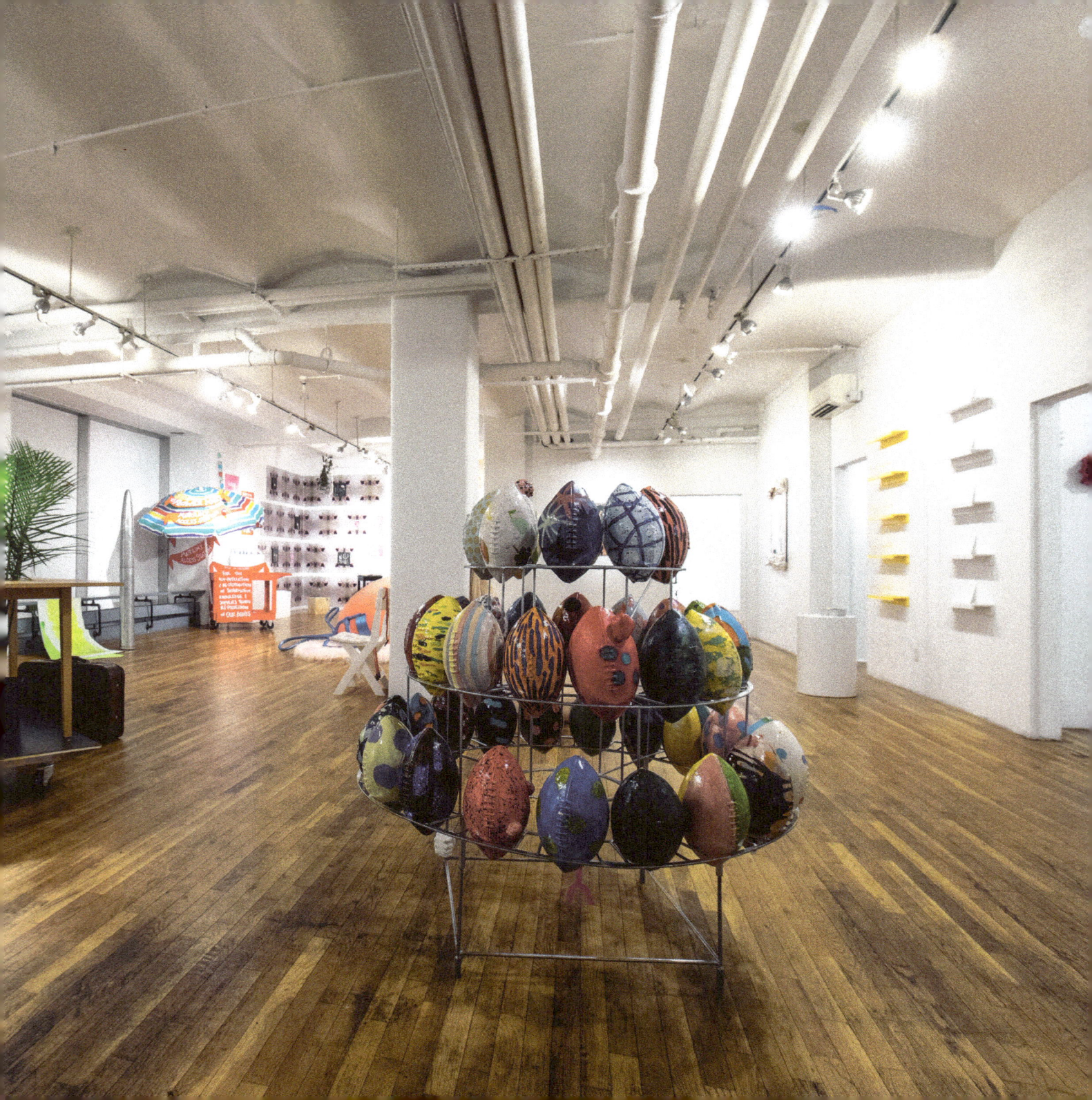

Gallery Key

Pages 16-17 (clockwise from main image): installation shot of Westbeth Gallery; *A Seat For The Elderly: The Invisible Generation,* LuLu LoLo; *Duet,* Jody Oberfelder Projects; Denise Treizman & Adam Brazil; *Shock Corridor*

Page 18 (clockwise from above): *Stubborn Femme Growth Controlling the Feed,* Dakota Gearheart; *Flower Kart* [detail], No Wave Performance Task Force; *Flower Kart* [detail], No Wave Performance Task Force; *Shield,* Stacey Cann; *Absence of Three,* Pei-Ling Ho

Page 19 (clockwise from top left): *th3_n3st,* Sierra Ortega; *The Station,* TANGA!; *The Stacys: An Interview,* Grace Whiteside; *Hura Maymunah Walking Through the Garden of Black Eden,* Clarivel Ruiz; *Dance Memoir,* Elaine Angelopoulos; *Hell Hath No Fury,* Donna Cleary & Kathy Halfin

Pages 20-21:
Top Row: *Possible Deformations,* Maya Pindyck; *A Documentation of Intimacy: Purchase & Contamination,* Claus Hedman; *Urbestselfie,* Martha Hipley; *My Time is Valuable,* Jody Servon

Middle Row: *Cover Girls,* Nadja Verena Marcin; *A Documentation of Intimacy: Purchase & Contamination,* Claus Hedman; *Off the Grid-Iron,* Denise Treizman & Adam Brazil; *Shock Corridor,* Joanne Leah

Bottom Row: *Kiss Mark* [left] & *Mutual Recognition System (Concerning Max Factor)* [right], Maryam Monalisa Gharavi; *My Body Is Not In Question,* Daniela Mekler; *Untitled Speech,* Deborah Castillo

Pages 22-23:
Top Row: *Body of Institution: Public Grant T.B.A.,* Esther Neff; *Washington's Texts!,* The Museum on Site; *Don't Move; Meditating My Way Out of Capitalism and Communism: 12410 Days of Isolation,* Yali Romagoza

Middle Row: *Picnic Parade,* Jodie Lyn-Kee-Chow; *(Un)folding,* The Do-Mystics; *Silver Sirens,* Laura Nova; *Gymnasia Hysteria,* Rose Nestler

Bottom Row: *Infirm Performance Still* [left] & *Whore Bath* [right], Jessica Elaine Blinkhorn; *Matter Rearrangements,* Veronica Peña [left] & *Dirty White Matter,* Meg Stein [right]; *Ain't I a Woman (?/!),* Nicole Goodwin

Pages 24-25:
Top Row: *We are Revealed,* Kasie Campbell; *Possible Deformations,* Maya Pindyck; *A Rap on Race with Rice: documented,* Dominique Duroseau

Middle Row: *Say it With Flowers,* Catherine Feliz; *You Are What You Eat,* Luiza Kurzyna; *My Body Is Not In Question,* Daniela Mekler; *Foundation,* Questions Collective

Bottom Row: *Flower Kart,* No Wave Performance Task Force; *Ear to Ear,* Jaime Sunwoo; *A Seat For The Elderly: The Invisible Generation,* LuLu LoLo; *Queens Museum, Unbound Feminisms and Territorialities,* Legacy Fatale

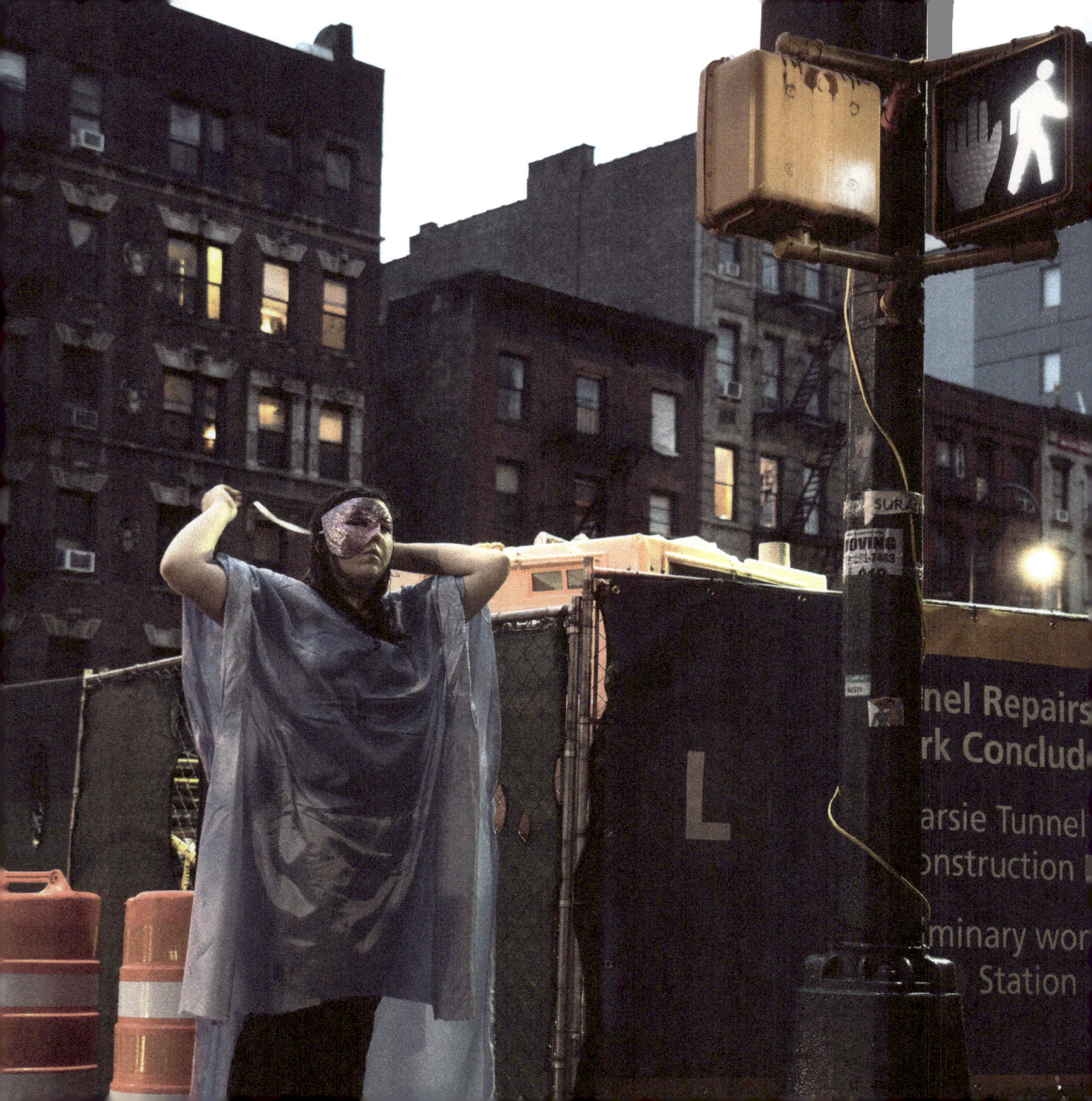

Photo Credits

Andrea Basteris: 106

Kit Fretz: vi, vii, 2, 7, 9, 12, 15, 29, 34, 35, 38, 39, 42, 43, 46, 47, 50-58, 54-57, 59, 61, 70, 71, 74-81, 83-87, 91, 94, 95, 97, 100-105, 108-111, 121, 128, 130, 131, 135

Alonso Nuñez: 36, 37

Joan Oh: 44, 45

The Dusty Rebel: 96

Christopher Rego: 40, 41

Andrew Rubin: 90

Fernando Scrupp: 72, 73

Walter Wlodarczyk: 10, 16-25, 28, 30-33, 48, 49, 53, 58, 60, 62-67, 69, 82, 88, 89, 92, 93, 98, 99, 107, 112-114, 122, 125, 126, 132

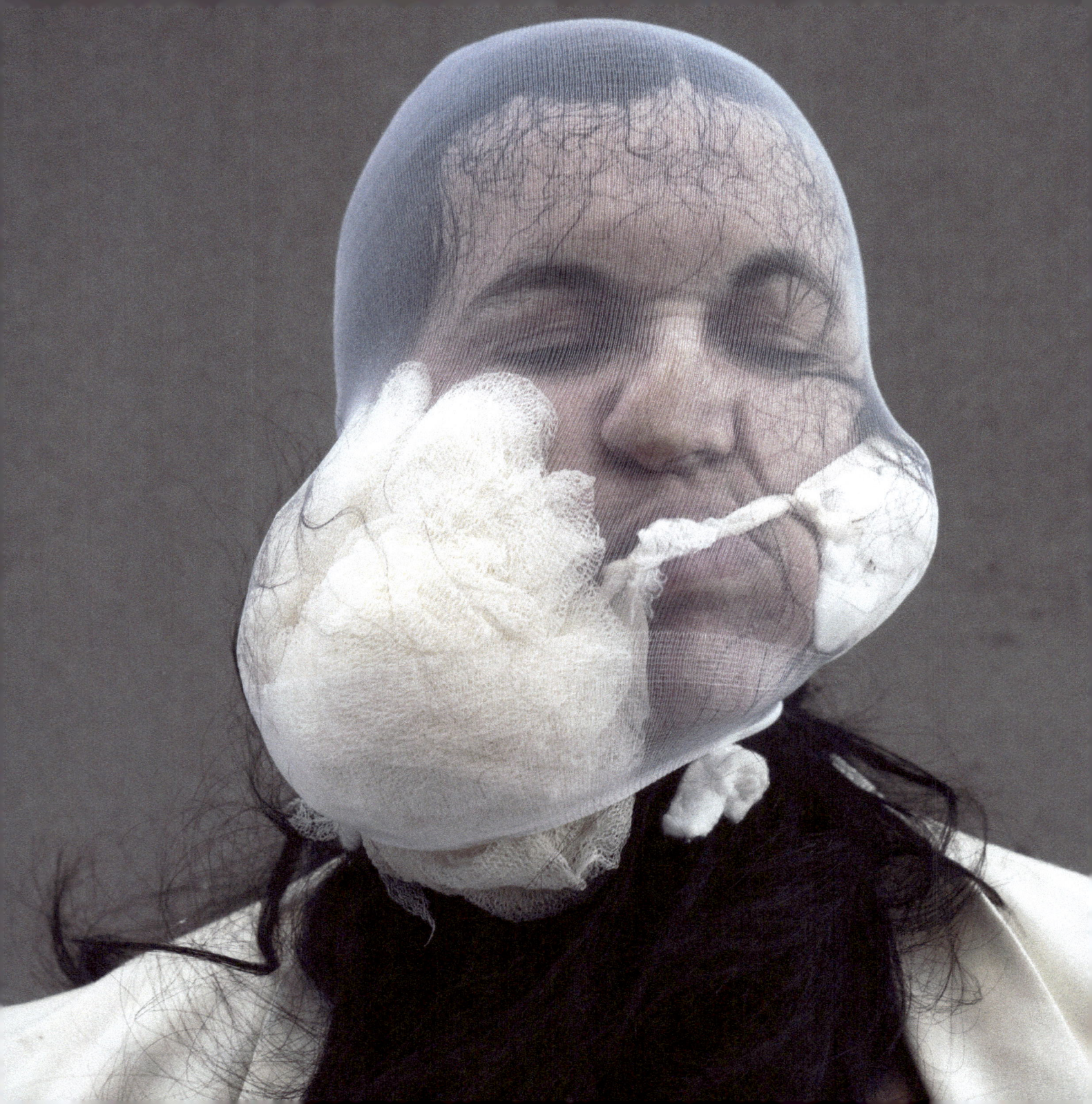

About

Art in Odd Places (*AiOP*) began as an action by a group of artists led by Ed Woodham to encourage local participation in the Cultural Olympiad of the 1996 Olympics in Atlanta. In 2005, after moving back to New York City, Woodham re-imagined it as a response to the dwindling of public space and personal civil liberties—first in the Lower East Side and East Village, and since 2008, on 14th Street in Manhattan.

Today, *AiOP* presents visual and performance art in public spaces with an annual festival each October along 14th Street in Manhattan, from Avenue C to the Hudson River.

The festival aims to stretch the boundaries of communication in the public realm by presenting artworks in all disciplines outside the confines of traditional public space regulations. *AiOP* reminds us that public spaces function as the epicenter for diverse social interactions and the unfettered exchange of ideas. It has always been a grassroots project, fueled by the goodwill and inventiveness of its participants.

www.artinoddplaces.org
artinoddplaces@gmail.com

Art in Odd Places is a project of GOH Productions.
Bonnie Stein, Executive Director
www.gohproductions.org

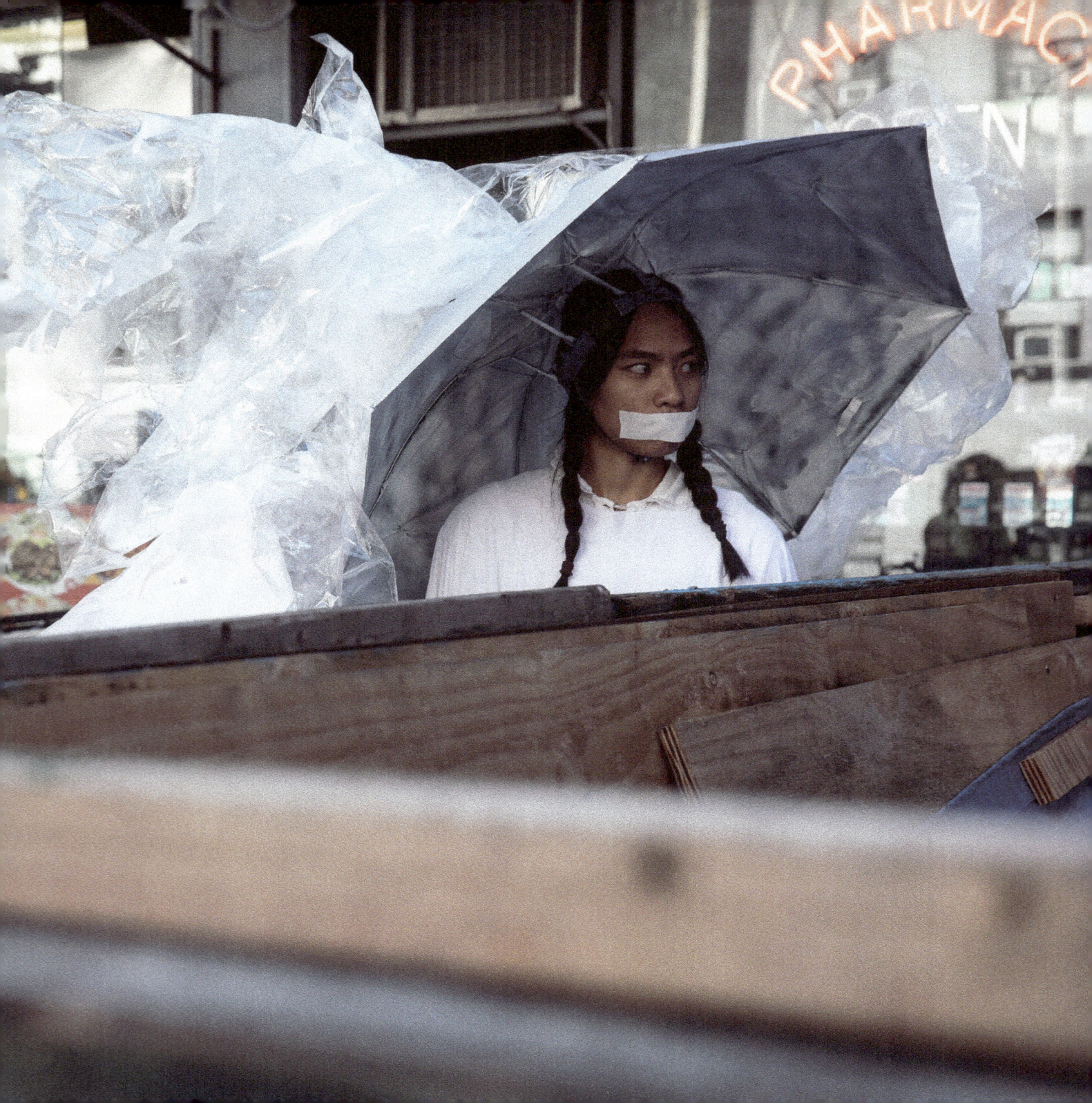

Acknowledgements

Team:
Ed Woodham, Founder & Director
Katya Grokhovsky, Curator
Audra Lambert, Curatorial Manager
Katie Hector, Curatorial Assistant
Bridget Leslie, Press and Exhibition Coordinator
Alison Pirie, Administrative Assistant
Alex Sullivan, Volunteer Coordinator / Website Designer / Misc.
Emily Markert, Social Media Coordinator
Laurie Waxman & Ollya Andreeva, Graphic Design
Juana Urrea, Intern
Kit Fretz, Intern & Photographer
Performance is Alive, Media Sponsor

Sponsors: GOH Productions, NYC Department of Cultural Affairs, Leo S. Walsh Foundation, Materials for the Arts, Two Boots Pizza,

Catalog Design: Kit Fretz & Alex Sullivan

Special Thanks: (in no particular order)

Participating artists, all of the volunteers, the *AiOP* team, the art handlers, Walter Wlodarczyk, Michael at Beauty Bar, Erin Carr, Quizayra Gonzalez, Ximena Kilroe, Jodi Waynberg, Materials for the Arts, Bonnie Stein, Vit Horejs, Joshua Suzanne at Rags-A-Gogo, Alicia Grullon, Clarinda Mac Low, Martha Wilson, Franklin Furnace Archive, Wesbeth Gallery

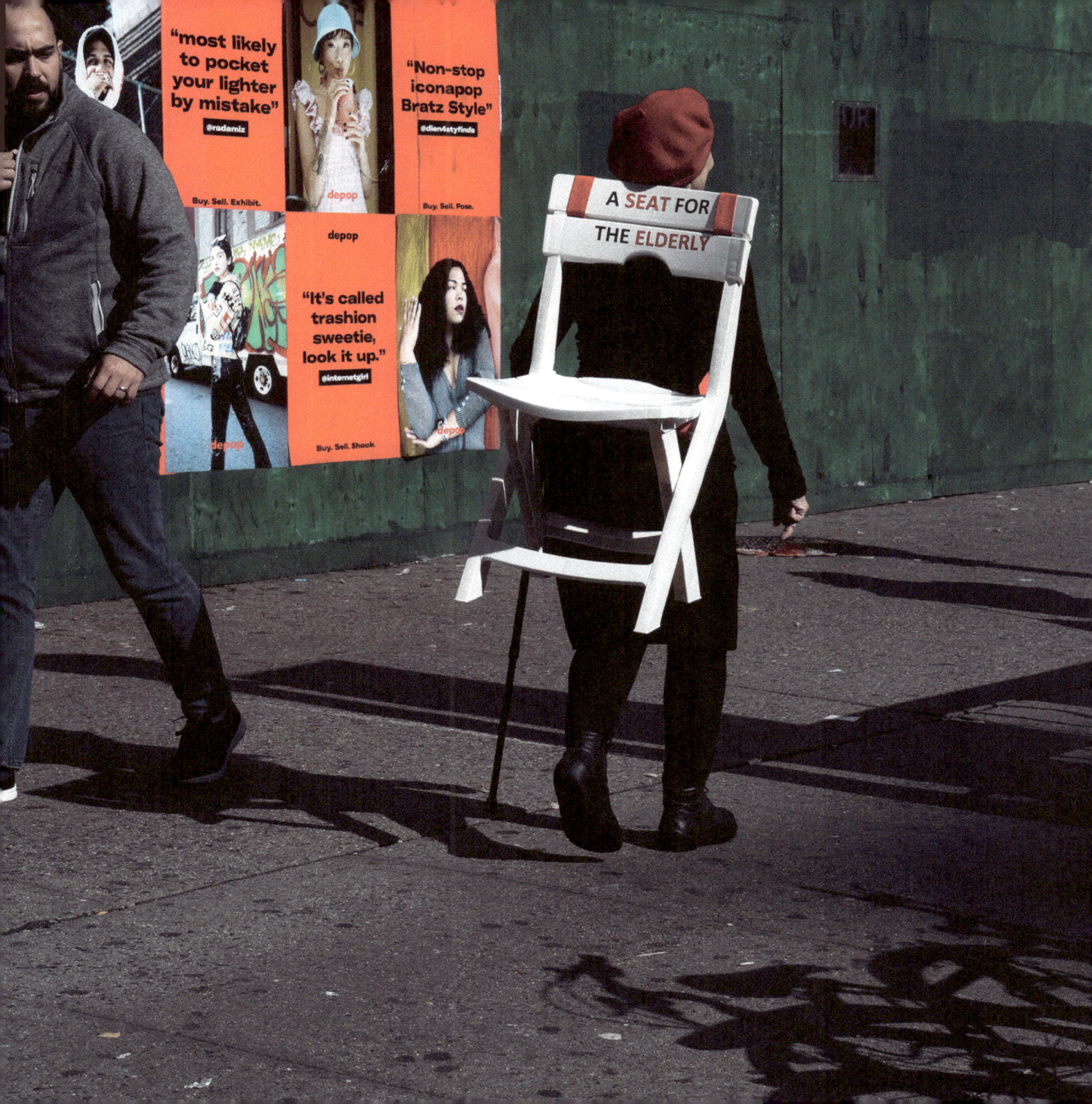